THE

WAY

WE

WED

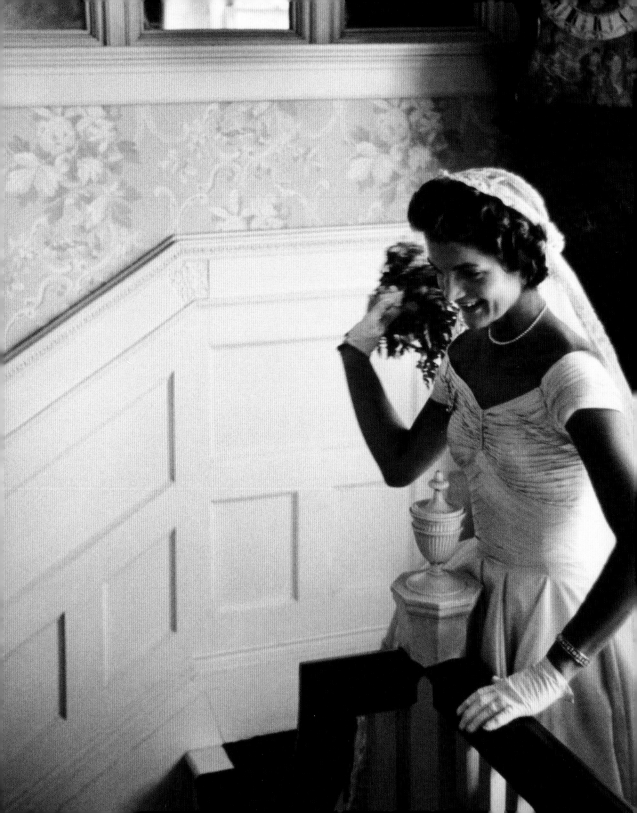

THE WAY
WE WED

A GLOBAL HISTORY OF
WEDDING FASHION

KIMBERLY CHRISMAN-CAMPBELL

RUNNING PRESS
PHILADELPHIA

Running Press
Hachette Book Group
1290 Avenue of the Americas, New York, NY 10104
www.runningpress.com
@Running_Press

Printed in China

First Edition: December 2020

Published by Running Press, an imprint of Perseus Books, LLC,
a subsidiary of Hachette Book Group, Inc. The Running Press name
and logo is a trademark of the Hachette Book Group.

The Hachette Speakers Bureau provides a wide range of authors for
speaking events. To find out more, go to www.hachettespeakersbureau.com
or call (866) 376-6591.

The publisher is not responsible for websites (or their content)
that are not owned by the publisher.

Additional copyright/credits information is on page 207.

Cover photography © Howell Conant/Bob Adelman Books, Inc.
Print book cover and interior design by Marissa Raybuck.

Library of Congress Control Number: 2020933072

ISBNs: 978-0-7624-7030-3 (hardcover),
978-0-7624-7028-0 (ebook)

1010

10 9 8 7 6 5 4 3 2 1

FOR MY HUSBAND

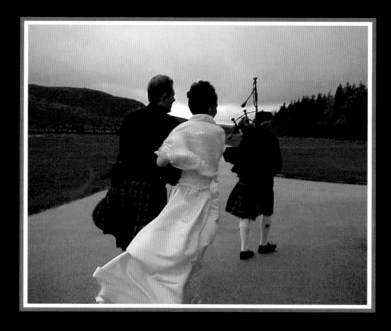

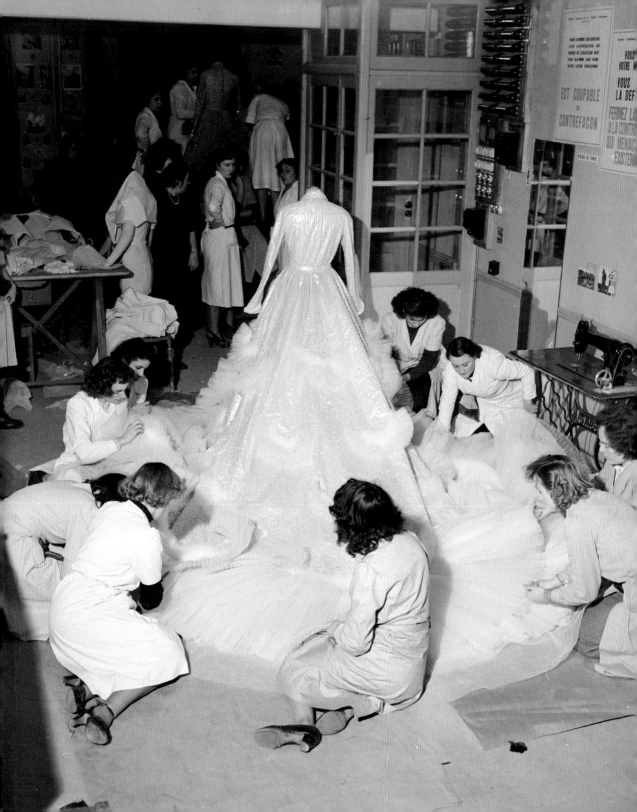

CONTENTS

CHAPTER 1

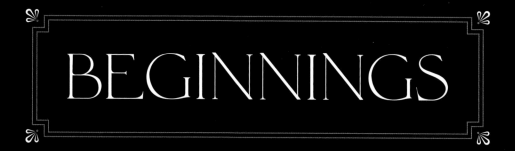

BEGINNINGS

T *HE WAY WE WED* **EXPLORES THE HISTORY** of wedding clothes from the Renaissance to the present day. The objects and images highlighted in this book celebrate the art of fashion while revealing how tastes and traditions have changed over history. Far from being immutable, wedding clothes reflect changing fashions as well as changing customs, lifestyles, and values. They tell intimately personal stories, but they also illustrate broader societal narratives.

The history of weddings is, in many ways, a history of clothing. Wedding rituals have always revolved around the exchange and display of garments and jewelry, from trousseaux and luxurious wearable gifts—which were put on public view or symbolically exhibited through itemized lists published in newspapers and fashion magazines—to the clothes and rings worn on the wedding day itself. In the Middle Ages, guests took home pieces of the wedding gown for luck, a custom that survives in the tossing of garters and bouquets. The Jewish *huppah* was originally a shawl or scarf draped over the heads of the bride and bridegroom. Wedding guests have traditionally received wearable favors like gloves, sword knots, and fans—a practice reprised today, as couples distribute fans and umbrellas for outdoor weddings or slippers for reception dancing. Pre- and post-wedding ceremonies and celebrations have their own dress codes. In many cultures, clothing and textiles play a role in the wedding ceremony itself, and there is a fine line between tradition and superstition: something old, something new. Weddings are rites of passage—particularly for women—and changes of clothing symbolize the changing status and identity of the participants.

While wedding clothes are often thought of as being bound by tradition, however, many of these "traditions" are, in fact, relatively recent innovations. Veils, for example, have long symbolized modesty and transformation in Jewish weddings, but they did not become part of Christian wedding rites until the nineteenth century. Similarly, though diamonds have been used in engagement rings since the Renaissance, it was only in the twentieth century that advertising slogans like "a diamond is forever" and "diamonds are a girl's best friend" made diamond rings synonymous with getting engaged.

The long, white wedding gown was popularized by Queen Victoria in 1840, and solemnized with the proclamation of the Immaculate Conception by Pope Pius IX in 1854. Since then, it has been largely reserved for the upper classes and frequently abandoned in times of war, economic hardship, or mourning. Furthermore, it was originally associated with young and elite brides; older brides or widows wore gray, lavender, and other colors, while women who could not afford an impractical white gown wore their best dress, regardless of hue. And not even well-to-do brides wore their wedding gowns just once; they became part of a woman's wardrobe, often her "best dress." Today, however, bridal gowns may have little in common with everyday dress; indeed, they might incorporate elements of Victorian style, like long, full skirts, and come from specialist bridal shops, having been made by dedicated bridal designers, who have their own fashion magazines and their own Fashion Week.

In *White Weddings: Romancing Hetero-sexuality in Popular Culture*, sociologist Chrys Ingraham observed that the "traditional" or "white" wedding—"a spectacle featuring a bride in a formal white wedding gown, combined with some combination of attendants and wit-nesses, religious ceremony, wedding reception, and honeymoon"—tends to enjoy a resurgence in popularity at times when heterosexuality is perceived as being under siege. "We hold up the institution of heterosexuality as time-less, devoid of historical variation, and as 'just the way it is.'" This tradition is "white" in more ways than one, often precluding both sexual and racial diversity.

At the same time, many of the wedding clothing rituals that are now thought of as modern or trendy have ancient roots, such as the practice of wearing several special outfits in the course of a wedding ceremony, reception, or "wedding weekend." For much of recorded history, wedding rites did not begin or end with the vows, and neither did the clothes they required. Depending on her social sta-tus, a bride's wedding clothes could consist of anything from a new hat to a lavish trousseau intended to last for years. Clothes often formed part of a bride's dowry, or a groom's wedding gifts to his bride.

In many cases, wedding clothes—not just gowns and veils but shoes, suits, vests, undergarments, and "second-day" or "going-away" dresses—have survived in museum collections and within families. This is partly for sentimental reasons, and partly because the clothes were too specialized or too expensive to wear frequently. Indeed, this material record has distorted our perception of the fashion his-tory of weddings as much as has informed it, as have stereotypical depictions of white-clad brides. As curator Cynthia Amnéus has pointed out, "it is likely that the dresses that were most recognizable as wedding gowns—those that were white—were preserved by descendants, creating the impression of a preponderance of white wedding attire in the period." Though colored wedding gowns may have been just as plentiful, they have not been identified as such by later generations and, thus, preserved.

While films, fashion magazines, fiction, and the fantasies of the runway have all helped to craft our cultural notions of "traditional" or "historical" wedding dress, this book will focus on real clothes worn by real people—and not just brides, but the wide cast of characters that makes up any wedding: flower girls, brides-maids, mothers of the bride, guests, and, of course, grooms. Same-sex weddings and sec-ond (or third, or fourth) marriages are also represented. Royals and celebrities appear alongside ordinary or anonymous couples. This book does not claim to be a comprehensive

survey of wedding fashions throughout history, or even a part of history. Nor is it a catalogue of one collection or designer. Rather, it approaches wedding fashion *as* fashion, reflective of and relevant to wider trends in morality, technology, and aesthetics.

Until relatively recently—that is, within the past century or two—single men and women were largely kept segregated from each other, and marriages were often arranged, especially among the fashion-conscious upper classes. Weddings were financial transactions, not love matches. Despite (or because of) this, appearances mattered, and wedding clothes were chosen with careful deliberation to communicate one's social and financial status and family connections. Before the Industrial Revolution, clothing was, proportionally, much more expensive than it is today; as a form of wearable wealth, it played an important role in marriage negotiations and rituals. It functioned as not just social currency but as actual currency.

BEFORE THE WEDDING

♦ ♦ ♦ ♦

The transactional nature of marriages was made manifest in an additional ceremony, the signing of the marriage contract—an event many considered to be more important than the religious ceremony that followed, and one that was frequently depicted in paintings and prints romanticizing the lifestyles of the rich and famous. The contract was not a prenuptial agreement between the bride and groom in the modern sense—outlining the division of assets in the event of a divorce—but a combination bill of sale and will, specifying the terms of the dowry, property rights, and inheritance. The Marquise de la Tour du Pin—an apprentice lady-in-waiting to Queen Marie-Antoinette—recalled of the signing of her own marriage contract in 1787: "This ceremony was conducted with all the usual solemnity. The parents, the witnesses, the notaries, the costumes, everything was very correct." The marquise deliberately chose a colored *habit d'accord* ("outfit of agreement"), explaining: "The white gown was reserved for the wedding day." Though white was not yet *de rigueur* for wedding gowns, it was the most fashionable color at the time, as well as an expensive and, thus, prestigious one. Similar formal engagement rituals—such as the Jewish *erusin* (betrothal) or the Indian ring ceremony—have taken place in many cultures and time periods, followed more or less promptly by the wedding itself.

The formal public announcement of the engagement might require an entirely different outfit, particularly in royal contexts, where the choice of a spouse affected the fate of the entire nation. The pink gown Princess Caroline Amalie of Schleswig-Holstein-Sonderburg-Augustenburg wore to announce

FOLLOWING: A fashionable French couple hold hands while their parents haggle in *The Marriage Contract* (1633) by Abraham Bosse.

her engagement to Crown Prince Christian of Denmark in 1815 survives at Rosenborg Castle in Copenhagen; it was a gift from her fiancé, made in Denmark, and thus a suitable garb in which to introduce herself to her future subjects.

In 2010, Prince William—grandson to Queen Elizabeth II—and his girlfriend, Kate Middleton, announced their engagement to the public via a press conference attended by a throng of reporters and photographers (see Chapter 10). Middleton's blue silk jersey wrap dress was chosen for the cameras to match her twelve-carat blue Ceylon sapphire engagement ring. It was the same ring Prince Charles had presented to William's late mother, Princess Diana, nearly thirty years earlier; Diana reportedly chose it from a selection of rings because its vivid color— and enormous size—made it easily visible to

ABOVE: An elegant bride drops her quill in surprise as an unexpected clause derails the ceremony in Michel Garnier's *The Marriage Contract Interrupted* (1789).

the public. The ladylike, knee-grazing style of Middleton's British-made Issa dress—paired with nylons and closed-toe black suede heels by Episode—declared her transition from commoner to queen-in-waiting, and set a precedent for her chic but conservative wardrobe as Duchess of Cambridge. In another harbinger of things to come, Middleton's dress sold out within minutes, while cheap, hastily produced knockoffs flooded shops.

Each country has its own regional pre-wedding traditions, with their attendant sartorial traditions and requirements. Elisabeth of Bavaria wore a *Polterabendkleid* or "wedding eve dress" to the celebrations on the night before her marriage to Emperor Franz Joseph I of Austria in 1854. *Poltern* is a German verb meaning "to crash" or "to make a racket"; a couple's *Polterabend* was (and still is) a noisy pre-wedding party, often involving smashing porcelain for good luck. The royal bachelorette's white organdy dress and its matching shawl were embroidered in green floss and gold metallic thread with floral motifs and Arabic characters, chosen for their decorative effect rather than their literal meaning, while also reflecting Austria's deep historic ties to the Ottoman Empire.

A Japanese royal wedding can consist of up to twenty separate ceremonies, incorporating both traditional and modern dress. When Princess Sayako—the only daughter of Emperor Akihito

and Empress Michiko—married Yoshiki Kuroda in 2005, forfeiting her royal status, she donned the traditional *jūnihitoe* to visit the three imperial shrines, ritually informing her ancestors of her intention to marry three days later. *Jūnihitoe*—literally "the twelve layers"—was formal court dress during the Heian period (A.D. 794–1185); today, it is generally seen only in the contexts of royal weddings and enthronement ceremonies.

Several factors contribute to the prestige of this ancient garment. Its old age is, in itself, a measure of its importance; in many cultures and time periods, wedding clothes reference the fashions or traditions of the past. Its expense, as well as the time and expertise required to put on the twelve layers of robes, confine it to the upper echelons of society. The physical difficulty of wearing the *jūnihitoe*, which can weigh up to forty pounds, with grace is both a cause of and a comment on its high status. Only the borders of the inner eleven robes of colorful silk are visible; the choice and arrangement of colors changed with the seasons and indicated the wearer's rank and savoir faire. The male equivalent is the *sokutai*: a robe with voluminous sleeves, color-coded according to rank, paired with a flat baton called a *shaku*—a vestigial scepter—and a lacquered black *kanmuri* hat. Like many Western wedding garments, these elaborate, expensive ensembles, rich in history and symbolism, reinforce the gravity of the vows being made, not

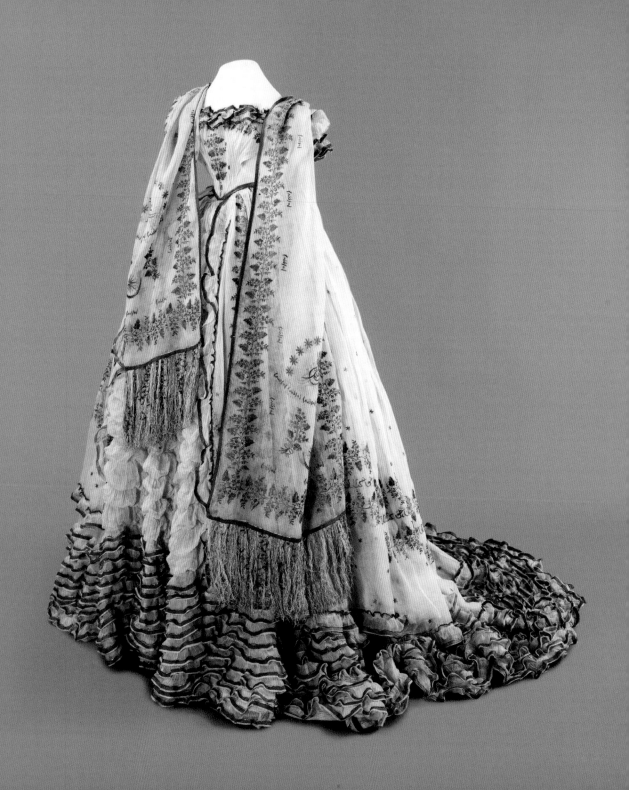

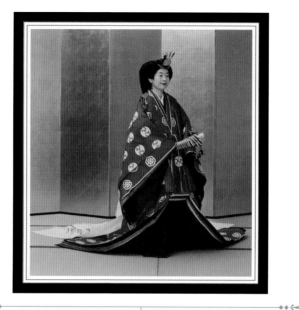

only for the couple, but for their families and, sometimes, nations.

This is true of the clothing worn for pre- and post-wedding rites as well as for the ceremony itself. Indeed, these garments tend to survive where the actual wedding clothes have not, and may be worn repeatedly and seen by more people. Empress Sisi kept her *Polterabendkleid* but donated her white satin wedding gown embroidered with silver and gold to the church where she married, to be made into vestments, as was customary at the time. Only one part of it—her gold-embroidered court train, which was detachable and, presumably, reused—has survived intact. Princess Caroline Amalie's engagement gown survives, but her wedding gown does not. Her will specified: "I wish it to be laid under my head in the Coffin." Queen Victoria, too, had her lace wedding veil buried with her. A *Polterabendkleid*, *jūnihitoe*, or *habit d'accord*—much like the clothes purchased for modern-day engagement photos, bridal showers, rehearsal dinners, or bachelorette parties—might have less sentimental value than a wedding gown but represented a comparable investment of time, money, and taste. These garments mattered, not just because they set the tone for the wedding itself, but because they marked the beginning steps in the journey of marriage. ◆

OPPOSITE: Empress Elisabeth of Austria's Polterabendkleid (wedding eve dress) survives, although her wedding gown does not. ABOVE: Princess Sayako of Japan donned a twelve-layer court costume for her ceremonial pre-wedding visit to the imperial shrines in 2005.

ROYAL WEDDINGS

FOR CENTURIES, ROYAL WEDDINGS HAVE set styles and standards imitated by commoners. These high-profile events were historically motivated by dynastic concerns more than romantic love, with all the pomp and pageantry that implies. To this day, royal weddings feature archaic accoutrements like horses and carriages, coachmen in livery, bishops in elaborate vestments, soldiers (and grooms) in uniform, and trumpeters. Yet royal brides typically choose the same fashion-conscious styles that other brides wear, though they may be the work of exclusive couture houses and have conservative details like long sleeves, antique lace, or long trains, in deference to the solemnity of the setting (typically a grand cathedral or palace) and the gravity of the occasion.

This has not always been the case. If royal marriages were arranged to create dynastic alliances, wedding clothes reinforced those alliances; appearance was everything. In some cases, brides had to undress and put on new clothes at the border as they entered their new country, symbolically shedding their foreign identities. They adopted new hairstyles, cosmetics, and languages. At the very least, they were expected to wear clothes made in their new homelands for their weddings, even if they closely resembled the clothes worn in their ancestral courts. Wedding clothes might be woven or embroidered with patriotic or dynastic imagery, or derived from regional folk dress. In 1956, Archduke Joseph Árpád of Austria wore "the robes of a once mighty nobility" for his wedding, according to *LIFE* magazine: a sable-trimmed *mente*, a jacket usually worn thrown over the shoulders. Princess Charlene of Monaco wore Armani for her 2011 wedding to Prince Albert, but her seven child bridesmaids wore the country's national dress: flat straw hats, lace-up slippers, and dresses in a rustic eighteenth-century style, embellished with personal touches, like silk stockings and aprons embroidered with the couple's monogram.

Depending on the country, royal weddings might last days or weeks and include a variety of different ceremonies and events, all with their own wardrobe requirements. In 1810,

Crown Prince Ludwig threw a massive public party in Munich in honor of his wedding to Princess Therese; it is still celebrated every year as Oktoberfest. Royal grooms might don armor for celebratory jousting tournaments. The wedding of Caliph Sidi Muley el Hassan and Princess Lal-la in Morocco in 1949 went on for fifteen days. *LIFE* magazine photographer Dmitri Kessel remembered:

There were daily receptions in the caliph's palace—lunches and dinners where men sat on cushions around low tables and consumed great quantities of roast lamb, chicken cooked with almonds, chicken cooked with green olives, chicken cooked with honey. During the celebrations the guests ate 15,000 chickens and 3,000 lambs, washed down with vats of fruit juices; good Muslims, they did not drink alcohol. No women were present except at the last dinner. . . . The bride-to-be was never seen.

Royal trousseaux were equally elaborate. A trousseau—from the French term *trousse*, meaning "bundle"—was the supply of clothing, lingerie, and table linens a bride brought to her marriage; it usually included clothes for the wedding and honeymoon, if not the entire first year of marriage. When Queen Victoria's oldest daughter, Princess Vicky, married in 1858, her

trousseau filled a hundred packing cases and included not only dozens of gowns but fabric, carpets, wallpaper, furniture, and saddles. Vicky's niece, Princess Marie of Edinburgh, who married Crown Prince Ferdinand of Romania in 1893, remembered:

Mama gave me a wonderful trousseau, a real princess's trousseau in keeping with that time of prosperity and abundance. . . . I . . . loved clothes, furs and precious gems, but I was astonished at the masses of dresses, cloaks, hats, handkerchiefs, stockings, shoes and fine linen that I was supposed to need. All these manifold treasures were put out in a large room and I, with my sisters and many friends, used to walk about amongst them, awed by their magnitude. Getting married was certainly a stirring event.

And when Princess May, another daughter of Queen Victoria, married the Duke of York in the same year, her trousseau included forty suits, fifteen ball gowns, and five afternoon gowns, with all their accessories. Crown Princess Stéphanie of Austria—the Belgian-born widow of Archduke Rudolf—remarried in 1900. Her trousseau was so large that a special train was required to transport it from Vienna.

Royal trousseaux and wedding gifts were considered state property, to some extent, and displayed and itemized for public consumption (and fashion inspiration). When Princess Margaret of Connaught married the Crown Prince of Sweden in 1905, her trousseau and presents went on display at Clarence House in London, including gowns by Paquin and Lucile and an enviable assortment of jewelry. Nevertheless, the newspaper *The Sphere* complained: "It is a great disappointment that so little of [her] trousseau is on view, but with few exceptions the dresses and *lingerie* are being sent direct to Sweden."

White first emerged as a popular choice for gowns of all kinds in the eighteenth century; inevitably, some women chose white gowns for their weddings, but it was because they were fashionable (and luxurious) rather than because of any symbolism attached to the color. Fashion plates of the time depict bridal gowns of red, blue, and other vivid hues. When the *Magasin des modes nouvelles* illustrated a white wedding gown in 1787, the editors stressed that the quality of the fabric, not its color, was the most important consideration: "One always chooses that which is the most rich and the most elegant." It was perfectly acceptable and, indeed, expected for women to wear their wedding gowns again and again, regardless of color.

THE BRIDE WORE SILVER

◆ ◆ ◆ ◆

But royal brides were held to a different standard. For royal weddings, brides and grooms alike frequently wore cloth of silver, an extremely expensive fabric woven with real silver threads that had been reserved by law for the nobility since the seventeenth century. A reigning monarch might even wear cloth of gold. Catherine the Great wore cloth of silver for her 1744 wedding. When she married the future King Louis XVI in the Royal Chapel of the Palace of Versailles in 1770, Marie-Antoinette wore cloth of silver trimmed with gold filigree but omitted the ermine-trimmed cloak of purple velvet, approximately thirty-three feet long, that would have been worn by the bride of a reigning monarch. One wedding guest, the Duchess of Northumberland, remarked that the fourteen-year-old bride was "very fine in Diamonds. She really had quite a Load of Jewels."

As royal wedding gowns go, it's hard to top the one worn by Princess Sofia Magdalena of Denmark when she married the future King Gustave III of Sweden at Stockholm Palace in 1766. With a hoop petticoat measuring six feet across and a ten-foot train, the bride was wider—and longer—than she was high. The cloth of silver was further embellished with a woven floral and lace pattern. In total, twenty-seven yards of the precious fabric were required to make the glittering gown fit for a future queen. Her husband, the Crown Prince, was equally resplendent in a three-piece suit of cloth of silver, embroidered in silver and gold.

Royal weddings required the bride, groom, and guests alike to wear court dress. For women of the eighteenth century, this meant the *grand habit*, loosely translated as "formal dress." In the 1670s, King Louis XIV personally invented this three-piece ensemble consisting of a low-necked, sleeveless bodice; a skirt; and a separate train attached at the waist. Even at its first appearance at the court of Versailles, it was a hybrid of new and old, as the aging king tried to revive the female fashions he had admired in his youth. The bare shoulders and back-laced bodice stiffened with ribs of whalebone (the contemporary name for baleen, the rigid, hairlike substance that takes the place of teeth in some whales) harked back to the fashions of the 1660s. The length of the train and, sometimes, the materials and colors of the *grand habit* corresponded to a woman's social status.

By 1700, the *grand habit* had been adopted as formal female court dress throughout Europe, from Spain to Russia, with only minor regional variations—a powerful testament to French fashion's dominance. (Indeed, the Swedish ambassador to the court of Versailles purchased Gustave and Sofia Magdalena's wedding clothes in Paris.) It remained in use for more than one

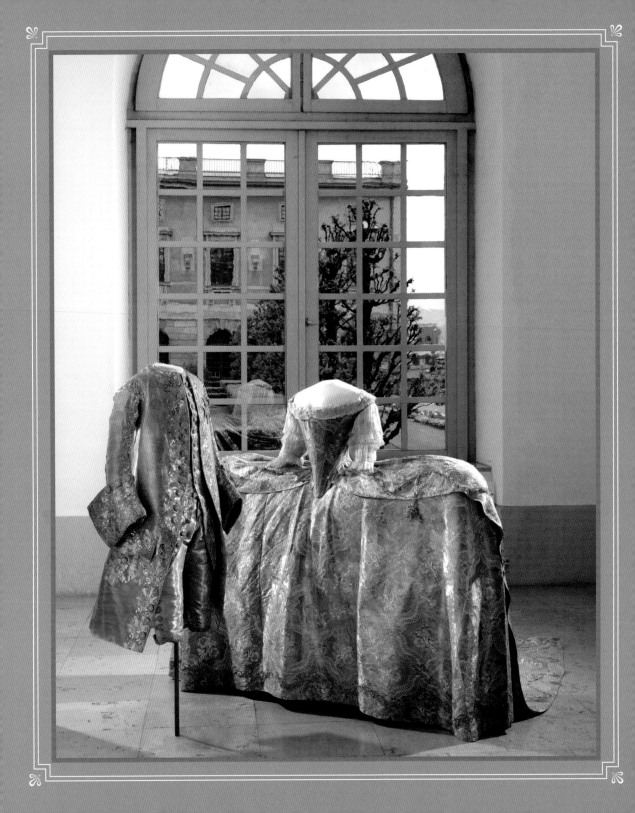

hundred years because it was a remarkably effective vehicle for showing off costly textiles, trimmings, embroidery, and jewels, as well as elegant posture and deportment. Men, too, wore court dress, but it generally consisted of a more opulent version of fashionable dress, while the *grand habit* was absolutely unique to the court.

Due to a culture of enthusiastic preservation dating back to the early seventeenth century, several royal wedding gowns have survived in the Swedish Royal Armoury; they are rare examples of what was, at the time, an international courtly style. The 1823 wedding ensembles of Crown Prince Oscar and Princess Joséphine of Leuchtenberg illustrate the evolution in fashion from the late eighteenth century to the early nineteenth, dramatically accelerated by the social upheavals of the French Revolution, which impacted fashion all over Europe.

While retaining the rich metallic textiles and embroideries of the previous century, the silhouettes reflect the trends of the time: close-fitting coats and long trousers (instead of knee-length breeches) for men, and high waistlines, slim skirts, and short, puffed sleeves for women. Yet no one would mistake Oscar and Joséphine's wedding clothes for everyday dress; apart from the sumptuous fabrics, they include archaic elements that would only be worn at

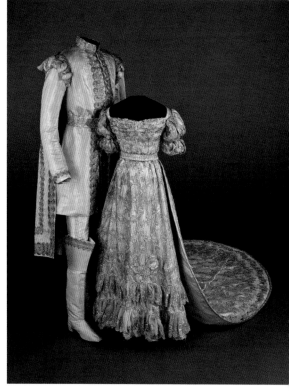

court, such as her train (which is detachable) and antiquated gathered and slashed sleeves, and his somewhat theatrical cape, shoulder tabs, and tall boots, which recall the fashions of the seventeenth century. Gustave III had instituted a romantic "national costume" inspired by the dress of Sweden's Golden Age as court and official dress in 1778, and vestiges of it continued to be worn at court until the late twentieth century; even today, ladies-in-waiting wear it at Swedish royal weddings.

OPPOSITE: The future King Gustave III of Sweden and Princess Sofia Magdalena of Denmark married in court dress in 1766. ABOVE: Princess Joséphine of Leuchtenberg evoked the elegance of her grandmother and namesake, Empress Joséphine, at her wedding to Crown Prince Oscar of Sweden.

THE BRIDE WORE WHITE

◆ ◆ ◆ ◆

Thus, when Queen Victoria married Prince Albert in 1840, centuries of royal precedent dictated that she should wear a gown of gold or silver, along with her velvet coronation robes. But while many brides relish the chance to be queen for a day, the lovestruck young Victoria was determined to go to the altar as an ordinary woman, wearing a fashionable gown of white silk satin trimmed with lace flounces, with the cursory addition of an eighteen-foot-long court train around her waist, ornamented with sprays of orange blossoms. Instead of a crown, she wore a lace veil anchored by a wreath of orange blossoms (symbolizing fertility) and myrtle (representing love and domestic bliss). She accessorized with the sapphire and diamond brooch Prince Albert had given her on the eve of the ceremony, which she pinned to her bodice; an impressive necklace and earrings of Turkish diamonds; and the insignia of the Order of the Garter, England's oldest and most prestigious order of chivalry. Along with his scarlet and white British field marshal uniform, Albert also wore Garter insignia: a diamond-studded star and blue velvet garter, both gifts from his bride.

Queen Victoria was not the first bride to wear a white dress, just as she was not the first to wear lace and orange blossoms; all three elements were present in the wedding fashions of the previous century. But she's the reason brides still wear them to this day. The intense press and public sentiment surrounding her wedding made it the standard to which all other brides aspired. The fact that white symbolized innocence, purity, and virginity and visually set the bride apart from her guests and attendants ensured its lasting popularity. Of course, "white" at the time generally meant ivory; natural silk and wool has a yellow tinge. It was not until the advent of synthetic fabrics in the early twentieth century that optical white bridal gowns became available.

The queen's gown was conceived with patriotism rather than precedent in mind. It was designed by Scottish pre-Raphaelite painter William Dyce, the head of the Government School of Design (later known as the Royal College of Art). It was his only fashion commission, and his original sketches are thought to have been destroyed so they could not be copied. Dyce also designed the floral motifs for the wedding lace; it was, Victoria recorded in her diary, "an imitation of an old design." The gown had a wide, off-the-shoulder neckline encircled by a deep flounce of lace, called a bertha, as well as lace flounces on the elbow-length sleeves and the lower half of the skirt. Although Brussels lace was more fashionable, Victoria commissioned her wedding lace from the bobbin lace makers of Honiton, Devon, who had suffered competition from

machine-made lace. The bobbin net machine, invented in 1809 by John Heathcoat, introduced machine-made lace as a fashionable novelty; when Heathcoat's patent expired in 1823, the market was flooded with cheap imitation lace. Victoria's handmade wedding lace kept two hundred women employed for nine months; Victoria would continue to use Honiton lace on her clothes and those of her children, and insisted that her daughters and daughters-in-law wear Honiton lace for their own weddings.

The actual sewing of the gown was probably done by the queen's frequent dressmaker, Mary Bettans of Jermyn Street, using silk woven in the Spitalfields neighborhood of London. Victoria's gloves were of English kid leather; her white satin shoes by Gundry & Son had gold trim and resembled modern ballet flats.

ABOVE: Queen Victoria's 1840 wedding to Prince Albert broke with royal fashion tradition but inspired generations of future brides.

The intense international publicity surrounding the royal wedding ensured that the gown had a lasting influence. Indeed, white wedding gowns soon became so commonplace that it was hard to believe that they had ever been any other color. "Custom has decided, from the earliest ages, that tint white is the most fitting hue, whatever may be the material," *Godey's Lady's Book* claimed, falsely, in 1849. "It is an emblem of the purity and innocence of girlhood, and the unsullied heart she now yields to the chosen one." By 1870, an American etiquette guide, *The Art of Dressing Well*, would insist that "from the millionaire's daughter to the mechanic's child, there is always one rule, that the bride must be white throughout. Dress, veil, gloves, slippers, wreath, or bonnet, all must be of pure white for a full dress bridal." Such sweeping declarations must be taken with a grain of salt, however; fashions changed quickly. In 1875, *Godey's Lady's Book* mentioned that white tinged with pink was the most fashionable hue.

The sentimental queen re-wore her wedding gown and lace at every possible opportunity. In 1847, she had her portrait painted in her wedding gown as a seventh anniversary gift for Albert. Handmade lace was as expensive as fine jewelry, and it was not unusual to re-wear the same pieces of lace with many different garments. Victoria made a habit of wearing her wedding lace to the christenings and weddings of her many children and grandchildren; she even allowed her youngest daughter, Beatrice, to wear it for her own wedding. Albert's death in 1861 sent Victoria into black mourning garb for the rest of her life, but she continued to wear her wedding lace, pairing the large skirt flounce with a black gown for her Diamond Jubilee celebrations. When she died in 1901, her bridal veil was buried with her.

Victoria's daughter, Vicky, the Princess Royal, and her daughter-in-law, Princess Alexandra of Denmark, were among the many women who emulated her by choosing white dresses for their own high-profile weddings, perpetuating the association of royalty and white (see Chapter 11). Although Alexandra's future great-uncle-in-law Leopold, King of the Belgians, gave her an exquisite gown of Belgian lace—the finest in the world—as a wedding present, it was unthinkable that she would wear a wedding gown of foreign manufacture. Instead, London dressmaker Mrs. James created a gown of English moiré silk covered in flounces of Honiton lace. After the wedding, the gown was remodeled and likely worn to social events.

CROWN AND COUNTRY

◆ ◆ ◆ ◆

Although lace began to disappear from fashionable dress in the last years of the eighteenth

century as handmade lace was replaced by inexpensive machine-made lace, handmade and antique lace continued to figure prominently in elite wedding garments and trousseaux. Princess Marie of Edinburgh allowed her mother to dress her in "rather overpowering finery" for her wedding to Crown Prince Ferdinand of Romania in 1893, but drew the line at an antique lace veil. "I had a dislike of lace veils, so in spite of all the old family lace I wore tulle, kept in place by a diamond tiara inside which a small wreath of orange blossoms lay curled as in a nest," she remembered.

Princess Mary, the daughter of King George V, was also guided by patriotism when she wed Viscount Lascelles in 1922. Though her medieval-style gown with a low waistline belted by a silver cord was in the latest fashion, it was embroidered with emblems of the British Empire—roses, shamrocks, thistles, Australian wattles, Canadian maple leaf, Indian lotus, and New Zealand fern—and trimmed with Honiton lace. Her veil, too, was heirloom Honiton lace. British *Vogue* admired how the silver lamé and ivory silk gauze gown—created by William Wallace Terry of Reville, London's leading court dressmaker—fused courtly splendor with youthful simplicity and style. The silver hue was a rare throwback to pre-Victorian royal wedding gowns but also harmonized with the general vogue for metallic gowns in the 1920s.

Outside Europe, royal wedding dress was similarly governed by dynastic symbolism and long-standing court etiquette. Crown Prince Yeong of Korea married Princess Masako of Japan in Tokyo in 1920. In 1922, the couple traveled to Seoul, where they participated in a Korean wedding ceremony on the second anniversary of their Japanese wedding. Masako assumed the dress of a Korean royal bride: a formal *jeokui*, meaning "pheasant robe," of deep blue silk embroidered with 154 pairs of green pheasants, symbolizing love and longevity in marriage.

The birds were rendered in five colors, representing the five virtues a queen was expected to embody: benevolence, righteousness, propriety, wisdom, and trust. Like the European *grand habit*, the *jeokui* was color-coded according to rank; an empress wore purple-red, a queen wore pink, and a crown princess wore blue. Roundels embroidered with dragons decorated the breast, back, and shoulders. On her head, Masako wore a triangular ceremonial wig decorated with ornate hairpins and jewels; nearly eight inches high, it was so heavy that a lady-in-waiting had to support it from behind as she walked. Yeong, the groom, wore a *yongpo*, a court robe of red with a dragon design in golden threads, and the crown of the Yi royal dynasty. Not just the clothing but the three-hour ceremony itself drew solemnity from its tangible links to the past; indeed, parts of it were conducted in a medieval,

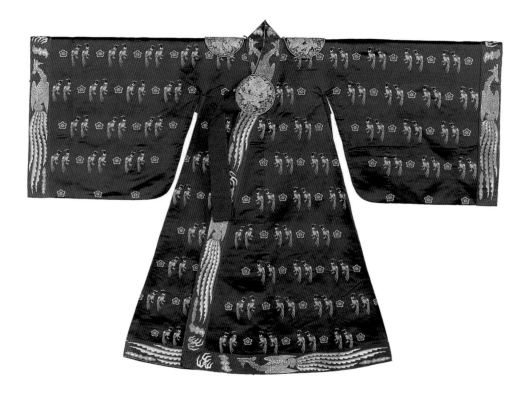

courtly form of the Korean language that few of those present understood.

HOLLYWOOD ENDINGS

♦ ♦ ♦ ♦

From the 1920s until the Islamic Revolution of 1979, Iran embraced western social norms and fashions, including one of the most spectacular royal wedding gowns of all time. In 1951, the divorced Shah Mohammad Reza Pahlavi of Iran married Soraya Esfandiary-Bakhtiary—a half-Persian, half-German beauty—at the Golestan Palace in Tehran. The wedding had to be postponed when the bride contracted typhoid fever; she barely recovered in time for the rescheduled event, which took place on a rare snowy day in February. Between her delicate health, the freezing temperatures, and

ABOVE: Princess Masako of Japan wore this *jeokui* or "pheasant robe" at her second wedding to Crown Prince Yeong of Korea. **OPPOSITE:** Soraya Esfandiary-Bakhtiary hid wool socks under her Christian Dior couture gown at her 1951 wedding to Shah Mohammad Reza Pahlavi in Tehran.

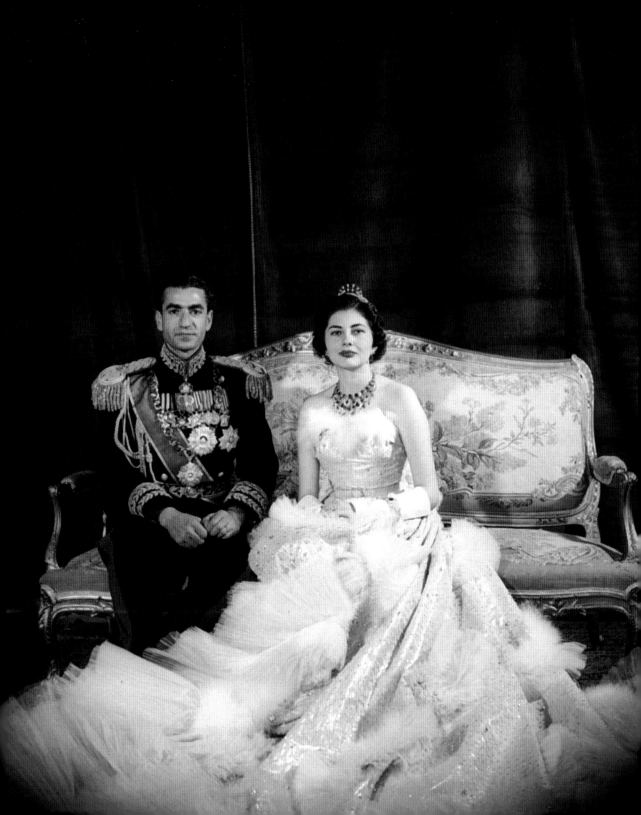

her forty-four-pound Christian Dior couture gown made of thirty-seven yards of silver lamé trimmed with six thousand artificial diamonds, pearls, netting, and twenty thousand marabou feathers, the celebration was a physical ordeal for the bride.

She wore wool socks under her gown to keep her feet warm, descending from the bridal limousine carefully so they wouldn't show. The gown's vast train proved to be too heavy for the four child bridesmaids; two ladies in waiting had to lend a hand. The glittering strapless dress came with a matching jacket and veil; a full-length white mink cape kept the cold at bay. "The train is scattered with a myriad of glass diamonds," Soraya wrote in her memoirs. "'No outrageous expenses, we are in a period of austerity,' the shah had specified." Guests were asked to donate money to a charity for the Iranian poor in lieu of wedding gifts. Because Soraya was so ill in the run-up to the wedding, the shah's older sister, Princess Chams, oversaw the gown's construction. "This riot of glassware was her idea," Soraya noted, with a hint of disapproval. "Bedridden and sick, how could I have imagined, when she showed me the photo of this creation of Dior's, that she would have taken responsibility for embellishing it as well?" After the short ceremony, Soraya discarded the jacket and veil in favor of elbow-length white gloves, a tiara, and an emerald and diamond parure. These gems,

at least, were real—but at the end of the night, Soraya had to return them to their vault, like "a Persian Cinderella," as she put it.

LIFE magazine photographer Dmitri Kessel was surprised that, in contrast to the Moroccan royal wedding he had covered in 1949, this was "a glamorous, Western-style affair. Bejeweled women were dressed in Dior and Jacques Fath creations; the men's formal wear had been tailored in Paris or Rome." Unlike the orthodox Muslims of North Africa, the Iranians drank alcohol. "The champagne flowed freely, and large silver platters of caviar were passed around," Kessel marveled. As the celebrations stretched into the night, Soraya began to feel faint. "Maybe we could cut the train of her gown?" the shah suggested. "A lady in waiting is already bending over me," Soraya remembered. "Flash of scissors, rustling of torn fabric, a cloud of tulle on the floor. I'm like a daisy being plucked. Relieved of 10 meters of frills and a few petticoats, I feel as light as air." The party could go on—but the marriage was doomed. Soraya and the shah divorced—reluctantly—seven years later when it became clear that she could not have children, an incontrovertible requirement of many royal marriages. The beautiful ex-empress had a brief second career as a film actress.

When another actress, Grace Kelly, married Prince Rainier of Monaco in 1956, Monégasque law required two royal weddings: a civil ceremony

and a religious ceremony. MGM Studios announced that both bridal ensembles would be its gifts to its departing star. Although Kelly was technically still under contract to MGM, her new husband had declared that she would no longer appear in films. The studio undoubtedly hoped to change his mind or, failing that, garner publicity for Kelly's two as yet unreleased MGM films.

For the forty-minute civil ceremony in the throne room of the pink-hued Prince's Palace, Kelly wore a full-skirted suit of pink silk overlaid with beige machine-made lace, its floral pattern outlined with dusty pink silk floss (shown on the book's cover). It was designed by Academy Award–winning costume designer Helen Rose, who had dressed Kelly for four MGM films including her last, *High Society*, in which her character marries Bing Crosby. Later that evening, the couple attended a gala at the Monte Carlo Opera. Princess Grace wore a white silk Lanvin-Castillo couture gown embroidered with eight hundred thousand sequins and fifteen hundred pearls and rhinestones, designed to show off the glittering decorations and orders that came with her new role.

The religious ceremony in Saint Nicholas Cathedral the following day was the television event of the year; MGM had bankrolled the event in exchange for the rights to produce a half-hour documentary on the wedding. An estimated thirty million people worldwide tuned in. The

seasoned experts in onscreen style in the MGM Studios wardrobe department rose to the occasion, creating a gown that was appropriate for the solemnity of the Catholic service, but also camera friendly.

"Everything we do is with a view to how it will photograph," Rose told a reporter. The lace headpiece anchoring the bride's lace-edged silk tulle veil was designed to keep her face on view; it was decorated with wax orange blossoms, which would not wilt. Tiny seed pearls and three-dimensional appliqué petals accentuated the pattern of the gown's antique rose point lace bodice, which disappeared into a high cummerbund of ivory silk faille encircling the bride's twenty-one-inch waist. Twenty-five yards of *peau de soie* and the same amount of silk taffeta went into the bell-shaped skirt and lace-inset train, gathered with three bows down the center. For most of the wedding ceremony, a bride's back is turned to her guests; Rose ensured that Kelly's gown was worth watching from all angles. The ensemble took the thirty-five wardrobe department employees six weeks to create, working in complete secrecy.

Kelly's shoes of silk, antique lace, seed pearls, and glass beads were made by New York's "King of Pumps," David Evins, who was known for his lightweight, comfortable heels with a flattering, low-cut profile. Kelly wore $150 pearl-trimmed stockings by Willys of Hollywood, hosiery maker

to the stars, who had designed a similar pair for Princess Elizabeth's wedding. Even the prayer book the bride carried was decked in lace and seed pearls, ready for its close-up.

MODERN MAJESTY

While Marie-Antoinette, Princess Alexandra, and other royal brides had to shed all vestiges of their native countries when they married, this tradition fell out of favor by the twentieth century. Spanish aristocrat Fabiola de Mora y Aragón proudly wore a gown made in Madrid by Spain's preeminent fashion designer, Cristóbal Balenciaga, for her winter wedding to King Baudouin I of Belgium in 1960.

A devout Catholic, Balenciaga was inspired by the austerity of monastic vestments and the

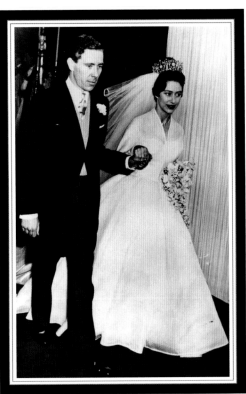

LEFT: Queen Fabiola turned to a fellow Spaniard, Cristóbal Balenciaga, for her wedding gown.
RIGHT: Princess Margaret accessorized her understated Norman Hartnell gown with the enormous Poltimore Tiara.

stiff, sculptural silhouettes of the Renaissance. Fabiola's gown was breathtaking in its simplicity; the clean lines showed off the designer's technical skill and modern artistry, while the long train and mink trim lent it majesty. A similar asceticism characterized the Norman Hartnell gown Princess Margaret wore the same year to marry Antony Armstrong-Jones, in Britain's first televised royal wedding. "As they came up the aisle, one realized that this was a new princess," *Vogue* observed. "Her dress, unadorned, struck a clear true note."

The same could not be said of the equally iconic gown worn by Lady Diana Spencer in 1981. With one hundred yards of tulle, twenty-five yards of silk taffeta, ten thousand pearls, a twenty-five-foot-long train, gigantic puffed sleeves, and more ruffles, bows, and antique Carrickmacross lace than could comfortably fit into the bride's horse-drawn carriage, Diana's wedding gown epitomized the term "meringue." Its fairy-tale romanticism may look over-the-top today, but the style—designed by the husband-wife team of David and Elizabeth Emanuel—was cutting-edge in the era of Gunne Sax and Laura Ashley (see Chapter 5). The Spencer family tiara anchored the bride's 153-yard tulle veil. Although the media made much of the fact the Prince of Wales was marrying a "commoner," Diana was the daughter of an earl, and her family's noble lineage went back much further than that of her husband's.

Her bridesmaids were Princess Margaret's daughter Lady Sarah Armstrong-Jones, seventeen, and India Hicks, thirteen, and they were "given the responsibility of Diana's twenty-five-foot-long train," Hicks remembered in *Harper's Bazaar* years later.

Twenty-five feet was unheard of, record breaking, and a bloody nightmare. Manipulating that much taffeta and antique lace in and out of the small state carriages posed considerable complications. We practiced with a long dust cloth tied to Diana's waist. She stood patiently as we were shown how to fold and unfold the fabric so it would glide effortlessly behind her.

On the day of the wedding, as they prepared to enter St. Paul's Cathedral, Diana "turned briefly to us both. 'Do your best,' she said and began to mount the steps. We knew what that meant: If we pulled too much, straightening the material, her tiara and veil would slip. But if we didn't pull enough, the effect of the train would be lost."

Diana's shoes could not be seen under her voluminous skirts, but they were equally ornate. Covered in 542 sequins and 132 pearls, they took custom cobbler Clive Shilton six months to create. An embroidered heart ringed by a ruffle of lace decorated each toe. The soles were suede

FOLLOWING: The husband-wife team of David and Elizabeth Emanuel designed Lady Diana Spencer's royal wedding gown.

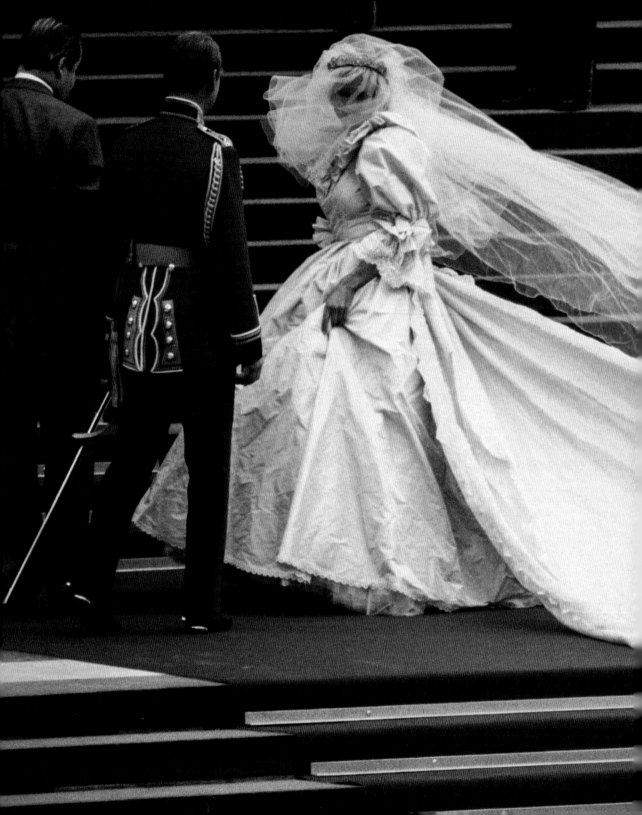

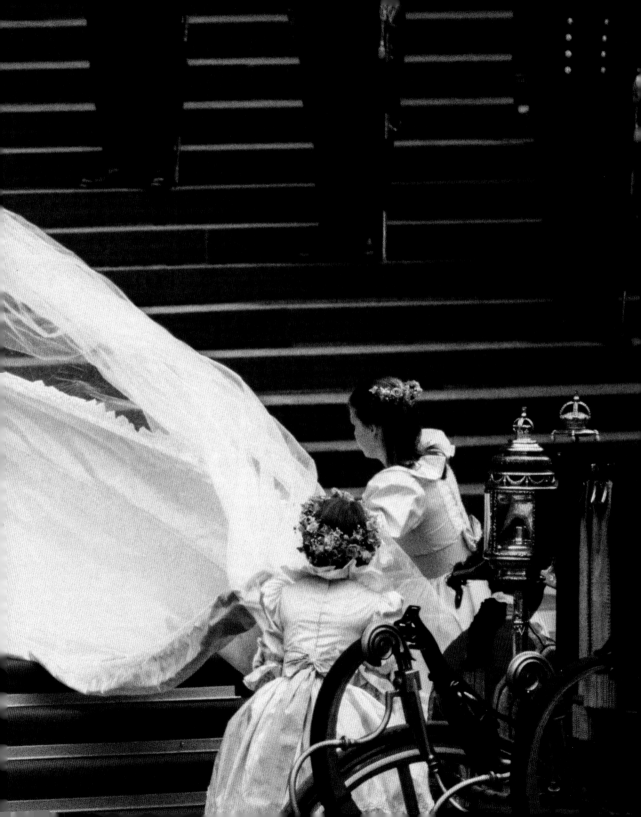

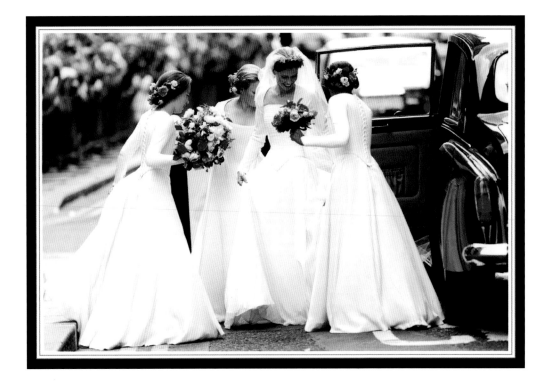

to provide grip on the red-carpeted aisle of St. Paul's Cathedral, and the shank was hand-painted, with a tiny "C" and "D" on either side of a heart. Because Diana stood 5'10"—the same height as the groom—she requested a low heel.

Minor royals—far from the spotlight and the line of succession—have historically felt more freedom to experiment with avant-garde designers and nontraditional gowns, though they may hew to tradition in other ways, for example, by choosing local designers or materials. Lady Sarah Armstrong-Jones went in the opposite direction from Diana for her own 1994 wedding to Daniel Chatto. She turned to British fashion and theatrical designer Jasper Conran, who dressed the bride and bridesmaids in strikingly simple long-sleeved white georgette gowns inspired by Tudor fashions, with full skirts and separate bodices

ABOVE: Jasper Conran's gowns for Lady Sarah Armstrong-Jones and her bridesmaids took inspiration from Tudor fashion.

laced down the back. The designer constructed a tiara from three antique brooches Sarah's father, Lord Snowdon, had given to her mother; it remains the only tiara the artsy, down-to-earth royal has ever worn.

When Mabel Wisse Smit married Prince Johan Friso of Orange-Nassau in Delft in 2004, she enlisted impish Dutch design duo Viktor & Rolf to make an unconventional gown that winked at tradition without offending it. The A-line, optical white duchesse satin dress had long sleeves, a modest boat neckline, a floor-length skirt, and a ten-foot cathedral train, but it was covered in a fabric trellis adorned with 128 crepe georgette bows that grew in size toward the hemline, where they reached comically gigantic proportions. Though the gown looked fairly conservative from the front, the

ABOVE: Dutch design duo Viktor & Rolf dressed Mabel Wisse Smit for her 2004 wedding to Prince Johan Friso of the Netherlands.

surreal back view was an ironic comment on the pomp and circumstance of the event. While some commentators found the tongue-in-cheek design disrespectful, others appreciated it as a master-piece of modern Dutch design.

Kate Middleton and Alexander McQueen designer Sarah Burton looked to previous royal brides—notably Princess Grace and Princess Margaret—for inspiration for the gown Middleton wore for her much-anticipated wedding to Prince William in 2011 (see Chapter 10). It featured a long-sleeved sheer bodice over a strapless corset-style underbodice, the bodice and skirt appliquéd with Carrickmacross lace handmade at the Royal School of Needlework. The collaboration between Britain's hottest designer and an embroidery school founded in 1872 encapsulated the royal wedding's broad appeal to both traditional monarchists and young trend-watchers. For the reception, William swapped his colorful Irish Guards uniform for a tuxedo, and Kate changed into a strapless white Alexander McQueen gown with a mohair shrug.

Later the same year, when King Jigme Khesar Namgyel Wangchuck of Bhutan married Jetsun Pema, the attractive young couple were dubbed the "Will and Kate of the Himalayas." But their nuptial outfits could not have been more different. For the combination wedding and coronation in Punakha, the couple wore traditional Bhutanese dress: a woven silk *kira* (wrapped

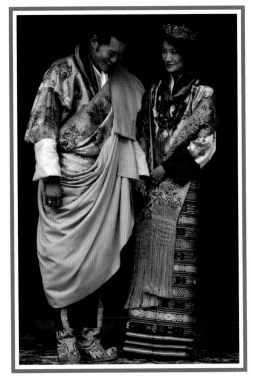

dress), *tego* (jacket), and *wonju* (blouse) for the queen, and, for the king, a rose-patterned yellow silk *gho* (robe)—the same one his father and grandfather had worn at their own weddings.

The vibrant outfits were not just decorative; the colors had significance in lama astrology, as did the timing of the wedding. On their heads, the couple wore hand-sewn silk crowns—the Raven Crown for him and the Phoenix Crown for her—and, as part of the ceremony, they each donned the Dar Na Nga, five silk scarves in auspicious colors.

ABOVE: King Jigme Khesar Namgyel Wangchuck and Jetsun Pema wore traditional Bhutanese dress for their combination wedding and coronation in Punakha.

Modern royals balance the weight of history and tradition with increasingly personal fashion statements. Princess Eugenie, granddaughter of Queen Elizabeth II, had spinal surgery to correct scoliosis at the age of twelve. As a patron of the Royal National Orthopaedic Hospital, where the eight-hour procedure was performed, she wanted to highlight—not hide—her scar. "I believe scars are like memories that tell a story on your body, that remind you how strong you had to be, and that you survived to talk about it," she told the *Telegraph*. Her wedding gown—designed by London-based Peter Pilotto—had a deep V neckline in the back, framing her scar.

Amidst the pomp and circumstance (and media circus) of a royal wedding at Windsor Castle, it was a poignant personal touch, and one strongly reminiscent of another royal wedding dress: her mother Sarah Ferguson's, which had a seventeen-foot train embroidered with Eugenie's father's initial, "A," and anchors referencing his naval service.

Throughout history, fashion has reinforced the notion that every bride is queen for a day, or at least Cinderella, and every groom is Prince Charming. Garments traditionally reserved for court—like trains and tiaras—have crept into civilian wedding dress. Swedish brides wear crowns; Chinese brides wear dragon tunics; Japanese brides wear *furisode*, the most formal style of kimono. In some cases, brides literally wear the same clothes and jewels as royalty. For her 1927 wedding, Adelaide Close wore the same handmade lace veil Princess Stéphanie of Belgium had worn for hers in 1881. Close's mother, the art collector Marjorie Merriweather Post, likely acquired it after the collapse of the Hapsburg Empire. And, in 2000, pop star Madonna married Guy Ritchie wearing a 1910 diamond tiara once worn by Princess Grace. Royal families may play a largely symbolic role in modern life, but they still wield enormous power as arbiters of style and guardians of tradition. ◆

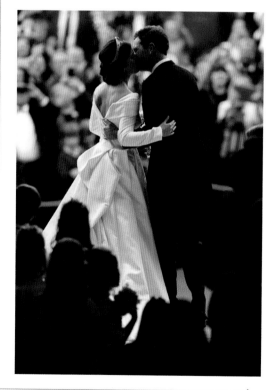

ABOVE: When Princess Eugenie married Jack Brooksbank at St. George's Chapel in 2018, her Peter Pilotto gown framed her scoliosis scar.

WHITE HOUSE WEDDINGS

THE FIRST FAMILY IS THE AMERICAN equivalent of royalty, and, like their crowned counterparts, they have historically balanced the personal, the political, and the patriotic in heavily publicized weddings attended by world leaders and diplomats. Even when these celebrations don't take place in the actual White House—which became the presidential residence in 1800—or during the president's term of office, they become part of American mythology. Political dynasties like the Adamses, the Harrisons, the Roosevelts, the Kennedys, and the Bushes span generations, and their weddings take place in the shadow of history—and the glare of publicity.

As syndicated columnist Louise Hutchinson noted with regard to First Daughter Luci Johnson's 1966 nuptials, a White House wedding is "not a state occasion" but "not necessarily a private one," either. The border between public and private has never been satisfactorily identified. Journalists accustomed to covering foreign royal and presidential weddings (and their audiences) have expected the same transparency and access when it came to the weddings of the First Family. When President Theodore Roosevelt refused to release any details of his daughter Alice's trousseau, the *New York Times* pouted: "These precautions are puzzling, because in the only cases that can be used as parallels—the weddings of feminine members of the families of the heads of other nations, whether these be royal or those of citizen Presidents—public interest is regarded not only as a matter of course, but as entirely legitimate." Johnson received angry letters after she refused to allow television cameras inside the church at her wedding; many Americans thought it was her duty to "invite" them to the ceremony, and their right to "attend" vicariously.

Weddings have always been fertile image-burnishing opportunities for those with presidential connections or ambitions. Many presidents (Dwight D. Eisenhower, Jimmy Carter, George H. W. Bush) married in uniform—military service having been, traditionally, a prerequisite

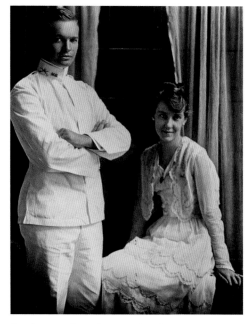

for election. Eisenhower, who obtained a ten-day leave from the Army in 1916 to get married, supposedly remained standing for two hours before his wedding to Mamie Doud so as not to wrinkle his starched white dress uniform.

During the wildly unpopular Vietnam War, both of President Johnson's daughters married men in uniform—though this backfired on Pat Nugent, whose Air National Guard uniform only called attention to how little he had actually served.

The first First Lady, Martha Custis, is supposed to have worn a gown of "deep yellow brocade with rich lace in the neck and sleeves" with an underskirt of "white silk interwoven with

ABOVE: Dwight Eisenhower married Mamie Doud in his white dress uniform during a ten-day leave from the Army in 1916.

silver" for her wedding to George Washington in 1759. Although the gown has not survived, her wedding shoes are preserved at Mount Vernon: purple satin with French heels, generously embellished by sequins and silver metallic lace.

They correspond to a modern US size 7. Detachable, probably highly decorative metal buckles held the fabric latchets closed. Though the shoes are unlabeled, historian Kimberly S. Alexander has convincingly traced them to London, where Martha patronized a handful of cordwainers. As curator Linda Baumgarten has pointed out, the Washingtons and other prosperous colonial families saw no disconnect between fighting England and emulating their fashions. A wealthy widow, Martha would have been accustomed to the best money could buy, and that meant British-made goods.

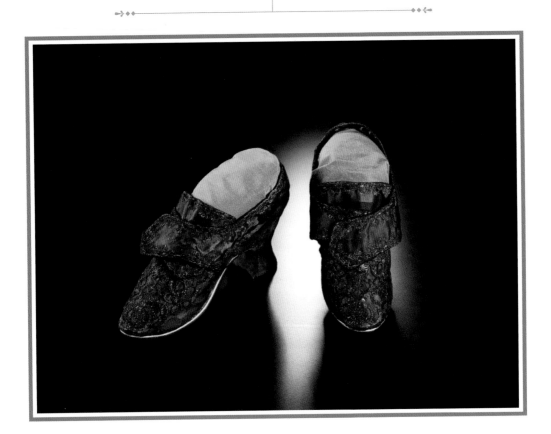

ABOVE: Martha Custis, a wealthy widow, wore these stylish shoes when she married George Washington in 1759.

While Ella "Nellie" Grant's wedding was not the first to take place in the White House, it has been described as "the greatest American social event of the nineteenth century." The eighteen-year-old was not just beautiful and well liked, but the daughter of a sitting president and war hero, Ulysses S. Grant. As the first teenage girl

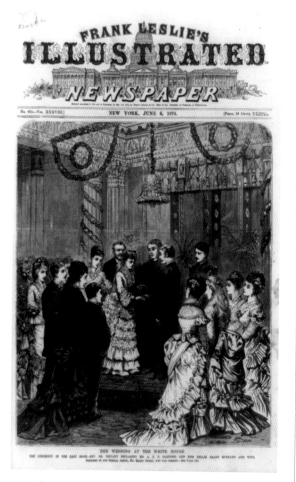

to live in the White House, Nellie was nicknamed "the Daughter of the Nation." She fell in love with Algernon Charles Sartoris, a wealthy English diplomat, on a ship crossing the Atlantic, as her chaperones battled sea sickness. He, too, was the child of a politician—a member of Parliament. To the public and the press, it was an irresistible international love story. The wedding took place on May 21, 1874, in the flower-bedecked East Room; White House doorkeeper Thomas Pendel remembered that it was decorated with "the beautiful National colors," underlining Nellie's role as a surrogate for her father and her country. The Marine Band played the "Wedding March." In addition to its patriotic flavor, the event had the glamour and aspirational appeal of a high-society spectacle. The bride's white satin gown "trimmed in rare Brussels point lace" was reportedly worth $1,500; she had no fewer than twelve bridesmaids.

A PRESIDENT WEDS

◆ ◆ ◆ ◆

The only president to marry in the White House was President Grover Cleveland, who wed the much-younger daughter of a family friend in 1886. An eyewitness described Frances Folsom's gown "of ivory satin, with trimmings of Indian silk, arranged in Grecian folds over the front of the corsage and fastened in the folds of satin at the side."

ABOVE: Nellie Grant's White House wedding in a $1,500 lace-trimmed gown was front-page news in 1874. **FOLLOWING:** Grover Cleveland was the only president to marry while in office, and his bride, Frances, became one of the most fashionable First Ladies in American history.

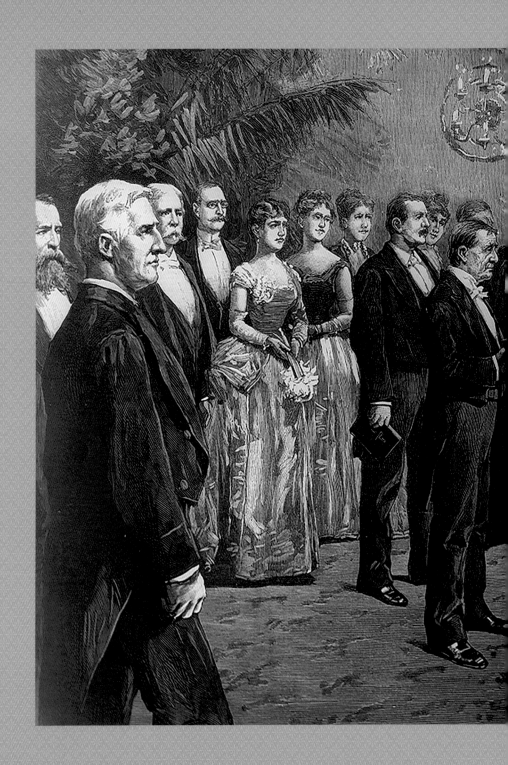

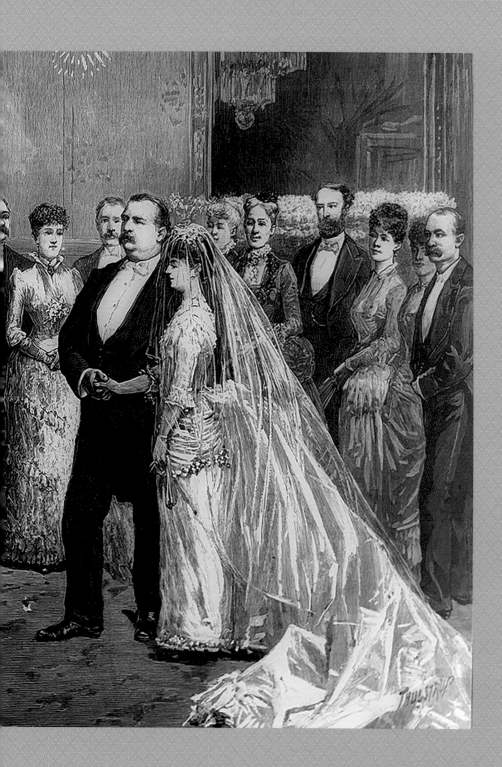

The dress—stiffened with buckram at the hem and a cagelike boned bustle—was so rigid that it could stand up by itself. Another press report admired the bride's train: "It was marvelous how she handled it in a small well-filled room, for it was nearly as long as the room itself and would have reached easily from the spot where the vows were pledged into the corridor through which the bridal party had come, but for the bride's deft management, whereby it lay in a glistening coil at her feet." The gown was laden with orange blossoms, popularized by another head of state, Queen Victoria, who wore them for her wedding to Prince Albert in 1840.

Folsom certainly wore the beautiful gown again. Two weeks after the wedding, she received the diplomatic corps at the White House, wearing the skirt of her wedding gown; for the evening event, she replaced the modest bodice with one with a lower neckline. Many of her gowns featured interchangeable skirts and bodices, creating the illusion that she had a more extensive wardrobe than was actually the case. When a Georgia woman had the audacity to ask Mrs. Cleveland if she could borrow her wedding gown for her own nuptials, she was informed that it was still in regular use.

Frances Cleveland became one of the most fashionable First Ladies in American history. Her stylish trousseau was described in forensic detail in newspapers. Although it was made in Europe, Cleveland became a steady customer of American department stores and dressmakers as First Lady, recognizing her duty to "buy American." Her preference for low-cut gowns stirred controversy, but women copied her distinctive hairstyle "à la Cleveland," curled at the forehead and trimmed at the nape of the neck. During the election of 1888, Cleveland's much-admired fashion sense became a talking point, as it was widely (if baselessly) reported that Caroline Harrison was pro-bustle while the First Lady was against the garment. When Republican Benjamin Harrison succeeded in unseating President Cleveland, the incumbent, the *Topeka Capital* quipped: "The bustle was not an overshadowing issue in the campaign, but it may be in the next one if it continues to grow."

AN AMERICAN DYNASTY

◆ ◆ ◆ ◆

Eleanor Roosevelt did not live in the White House until 1933, but she was the niece of President Theodore Roosevelt when she married Franklin D. Roosevelt in 1905; he himself was the president's fifth cousin. So the wedding—already uniting branches of one of America's oldest families—was also a matter of political interest, which was intensified by the fact that the president gave the bride away. Eleanor had lost both of her parents before the age of ten, and she was raised by her maternal grandmother, attending

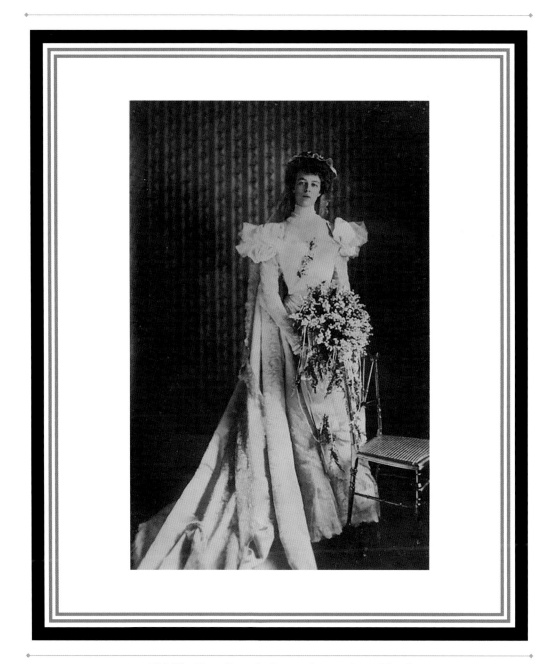

ABOVE: Eleanor Roosevelt—the niece of one president and the wife
of another—was "decked out beyond description" at her 1905 wedding.

finishing school in England. The couple married in New York on March 17, 1905, so the president, who was scheduled to be in the city for the St. Patrick's Day parade, could attend.

The wedding clothes underlined the social prestige of the Roosevelt clan even as the event memorialized Eleanor's lost family; March 17 was also her late mother's birthday. "The bridesmaids were dressed in cream taffeta with three feathers in their hair, and had tulle veils floating down their backs," Eleanor remembered in her auto-biography; the feathers evoked the Roosevelt family crest. "My own gown was heavy stiff satin, with shirred tulle in the neck, and long sleeves."

The tulle neckpiece filled in the low neckline of the satin gown; the floral decoration—likely the same lilies of the valley used in her bouquet—ended at the gown's bustline. Like the long sleeves, the neckpiece may have been detachable, or part of an underblouse that could be removed to convert the gown for evening wear. Her $4,000 Tiffany pearl collar necklace was a gift from her mother-in-law, "which I wore, feeling decked out beyond description."

The gown was covered in the rose-point Brussels lace her maternal grandmother and mother had worn at their own weddings. "A veil of the same lace fell from my head over my long train," Roosevelt recalled. Several sources claim that Roosevelt wore her mother's wedding dress, but she makes no mention of this in her autobiography, and the only photo of her in her gown (a studio portrait) depicts the hourglass silhouette, monobosom, and long, tight sleeves under wide puffed oversleeves of the turn of the century—slightly old-fashioned, perhaps, but hardly the columnar, bustled silhouette of 1883, the year her parents married. Indeed, Eleanor's cousin, the president's daughter Alice Roosevelt, who served as one of her bridesmaids and would marry the following year, later mistook a picture of Eleanor in her wedding dress for herself: "We looked so much alike."

While Eleanor was serious, reserved, and slightly homely, Alice—just eight months older—was a bold, beautiful celebrity who lived up to the nickname the newspapers had given her: "Princess Alice." As *Frank Leslie's Weekly* put it, "she has all the honors and pleasures of royalty, without being in the least hampered by its restrictions." Her mother had died two days after her birth, and she was raised by her stepmother, Edith. While Edith cared for her younger children, Alice frequently acted as White House hostess as well as a companion and advisor to her father, whose outdoorsy interests she shared; she even represented him on a diplomatic mission to Asia. America loved her; as the *Washington Post* put it, "they have come to see in her the embodiment of those fine qualities which make the American woman

superior to every other." Although Alice had no shortage of young male admirers, she later admitted that her "father complex" drew her to congressman Nicholas Longworth, a reputed playboy fourteen years her senior.

They married in the East Room on February 17, 1906. The next day, the wedding was on the front page of the *Washington Post*— the *entire* front page. "The bridal gown was a magnificent creation of cream satin, princess in style, with heavy court train of silver brocade,

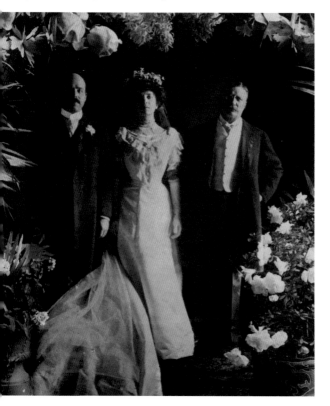

the yoke and elbow sleeves being of rare old lace," the paper duly reported. "The tulle veil, worn off the face, was caught with a coronet of orange blossoms, while clusters of the same flowers nestled in the lace on the shoulders."

The bride's only jewelry was a "magnificent" diamond necklace—a gift from her husband— and a diamond brooch, given by her father. Her slippers were "fashioned from the same material as the gown, and instead of buckles, tulle bows were worn, fastened with tiny clusters of orange blossoms." She carried a cascading bouquet of orchids, "almost obscuring her slender person." Longworth, the *Post* noted, wore "the conventional costume for afternoon weddings," meaning "a black frock coat unbuttoned, showing a white Marseilles waistcoat. The trousers were the darkest shade of gray . . . and his cravat was of pearl gray silk, tied in the puff style, and in it was a moonstone stick pin."

There was no description of bridesmaids' dresses because Alice, who had served as a bridesmaid five times, chose to walk down the aisle unattended, ensuring that she would be the center of attention. There was something else missing from the wedding. As the *New York Times* headline blared: "NO ORIENTAL GOODS USED." The Roosevelt administration was in the midst of a contentious trade war with China, and what the couple didn't wear was as meaningful as what they did wear.

ABOVE: First Daughter Alice Roosevelt—nicknamed "Princess Alice"—looked regal in a wedding gown with a court train, flanked by her husband and father.

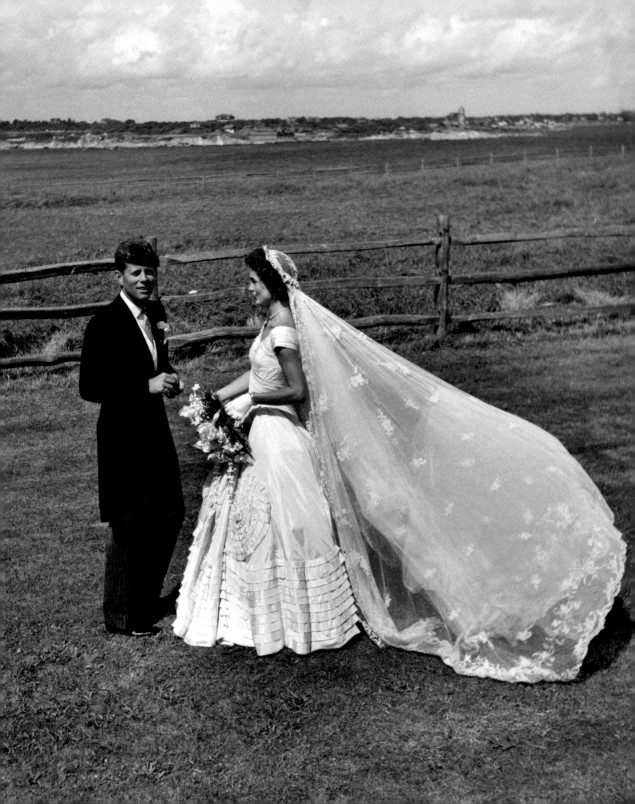

A CAMELOT CORONATION

◆ ◆ ◆ ◆

When Jacqueline Bouvier married into another political dynasty—the Kennedy family—in 1953, she hoped for a quiet, private ceremony and a contemporary couture gown in the slim, sporty lines that suited her best. But her new father-in-law, Joe Kennedy, had other ideas, seeing the wedding as a public relations opportunity for his ambitious clan. Overriding the bride's wishes, he planned a media-friendly celebration for twelve hundred guests, complete with a papal blessing, in Newport, Rhode Island. "The wedding turned out to be the most impressive the old society stronghold had seen in 30 years," *LIFE* magazine reported. "600 diplomats, senators, social figures crowded into St. Mary's Church. . . . Outside, 2,000 society fans, some come to Newport by chartered bus, cheered the guests and the newlyweds." The receiving line at the reception at the bride's childhood home, Hammersmith Farm, took two hours. It was, said one guest, "just like a coronation."

At Joe's insistence, Bouvier wore a traditional gown fit for American royalty. The designer, Ann Lowe, was an African American dressmaker who catered to a wealthy WASP clientele. Instead of the streamlined silhouette that would later define the "Jackie Look," the hourglass-shaped gown used 50 yards of ivory silk taffeta. It was embellished with bands and scallops of pintucks and tiny wax flowers; Jackie compared it to a lampshade. The off-the-shoulder portrait neckline was design to draw attention upward to the bride's face, but she complained that it also emphasized her flat chest. She wore a veil of rose point lace inherited from her grandmother at the back of the head, white gloves, a diamond bracelet and pin—gifts from her husband and in-laws—and a strand of Bouvier pearls. The enormous bridal party consisted of fourteen ushers in morning suits and ten bridesmaids, who wore pink silk faille gowns with claret-colored sashes, also by Lowe. It wasn't until her second wedding, to Aristotle Onassis in 1968, that Jackie got the contemporary couture gown she'd wanted all along, a knee-length Valentino dress (see Chapter 9).

FASHIONABLE FIRST DAUGHTERS

◆ ◆ ◆ ◆

Luci Johnson was the first First Daughter to marry at the White House since Alice Roosevelt in 1906 and Jessie Woodrow Wilson in 1913. As historian Karen Dunak has pointed out, Roosevelt's wedding "was a spectacle, a sharp contrast to the front parlor wedding of rural America and the middle class." By the Johnson administration, however, White House weddings "shared elements familiar to weddings many Americans in the 1960s had attended or even celebrated themselves." A white dress,

OPPOSITE: Jacqueline Bouvier married John F. Kennedy in a gown made by African American dressmaker Ann Lowe.

a tiered cake, flowers, and a wedding march were no longer luxuries but requirements. Instead of being distracted by spectacle, the public was much more attuned to perceived slights. In addition to the flap over television cameras in the church, some were uncomfortable that Luci had been rebaptized when she converted to Catholicism, her fiancé's faith. The Hiroshima World Friendship Center complained about the choice of date: August 6, the anniversary of the Hiroshima bombing. And there were numerous controversies over Luci's Priscilla of Boston wedding gown. The International Ladies' Garment Workers' Union (ILGWU) was a powerful lobbying force in Washington, as the Johnsons discovered when Luci inadvertently chose a gown made by a nonunion manufacturer. The president had to intervene to avoid a scandal.

Just as Theodore Roosevelt had refused to release details of his daughter's trousseau to the papers, Lady Bird Johnson went to great lengths to keep Luci's wedding dress a secret from the press and public until the wedding day. When the bride and her bridesmaids scheduled fittings at the Carlyle in New York, Johnson recorded in her diary, the hotel became "a sort of embattled fortress with the press stationed downstairs at every entrance in force, with plenty of cameras and recording such world-shaking news as that 'the well-known gown firm of Priscilla's of Boston slipped some entries into the suite on two hangers covered with muslin'" (see Chapter 10). Finally, reporters from *Women's Wear Daily* broke into Priscilla's premises and published an unauthorized advance sketch of the long-sleeved white lace dress embroidered with pearls, leaving Luci "woefully distressed," as her mother put it. ("Personally, I didn't think it was any great matter," Mrs. Johnson added.) As a result, *Women's Wear* was banned from covering the wedding, perpetuating a long-running war between the publication and the First Lady it could not forgive for replacing the effortlessly chic Jackie Kennedy.

It must have given *Women's Wear* hope when the Johnsons' older daughter, Lynda Bird, discovered fashion around the time of her sister's wedding. By the following year, Lynda had joined the ranks of the International Best Dressed List, and her own 1967 White House wedding to Captain Charles Robb was a celebration of young American style.

Geoffrey Beene designed Lynda's on-trend medieval-style wedding gown—it was the year the film version of *Camelot* hit theaters—as well as her rehearsal dinner dress, going-away dress, and the bridesmaids' "Goya red" velvet gowns, inspired by Goya's portrait of *Manuel Osorio Manrique de Zúñiga* in the Metropolitan Museum of Art. The East Room was once again converted into a wedding chapel, complete with

OPPOSITE: Geoffrey Beene dressed First Daughter Lynda Bird Johnson for her 1967 wedding to Captain Charles Robb in the East Room of the White House.

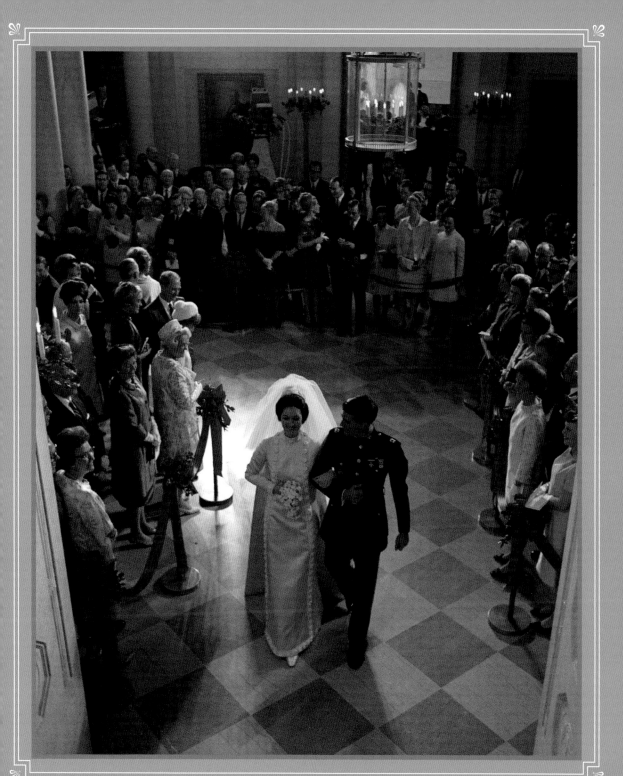

grand topiaries and a post-nuptial saber arch. Joseph Magnin, the West Coast department store directed by President Johnson's friend Cyril Magnin, was enlisted to supply the bride's trousseau—a coup for the store that had long been regarded as a youthful, downmarket alternative to its tony rival, I. Magnin, founded by Cyril's grandmother.

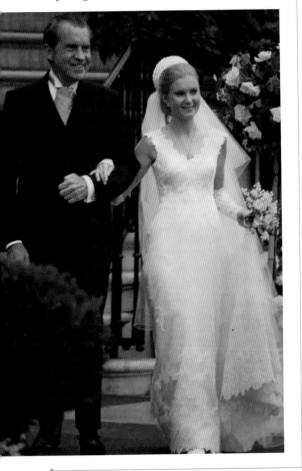

A few years later, in 1971, at a time when many young people were having hippie weddings or simply enjoying free love, Tricia Nixon's ultra-traditional marriage to Edward Finch Cox offered a reassuring blast of normality. It is a tribute to the bland timelessness of her white Priscilla of Boston gown overlaid with lace that it could still be worn today.

LIFE magazine—which put Tricia on its cover in her wedding gown—reported that "during the weeks it took to create them, Tricia's wedding dress and veil were given extra-cautious, top-secret handling by Priscilla and the White House staff. For the first fitting in Washington the gown had its own suitcase, strapped into its own first-class seat." It added: "The airline was going to charge her half fare for the case, but when Priscilla told them that Luci Johnson's gown, which she made, had flown free, the airline capitulated."

Priscilla of Boston—full name Priscilla Kidder—was a traditionalist, and a firm fan of white wedding gowns. "It's America's happy color," she told *LIFE*. Another reason for her popularity among White House brides (in addition to Luci Johnson and her bridesmaids, she had dressed Tricia's sister, Julie, for her wedding as well as making several dresses for their mother) was that her gowns were entirely American-made, in her workrooms, appropriately situated near Bunker Hill. In an echo of

ABOVE: President Richard Nixon gave away his daughter Tricia, wearing a lace gown by Priscilla of Boston, in the first Rose Garden wedding.

Alice Roosevelt's wedding coverage, she boasted: "We never even send our embroidery to the Orient." The magazine noted approvingly that the bride had registered for "solidly American" Lenox china. Indeed, the only wild card in Nixon's wedding was the venue: it was the first wedding to be held in the White House Rose Garden. It was a risky proposition given the unpredictability of summer rain in Washington, but the weather cooperated.

A NEW JACKIE

♦ ♦ ♦ ♦

One of the most influential White House weddings, fashion-wise, was one of the furthest removed from the White House itself. John F. Kennedy Jr. was born two weeks after his father was elected president, and JFK had been dead for nearly thirty-three years when his son married Calvin Klein publicist Carolyn Bessette in an intimate, top-secret ceremony on Cumberland Island, off the coast of Georgia, on September 21, 1996. The bride wore a bias-cut silk crêpe slip dress by Narciso Rodriguez, a former Calvin Klein colleague, with a tulle veil, sheer elbow-length gloves, and beaded high-heeled sandals.

According to *Vanity Fair*, the dress "turned an entire industry on its head. . . . To choose a dress lacking in grandiosity and to pair it with casual, swept-back hair, an ultra-simple

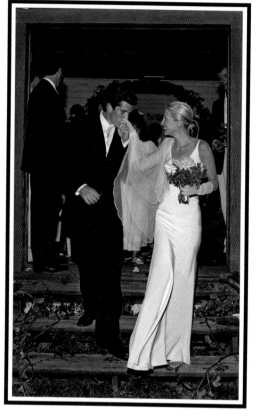

bouquet, and no jewelry at all was in itself a statement." Though she was a fashion industry insider with money, beauty, and privilege to spare, Bessette's style was understated and austere; she had the confidence to downplay her looks and avoid high-status labels. The media hailed her as a worthy successor to her late mother-in-law, Jackie, and she continued to be a leader of American fashion until the couple died in a plane crash on July 16, 1999. ♦

ABOVE: John F. Kennedy Jr.'s bride, fashion publicist Carolyn Bessette, set a trend for simplicity in 1996, photographed by Denis Reggie.

FOR RICHER

WHILE ROYAL AND POLITICAL WEDDINGS are strictly bound by etiquette, tradition, and concerns of state, the merely wealthy have more freedom to take risks and indulge in fashionable whims, individual fancies, and luxurious materials. For centuries, the weddings of aristocrats, heiresses, and socialites have showcased the art of elite tailors, couturiers, and jewelers. High-profile weddings served as fashion advertisements in their own rights. From the mid-nineteenth century, newspapers covered society weddings in lavish sartorial detail and published pictures of bridal gowns, gifts, jewelry, and trousseaux. Wedding gowns—and, to an even greater extent, the trousseaux frequently ordered at the same time—have long been the backbone of the haute couture industry. In the early twentieth century, designers like Madeleine Vionnet, Jeanne Lanvin, and Lucile began ending their fashion shows with wedding gowns, and sometimes even bridesmaids gowns—a tradition that was universally adopted by the 1950s.

A couture wedding gown might involve hundreds of hours of fittings and highly skilled labor, in addition to the finest and rarest materials. As a result, even the very rich often wore their wedding clothes more than once; until the twentieth century, wedding gowns conformed to contemporary fashion (rather than being excessively formal or historical in inspiration, as they often are today), and brides, with their busy social lives, were expected to wear them frequently, at least for the first year of marriage. Aristocratic brides were often presented at court shortly after their weddings, and their gowns (and tiaras) doubled as court dress, with long trains conforming to royal etiquette, or neckpieces and sleeves that could be removed to convert conservative church wear into formal evening wear. In the late nineteenth century, fashionable gowns—including wedding gowns—often came with two separate bodices, one for day and one for evening, to extract the maximum use out of the costly costume. These gowns "*à transformation*" prefigured today's bridal gowns that can be transformed by the removal of a jacket or long overskirt into a sleek sheath or fun minidress for reception cocktails and dancing—an idea couturier Pierre Balmain was already promoting in 1952.

In 1886, the British Parliament relaxed the rules around wedding ceremonies, meaning they could take place later in the day,

eventually stretching into the evening; the United States followed suit. Wedding festivities—and fashions—evolved accordingly. But fashion magazines and etiquette books recommended a strict division between wedding wear and evening wear. As the *Ladies' Home Journal* pointed out in 1890, "she is not going to a dance or a reception, but to a religious ceremony that means the joy or misery of her future life. . . . In the bride's frock there should be an expression of her knowledge of that which she is undertaking." In 1894, the magazine was more specific: "Her bodice must be high in the neck; her sleeves reach quite to her wrists, and her gown must fall in full, unbroken folds that show the richness of the material." A "modesty piece" could fill in a low neckline in church, allowing the gown to be worn for evenings afterward. A silk Jeanne Lanvin wedding gown worn by Elaine Joseph in 1931 in the collection of the Cincinnati Art Museum has long sleeves with elastic cuffs, designed to be pushed up for comfort in the summer heat once the covered-up church ceremony was over.

AN AMERICAN DUCHESS

◆ ◆ ◆ ◆

The lifestyles of the rich and famous have always offered harmless escapism as well as fashion inspiration, and, long before Instagram, society weddings were reported in minute detail. One

of the first society weddings to attract fanatical media coverage was the union of American heiress Consuelo Vanderbilt (whose grandfather, William Henry Vanderbilt, had been the richest man in America) and the 9th Duke of Marlborough in New York in 1895. The match was motivated by money and prestige rather than love; many American heiresses of the Gilded Age traded vast dowries for the prestige of a foreign title, refilling the coffers of crumbling English estates. The eighteen-year-old bride recorded in her memoirs that she "spent the morning of my wedding in tears and alone. . . . Like an automaton I donned the lovely lingerie with its real lace and the white silk stockings and shoes. My maid helped me into the beautiful dress, its tiers of Brussels lace cascading over white satin."

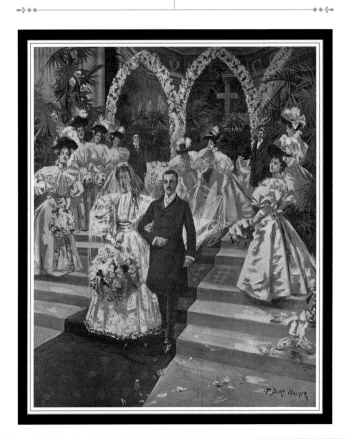

ABOVE: American heiress Consuelo Vanderbilt wore a copy of a Jacques Doucet couture gown when she married the 9th Duke of Marlborough in 1895.

The gown—a copy of a model by Parisian couturier Jacques Doucet by New York dressmaker Mrs. Donovan, chosen by Vanderbilt's mother—"had a high collar and long tight sleeves," the bride remembered. A detachable fifteen-foot-long court train "embroidered with seed pearls and silver fell from my shoulders in folds of billowing whiteness," she wrote. *Vogue* called this "exquisite" train "the most distinguishing feature" of the gown, adding: "It is an exact copy of the train made for presentation gowns and this will, no doubt, be the frock in which the Duchess of Marlborough will make her courtesy to her sovereign, the queen." Vanderbilt's maid "fitted the tulle veil to my head with a wreath of orange blossoms; it fell over my face to my knees." When she arrived at St. Thomas Episcopal Church—thronged with four thousand guests and even more curious spectators, held back by three hundred policemen—"so many eyes pried my defenses, I was thankful for the veil that covered my face."

Vanderbilt was horrified when the media, having been unable to obtain credible information about the nuptials despite "incessant" attempts, invented details: "I read to my stupefaction that my garters had gold clasps studded with diamonds, and wondered how I should live down such vulgarities." *Vogue* devoted four columns to a description of her trousseau, then proceeded to report on not just the bride's

and bridesmaids' dresses, but the dresses of the female guests. *Harper's Bazaar* provided a description and illustration of Vanderbilt's gown. *Vogue* published an illustrated article about her trousseau; the *New York Times* offered an in-depth (if inaccurate) report on her bridal lingerie, as well as an inventory of the gifts, which included jewelry, hair combs, fans, and "a purse of gold mesh, set with turquoise and diamonds," as well as silver inkstands, candlesticks, and bonbon boxes. Because it was assumed that upper-class households would already be fully furnished, wedding gifts often consisted of wearable luxuries for the bride, like furs or tiaras.

THE MILLION DOLLAR WEDDING

◆ ◆ ◆ ◆

Vanderbilt's wedding was the biggest nuptial news in America until 1920, when Detroit automobile heiress Delphine Dodge married James H. R. Cromwell of Philadelphia in what the media dubbed a "Million Dollar Wedding." It was widely reported that the wedding gifts numbered more than a thousand and filled a whole floor of the Dodge mansion. "The bride wore a Lucile creation especially designed for her," the *Washington Herald* reported. "The foundation was of soft white satin with inserts of Belgian lace outlined with silver thread. The overdress was of silk net with lace medallions,

lace formed the waist and fell in cascades over the train which was formed of bands of satin and puffings of net. It was adorned with a lover's knot of orange blossoms and a corsage of the same flowers . . . worn at the girdle." She accessorized with a Belgian lace and tulle veil worn low over her forehead, framing her bobbed hair; the $500,000 pearl necklace her father had given her as a wedding gift; and a sapphire bracelet, given by the groom. The bridesmaids wore blue Lucile gowns and "Bo-Peep" hats, with the maid of honor in a pink version.

London-based Lucile (a.k.a. Lucy, Lady Duff Gordon) became the go-to designer for stylish wedding gowns, bridesmaid dresses, and trousseaux in the teens and '20s. She had an international following that included aristocrats and actresses alike. Her diaphanous chiffons and delicate laces, pretty pastel hues, and decorative flourishes like ribbon roses, handkerchief hemlines, and obi-like sashes gave her designs a modern yet ultra-feminine aesthetic. She christened her gowns with romantic names; one wedding dress was dubbed "The Leap in the Dark." Her noble title made her especially attractive to ambitious American clients. When she designed a Russian-style wedding gown for one New York bride, "after that every other wedding was more or less Russian for the next six months," the designer remembered in her memoirs. In 1920 alone, Lucile made wedding gowns for Dodge and Postum cereal heiress Marjorie Merriweather Post, and the trousseau, bridesmaid dresses, and mother-of-the-bride dress for the wedding of Consuelo Morgan, the daughter of an American diplomat, to the Comte de Maupas.

Having married into the aristocracy herself, Lucile understood how to push the limits of propriety without exceeding them. Although Dodge's gown was enveloped by her huge veil and overstuffed bouquet, it was clearly tea-length rather than full-length. "The short skirt was bouffant over the hips with tiny clusters of orange blossoms visible beneath the transparent draperies," the *Washington Herald* reported. Rose point lace belonging to the bride's mother "formed a panel in the front of the skirt and also fashioned a wide bertha [collar]." Although Delphine's gown had a court train, long gowns and trains alike would fall out of favor over the course of the turbulent '20s, as brides scandalized their older relatives by walking down the aisle in knee-length skirts. In 1926, *Vogue* reported that trains were reduced to gossamer capes, "transparent from the shoulders down to the part below the waist, most subtle curtained little windows through which the audience can glimpse the figure of the bride as she advances up the aisle." As dresses shrunk, ethereal, cloud-like veils grew so large that the pendulum of fashion finally swung in the opposite direction, and they were increasingly replaced by small hats.

OPPOSITE: Detroit automobile heiress Delphine Dodge wore a Lucile gown for her "Million Dollar Wedding" to James H. R. Cromwell in 1920.

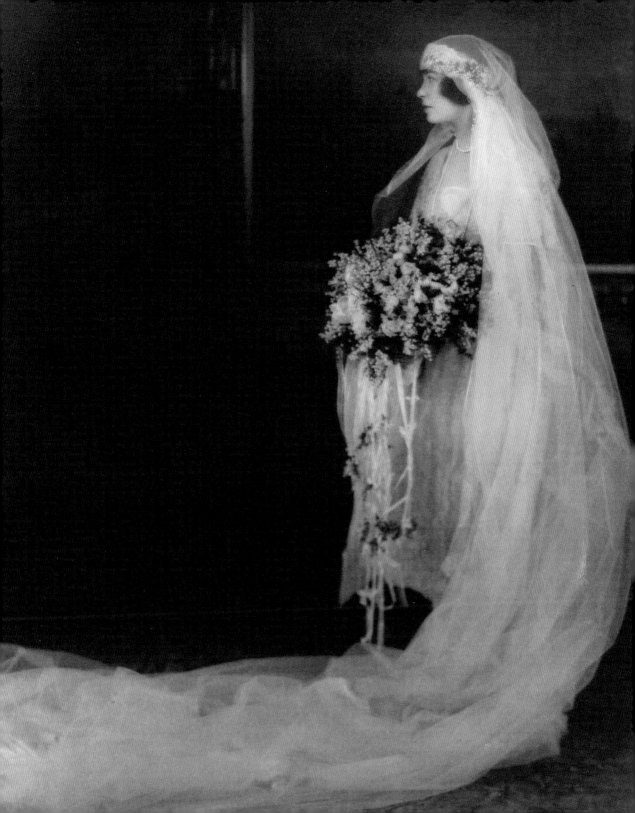

Dodge's wedding at Jefferson Avenue Presbyterian Church was followed by a reception at Rose Terrace, her family's lakefront manor in Grosse Point, where the music was provided by the Detroit Symphony Orchestra, an organist, and a dance band. Afterward, still in her wedding gown, the bride set sail with her groom on her family's 187-foot steam yacht, the *Delphine*, "for the first port in their round-the-world honeymoon while cornets played 'Farewell, My Own True Love,' a gun saluted 17 times and more than a thousand members of Detroit society waved an impressive adieu," as one newspaper gushed. Dodge tossed her bouquet from the deck of the ship. Despite this auspicious beginning, however, the couple divorced in 1928, having lost a fortune in Florida land speculation. Cromwell eventually married another young heiress with the initials "D. D.": Doris Duke.

A BILTMORE BRIDE

◆ ◆ ◆ ◆

A similarly ethereal gown and enormous tulle veil shrouded heiress Cornelia Vanderbilt when she married John Cecil four years later at Biltmore, her family's estate in Asheville, North Carolina, which she was due to inherit. (Cornelia was Consuelo Vanderbilt's first cousin, though she was not yet born at the time of Consuelo's much talked-about wedding.) "An outstanding feature of the wedding was the almost feudal

character maintained throughout," the *New York Times* noted. The estate's servants serenaded the couple on the eve of the wedding. The Biltmore Fire Department sprinkled the streets with water to keep the dust down. The guest rooms in the house had new wallpaper and freshly ironed sheets. The chancel of the Cathedral of All Souls was filled with lilies, dogwood, and other flowers gathered from the estate. And the children of the estate's tenants and workers formed an arch of flowering branches as the wedding party left the church; the *Times* called this "an old English custom," implying that it was a tribute to the groom, a British diplomat.

"The bride was lovely in a gown of white satin, very straight, with long sleeves," the *Asheville Citizen* reported (see Chapter 11). The "tabard" style gown featured a floral-patterned lace tunic over a satin sheath. "Her bridal veil of tulle and lace, which she wore over her face when entering the church, was four yards long. It was caught with orange blossoms from Florida." Perched low on Vanderbilt's brow, framing her bobbed hair, the headpiece incorporated her maternal grandmother's rose point wedding veil—which her mother and aunts had also worn at their own weddings. Although there is no designer identified, the maid of honor wore a Lanvin gown of white organdy in the "bouffante" style trimmed with pearls, with a correspondingly wide picture hat. "In striking contrast to the full-fashioned

gown of the maid of honor, the bridesmaids' gowns of soft Japanese silk, figured in large green and white begonias, were very narrow and straight," the *Times* reported. With their hand-painted gowns, the eight bridesmaids wore close-fitting white cloche hats, adorned with the bride's gift to them: "perfectly charming" hatpins, as the *Lincoln County News* called them, in the form of "two circles of lovely soft red carnelian . . . attached at either end of a rather long platinum bar ornamented in filigree."

CHICAGO CHIC

♦ ♦ ♦ ♦

In contrast to the boyish silhouette of the 1920s, the sleek, sinuous, bias-cut satin gowns of the 1930s emphasized the female form. According to *Vogue*, "the bride appears at her loveliest in the new fitted and moulded gowns with long, sweeping lines." Louise de Marigny Dewey chose a gown worthy of a Hollywood screen siren when she married Edward Byron Smith in Chicago in 1934. The *Chicago Tribune* called the wedding "one of the most important of the social season." Though the paper praised the "simplicity and good taste" of the event, the gown was anything but minimalist, with "a high neckline, long sleeves, and cut out shoulders. The only trimmings were epaulets of old lace, lace that had belonged to the bride's paternal grandmother"—a subtle marriage of something

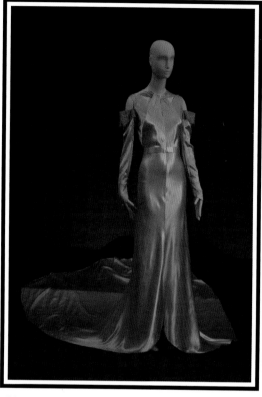

old and something new. A pearl cornet and tulle veil adorned the bride's blonde hair. Designer Norman Hartnell praised the trend toward tulle veils in the 1930s in his autobiography: "An antique bridal lace veil, extracted once a year from a grandmother's treasure chest and quickly replaced among sachets of lavender, rarely enhances the appearance of any bride. . . . A drifting cloud of crisp modern tulle is much more becoming, falling from a circle of blossom or from a sparkling tiara."

ABOVE: Louise de Marigny Dewey incorporated her grandmother's lace into her ultra-modern bias-cut satin gown by Madame Marguerite of Chicago.

Dewey's bridesmaids were "gowned alike in powder blue taffeta, made with short round trains, high necklines in front and low in back, and short puffed sleeves with cut out shoulders," the *Tribune* reported. "Very French and very chic the dresses were and so were the picture hats of powder blue straw with low crowns around which were narrow bands of ribbon," which were dark blue to match the large bouquets of bachelor's buttons. Long, powder blue gloves and deep blue sandals completed the ensembles. The father of the bride had been a financial adviser to the Polish government, and the Consul General and Vice Consul of Poland were among the guests. The ceremony at St. Chrysostom's Church—bedecked in fashionable calla and Easter lilies—was followed by a reception at the Casino Club; the exclusive club, still in operation today, limited itself to four hundred members.

SOMETHING BLUE

♦ ♦ ♦ ♦

When automobile heiress Frances Dodge married music magazine editor James B. Johnson in the drawing room of Meadowbrook Hall, her family's mansion near Rochester, Michigan, it wasn't just something blue. *Everything* was blue. It was a foregone conclusion that the wedding of "Detroit's No. 1 Glamour Girl" would "put another notch in that young woman's national reputation for glamour," the *Detroit Free Press* reported. After all, this was the same Frances Dodge who had carried black orchids with her silver debutante gown. The bride and her wedding party did not disappoint; they were a "rhapsody in blue" dressed in "every color and cadence of moonlight blue, from palest ciel to pale lapis lazuli," for an ombré effect— a popular choice for bridesmaids in the late '20s and '30s.

Pastel wedding gowns had a fashion moment in the 1930s. Evelyn Marie Wright wore a blue lace gown for her wedding in Carthage, Ohio, in 1935. More famously, Wallis Simpson chose a cornflower blue Mainbocher ensemble for her much-publicized 1937 wedding to the Duke of Windsor (see Chapter 9). "Heavenly blue" or "bridal blue" gowns evoked flattering associations with the Virgin Mary. But Dodge—who married on July 1, 1938—was likely inspired by the shades of a summer night. According to the *Free Press*, the "shimmering shafts of moonbeams and starlight" worn by the bridal party were "adroitly attuned to the hour of the ceremony," 8:30 p.m. Afterward, the nine hundred guests danced to a swing band under the stars.

The dresses were made by New York designer Peggy Hoyt, who milked the high-profile event for every last drop of publicity. The bride's gown, she claimed, was "inspired by the simplicity of ancient Grecian art"—apparently a reference

OPPOSITE: New York designer Peggy Hoyt made something blue for Frances Dodge, "Detroit's No. 1 Glamour Girl."

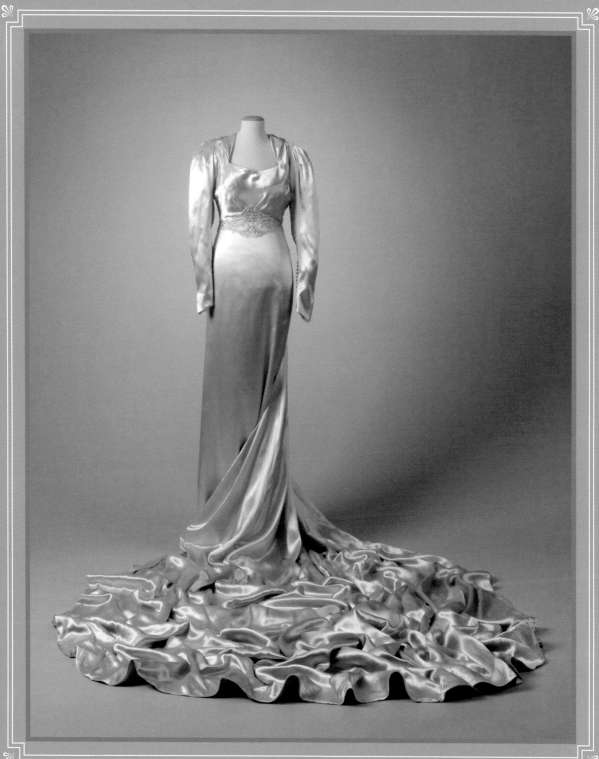

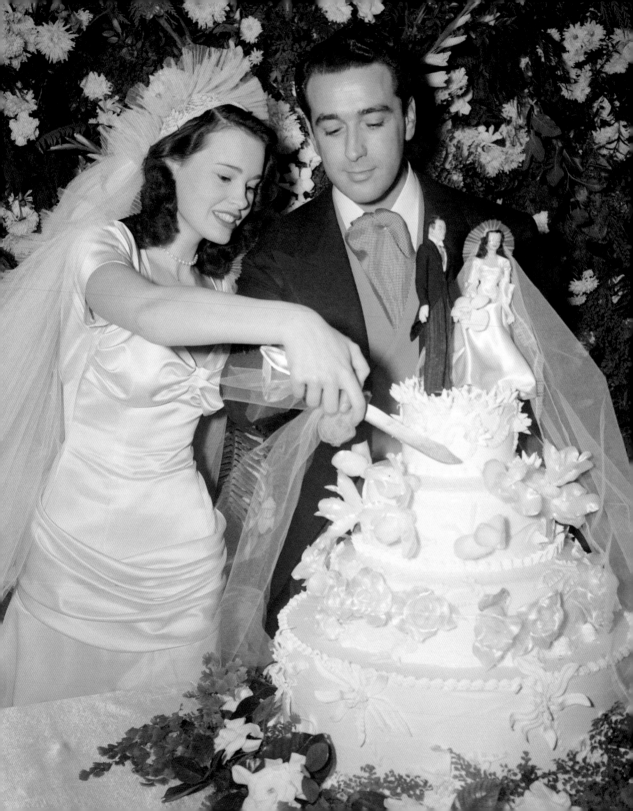

to the acanthus leaf pattern of the seed pearl beading at the waistline, as there is nothing else simple or Grecian about it. Much more than ancient Greece, it reflects the influence of Hollywood glamour on 1930s wedding fashions, with its thirteen-foot train and clinging fit created by bias cutting.

HOLLYWOOD GLAMOUR

♦ ♦ ♦ ♦

By the 1940s, wedding gowns were as likely to reflect the fashions of the past as the present, a trend spurred by Hollywood historical sagas like 1938's *Marie Antoinette* and 1939's *Gone with the Wind*. "Poor Little Rich Girl" Gloria Vanderbilt—niece of Consuelo Morgan, distant cousin to Consuelo and Cornelia Vanderbilt, and, later, mother to Anderson Cooper—turned to former Paramount Studios costume designer Howard Greer for her gown when she married her first husband, movie producer Pat DiCicco, in 1941. For the ceremony at the Santa Barbara Mission—followed by a reception in Beverly Hills—Greer dressed the seventeen-year-old bride in a satin gown with a sweetheart neckline, short puffed sleeves, and a draped, bustled overskirt "in the style of 1890," with an appropriately cinematic thirty-foot train. The bride on the couple's cake topper wore a miniature replica of Vanderbilt's gown and net veil. The couple divorced four years later (see Chapter 9).

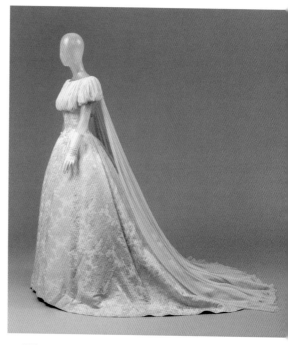

When Philadelphia bride Diene ("Dee-nah") Pitcairn—the daughter of multimillionaire theologian, missionary, and art collector Theodore Pitcairn—married her childhood sweetheart, jeweler Douglas J. Cooper, on January 9, 1960, she chose a gown by French couturier Pierre Balmain that seamlessly merged the mid-century hourglass silhouette with the court of Versailles, suggested by a sweeping silk chiffon train that fell from the shoulders of the damask gown like an eighteenth-century *robe à la française*. Balmain had opened a US boutique in 1949 and steadily built an American clientele, as well as dressing an international who's-who of

OPPOSITE: Gloria Vanderbilt's wedding cake was topped by a miniature version of her Howard Greer gown. ABOVE: Paris couturier Pierre Balmain built a loyal following among American brides after World War II, including Philadelphia heiress Diene Pitcairn.

actresses including Marlene Dietrich, Katharine Hepburn, Vivien Leigh, Brigitte Bardot, and Sophia Loren onscreen and off. He had had made wedding dresses for Audrey Hepburn, Errol Flynn's wife Patrice Wymore, and Doon Plunkett, who married the Earl Granville—Queen Elizabeth II's cousin.

"Good fashion is evolution, not revolution," Balmain once said. But revolution was coming in the form of the counterculture explosion of the late 1960s and early 1970s. The far-out fashions of the time featured androgyny, ethnic influences, and "flower power"—though not the kind normally found at weddings. "The bride today may want nothing traditional," a florist told the *Los Angeles Times* in 1970. "Individuality is very important to her and we spend time in counseling to create a wedding that reflects her own personality." In fashion, this meant "tiers of lace and ruffles are out"—except for grooms, who wore "ruffles and tuxedos in a rainbow of colors." Flowers or greenery replaced veils; short skirts and even pants in pastel hues replaced long white gowns and trains. Outdoor weddings eclipsed church ceremonies in popularity.

BOHEMIAN BEAUTY

◆ ◆ ◆ ◆

The rebellious mood of the 1960s penetrated even the staid upper echelons of high society. In 1966, Talitha Pol combined both youthful

iconoclasm and almost cartoonish luxury in her wedding garb, a short, fur-trimmed white velvet coatdress that bared her knees, clad in white nylons. The bride was a Dutch actress; the groom, John Paul Getty Jr., was the son of the richest man in the world, American oil magnate J. Paul Getty (who did not attend the wedding). But the event was a modest affair—just a few friends and family members attended the civil service at city hall in Rome, followed by dinner at a local restaurant. Instead of a veil, Pol's

ABOVE: Dutch actress Talitha Pol wore a *Dr. Zhivago*–inspired fur-trimmed coatdress to marry J. Paul Getty Jr., the son of American oil magnate J. Paul Getty, in 1966.

head was covered by a hood; her bouquet was a single stem of lilies. The groom wore a blue suit and tie. There was no honeymoon.

The 1965 film *Dr. Zhivago* launched a trend for fur-trimmed bridalwear, with muffs often replacing bouquets. Actress Judi Dench (in 1971) and singer Lulu (in 1969) wore gowns similar to Pol's, though theirs were full length. The cocoon-like "Zhivago look" or "snow queen look," as the *New York Times* called it, was enthusiastically adopted for winter weddings, along with Russian-inspired tunics and caftans for the rest of the year. Pol's on-trend wedding dress forecasted her role as a boho-chic muse to fashion designers like Ossie Clark and Yves Saint Laurent, until her death from a heroin overdose in 1971.

The union of two of France's oldest noble families at the bride's ancestral château in Provence in 1969 carried the weight of history. Gersende de Sabran-Pontevès and the Duc d'Orléans might have been expected to play it conservatively, sticking to time-honored convention. But while the bride's Yves Saint Laurent couture gown had the voluminous silhouette of a long-sleeved, high-necked, trained gown, it was anything but traditional. On closer inspection, the gown was a patchwork of matte and satin ivory silk squares—the newest technique from innovative Swiss textile designer Andrée Brossin de Mere. This humble, handcrafted

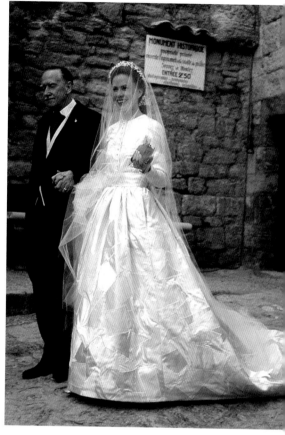

touch suggestive of *commedia dell'arte* costumes was perfectly in keeping with the playful, do-it-yourself ethos of the hippie movement.

BOURGEOIS BACKLASH

♦ ♦ ♦ ♦

By this time, the idea of wearing a wedding gown more than once was anathema; fashion had split into two distinct aesthetics, one for

A B O V E : Gersende de Sabran-Pontevès (with her father, the duc de Sabran) wore Yves Saint Laurent for her 1969 wedding to the duc d'Orléans.

weddings and one for everyday formal wear. A wedding gown was something to be preserved like a relic, not worn agvain, except perhaps by the bride's daughter; many elite wedding gowns, with their illustrious provenances and couture labels, ended up in museums. But not every bride felt a sentimental attachment to her gown—and not every marriage lasted. In the early 2000s, "Trash the Dress" photos and videos—in which brides creatively destroyed their wedding gowns—became popular as divorce celebrations or as Instagram-friendly postnuptial entertainments or wedding photo shoots.

The global economic crisis of 2008 brought this trend to an abrupt end. Instead of harmless, photogenic fun, trashing a wedding dress suddenly seemed like shameful profligacy. That year, *Vogue* contributing editor (and Poland Springs

ABOVE: In the "Trash the Dress" photo shoots popular in the early twenty-first century, brides creatively destroyed their wedding gowns.

mineral water heiress) Lauren Davis faced a similar backlash when she married Colombian brewing scion Andrés Santo Domingo in a three-day extravaganza in Cartagena. Many of the five hundred–plus guests flew nine hours each way from New York, where the couple lived. For the ceremony in a seventeenth-century church, Davis wore a merengue of a couture gown containing sixty meters of embroidered silk jacquard, designed by Olivier Theyskens for Nina Ricci; it took a total of two thousand hours to make. For the reception, she changed into a second gown by the same designer. In the middle of the party, she had Theyskens cut off the long, trained skirt of the strapless feathered sheath, transforming it into a flapper-style minidress. The stunt called attention to the cost (monetary and environmental) of the wedding, which the groom's mother justified by saying she hoped the publicity would attract tourism to Cartagena.

For better or for worse, Davis's wedding marked the end of an era. Brides began to seek out inexpensive or reusable wedding gowns, often turning to their favorite ready-to-wear retailers rather than couturiers or specialist bridal designers (see Chapter 5). In January 2020, the *Wall Street Journal* observed: "Modern brides accustomed to overnight shipping and celebrity-influenced purchases don't want nine months of fittings. . . . They want colorful, rewearable ensembles in unorthodox silhouettes," like jumpsuits and caftans. Given the changing retail landscape—and the continuing global conversation about class warfare, carbon footprints, and income inequality—it remains to be seen whether this is a temporary backlash or the way forward. ◆

ABOVE: Lauren Santo Domingo had designer Olivier Theyskens cut off the long, trained skirt of her reception gown midway through her 2008 wedding festivities.

CHAPTER 5

FOR POORER

WEDDING CLOTHES ARE NO LESS beautiful and meaningful for being practical, humble, or homemade. Before the Industrial Revolution, clothes of all kinds were, proportionately, far more expensive than they are today because they were hand-sewn, from fabric handwoven out of natural fibers. New clothes of any kind were the province of the very wealthy, and fashionable clothes—which would become stylistically obsolete long before they wore out—were a rare luxury. The idea of a gown—or any other garment—intended to be worn only once would have been antithetical to our forebearers. With industrialization, however, came the development of man-made fibers and the rapid, economical production of textiles and clothing. Coupled with the rise of the department store, this meant that clothes of all kinds became cheaper, and new, fashionable dress was suddenly within reach of the masses.

Historically, the lower and middle classes have made their own clothes, or purchased them used, through an extensive and highly organized network of resellers. For weddings, they wore their best clothes if they could not afford to purchase something new; if they did buy new clothes, they would be practical enough for repeated use. In 1885, author Laura Ingalls Wilder wore her best dress, made of black cashmere with imitation jet buttons, for her wedding—a quiet affair in the parlor of a friend's house, a larger church wedding having been deemed too expensive. Unfortunately, these modest ceremonies—though much more common—have not been as well documented as those of royalty, aristocracy, celebrity, and high society, and few garments have survived. Linda Baumgarten, the longtime costume curator at Colonial Williamsburg, has written that "survival of . . . any artifact for hundreds of years usually favors the beautiful and the unusual," which is why museums are full of gorgeously beaded and embroidered formal garments but short on everyday, inexpensive clothing.

For the vast majority of people, wedding clothing *was* everyday dress; it would be worn again and again, which is another reason why so little of it has survived. One rare example is the cotton dress worn by Sarah Maria Wright for her church wedding to Daniel Neal in Lincolnshire in 1841. The growing availability of

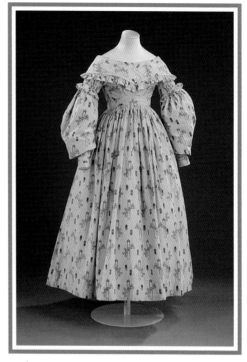

cotton in Europe in the early nineteenth century revolutionized fashion; unlike silk and wool, the principal fibers used for clothing, it was relatively affordable and—even more exciting—washable. For the first time, those of modest means could afford to purchase new, fashionable clothing. Neal was a rural laborer, probably involved in the production of woad dye. Wright's dress had the fashionable full sleeves, low neckline, gathered shoulders and full skirt of the era, and the textile's block-printed pattern of ombré ribbon motifs imitated the designs found on more expensive silks.

ABOVE: Sarah Maria Wright's printed cotton gown is a rare example of working-class wedding attire from 1841.

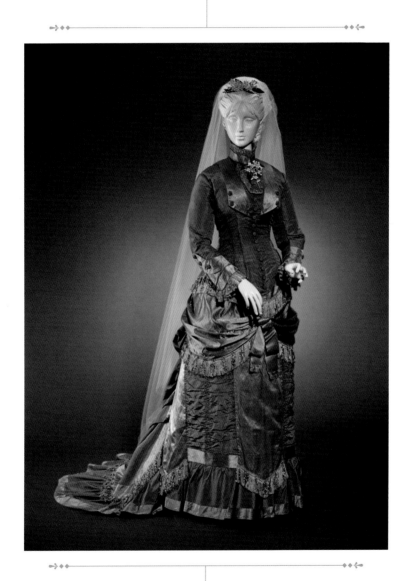

ABOVE: Kentucky dressmaker Ellen Curtis made her own
wedding gown, an impressive advertisement of her skills.

INDUSTRY INSIDERS

◆ ◆ ◆ ◆

One subset of working-class women has historically enjoyed uniquely stylish wedding gowns: professional dressmakers. With access to high-quality materials, fashion magazines, and well-to-do clients, they were abreast of the latest trends and had the skills to reproduce them, as well as a professional interest in dressing well. Ellen Curtis, a dressmaker in Lexington, Kentucky, made her own gown for her marriage to Louis A. Scott in 1879. The slim, fitted sheath had a fashionable "cuirass" bodice with a high neck, faux lapels, and military-style cuffs. Draped "paniers" at the hips evoked the popular eighteenth-century revival style. But instead of white satin, she used brown ribbed faille and satin with a view to wearing it again—probably when she called on potential clients. It was an impressive advertisement of her skills.

In a trade that depended on a workforce of young, single women, weddings were inevitable. The Tirocchi dressmaking shop, which operated in Providence, Rhode Island, in the early twentieth century, had a policy of giving each of its seamstresses a custom-made gown as a wedding present; the owners, the Tirocchi sisters, provided the materials and the seamstresses worked together to sew a gown worthy of a paying customer, like the stunning gown seamstress Mary Riccitelli wore for her wedding

to Panfilo Basilico in 1931. It was an especially generous gift considering that most of the girls did not return to work after they married. But the Tirocchis, who had emigrated from Italy, employed several daughters of immigrants in their workshop and treated them like family; making the wedding gowns was "a practice that bonded the women together," according to historian Susan Porter Benson.

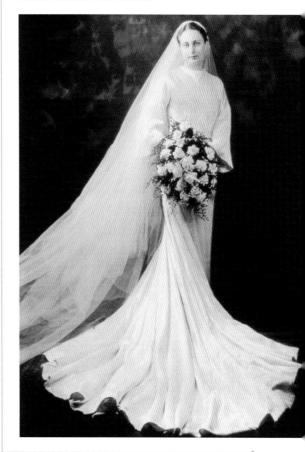

ABOVE: Seamstress Mary Riccitelli worked in the Tirocchi sisters' dressmaking shop, where her coworkers made her gown for her 1931 wedding.

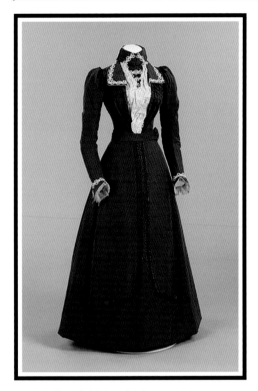

Another field in which a neat appearance and dressmaking skills were expected was service. Harriet Joyce, a lady's maid, made herself a purple gown for her wedding to Percy Raven Sams in Middlesex in 1899. Though colored dresses were certainly more practical, especially for working-class women, Harriet was motivated by different concerns: at thirty-five, she considered herself too old to wear white. She later altered the gown to bring it up to date, indicating that she wore it over a long period of time and wished to appear fashionable.

PLAIN AND PRACTICAL

◆ ◆ ◆ ◆

The same cannot be said of a contemporary of Joyce's, who worked in a very different profession. Scientist Marie Sklodowska owned only one dress when Pierre Curie proposed to her. He offered to buy her a new gown for their 1895 wedding in Sceaux, France. She told him: "If you are going to be kind enough to give me one, please let it be practical and dark so that I can put it on afterward to go to the laboratory." She ended up marrying in a dark blue dress. As a married woman, Marie made a habit of wearing the same plain, practical garments for years; when she met President Warren G. Harding at the White House in 1921, she wore the black lace and silk georgette dress she had worn to collect her Nobel Prize in Physics in 1903 *and* her Nobel Prize in Chemistry in 1911. While Curie was hardly poor at the time (the Nobel came with a substantial cash award), she had developed frugal habits as a student at the Sorbonne, where, she remembered, "my living conditions were far from easy, my own funds being small and my family not having the means to aid me as they would have liked to do. . . . The room I lived in was in a garret, very cold in winter. . . . Meals were often reduced to bread with a cup of chocolate, eggs, or fruit."

Curie was not alone in wanting a "practical" wedding gown. When the *Ladies' Home Journal*

ABOVE: Harriet Joyce made her own wedding gown, choosing purple because, at thirty-five, she considered herself too old to wear white.

published its first bridal issue in March 1905, it claimed to be responding to reader demand for advice on "suitable and inexpensive" fabrics and styles. The new bridal magazines were full of suggestions on how brides on a budget could adapt their wedding gowns for everyday use or evening wear—by cutting off the trains, for example, or dyeing white gowns more serviceable colors.

Such creative reuse was common, especially in times of war or economic crisis. Lawrence and Adele Atkin married on October 29, 1929—the day the New York Stock Market crashed, plunging the United States into the Great Depression. Mindful of the country's changed circumstances, Adele remodeled her knee-length ivory silk panné velvet wedding dress, now in The Museum at FIT, removing a bow and the long sleeves so it could be repurposed as evening wear. British *Vogue* recommended that Depression-era brides consider simple white satin dresses that could be dyed after the wedding; trains could be made into coats or capes.

The Depression forced many brides to rethink their wedding plans. Marriage rates dropped dramatically. According to a 1939 study by sociologist B. F. Timmons, one-third of couples were economizing on some element of the wedding ritual due to financial constraints, foregoing an engagement ring, a new gown, a reception, or honeymoon. A rise in secular ceremonies—held in courthouses and city halls rather than houses of worship—permitted greater variety and informality in wedding dress.

CHIC SHORTCUTS

◆ ◆ ◆ ◆

The advent of washable synthetic fabrics like rayon and nylon in the 1930s made it possible for brides to emulate the glamorous bias-cut silk and satin gowns of the silver screen without a Hollywood budget. Londoner Elizabeth Wray got married in 1938; like many brides of modest means, she made her own gown, using inexpensive artificial silk and, probably, a commercial pattern. Her cousin, a seamstress for Norman Hartnell, added couture-quality beadwork around the collar and cuffs. Licensed sewing patterns of French couture designs helped make Paris fashion accessible to a wider audience. Patterns began appearing in issues of *Vogue* magazine in 1899; by 1916, they could be bought in department stores. Wray's glamorous gown was subsequently worn by four other brides who could not afford to buy their own wedding dresses during the Depression and, later, World War II (see Chapter 8).

After the war, Christian Dior's so-called "New Look" brought long, full skirts, hourglass figures, and surface ornamentation back into fashion— features that translated well to the fairy-tale world of weddings. In 1957, Vivian Williams hired a London dressmaker to make up a *Vogue*

pattern of a couture wedding gown designed by Dior's rival, Jacques Fath, for a fraction of the cost of a custom-made gown. She wore it with an altered off-the-rack corset from Dickins & Jones department store.

In the volatile social and fashion climate of the 1960s, romance and tradition gave way to free love and hot pants in psychedelic prints. Disposable paper dresses enjoyed a brief vogue in the turbulent era, when young people literally wore their politics and interests on their sleeves—but were prepared to discard them just as easily as a piece of paper. Paper dresses were actually made of flame-retardant Kaycel pulp fiber, originally developed for hospital gowns and lab coats before being adapted for promotional products; manufacturers euphemistically dubbed these materials "non-wovens." They

ABOVE: Vivian Williams's Dickins & Jones wedding corset was taken in at the waist for a made-to-measure fit at an off-the-rack price.

were perfect for young, penniless brides and bridesmaids; beyond their novelty value, they offered the latest styles at an affordable price, and they could be easily altered and worn again (or simply tossed) after the wedding. "The ultimate disposable gown must be the paper wedding dress," the *Australian Women's Weekly* declared in 1967. "Why not? You only wear it once, anyway."

As textile designer Marcelle Tolkoff told the *New York Times*, paper "has given designers a new lift. You do things with paper you wouldn't dare with regular fabrics." That was certainly true of the daring bridal ensemble Elisa Daggs—a fashion editor turned paper dress designer—presented at a New York bridal fashion show in January 1967. It was "short enough to show more than a glimpse of ruffled knee pants at the front, though it rounds off into a big circular train at the back," the *Los Angeles Times* noted. "A huge candy box paper bow is its headdress." The made-to-order dress cost $35, a hefty increase from Daggs's usual price point of $6 to $8 for evening wear and beach clothes. "Paper's future is in these less frequently worn clothes," the designer told the *Australian Women's Weekly*.

In March 1967, James Sterling Paper Fashions introduced a more traditional paper wedding gown, a full-length sheath with a boatneck and short, puffed sleeves. The *Los*

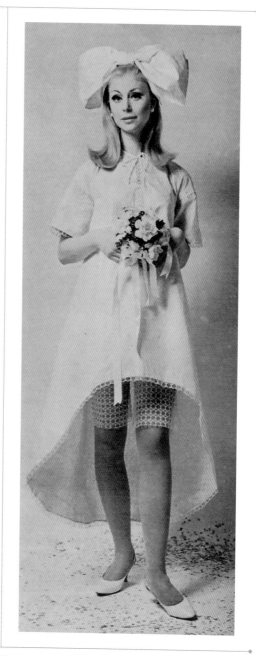

ABOVE: Elisa Daggs's $35 paper wedding dress came with a matching bow headdress and bloomers.

Angeles Times praised its "rather elegant simple lines" and $15 price tag. Two years later, the disposable dress fad was still going strong, the *Times* reported. At a wedding in Wisconsin, "the organist . . . had hardly finished playing the Mendelsohn 'Wedding March' when the new Mrs. Richard Stelter grabbed a pair of shears. She snipped two feet off the bottom of her Grecian-style wedding gown. Presto: an instant cocktail dress for the reception." The $40 dress by Chicago fashion designer Jita Merson could be easily repaired with tape or glue; Stelter's bridesmaids also wore paper gowns, which they, too, shortened after the ceremony. Although paper gowns were not made to last, two identical bridesmaid dresses of Reemay spun polyester "paper" in a colorful, impressionistic floral pattern with empire waistlines, divided long skirts, and zippers at the center back survive in the Texas Fashion Collection. According to the labels, the garments may be "washed a few times and need no ironing."

AFFORDABLE ELEGANCE

♦ ♦ ♦ ♦

Just as it looked like the traditional white wedding might be an endangered species, Laura Ashley launched her eponymous label in 1966. Ashley's long, ruffled skirts, pretty floral prints, lace trimmings, and feminine silhouettes inspired by Victorian and Edwardian fashion offered brides (and bridesmaids) a romantic alternative to the rebellious fashions of the day. At a time when many wedding gowns were made of synthetic silks, Ashley used natural fibers like cotton in nostalgic calico and gingham that appealed to the counterculture's earthy values. Caroline Peacock—a frequent customer of Laura Ashley's flagship London shop—chose an asparagus green gown for her 1973 wedding. The long, full skirt, high collar, and puffed

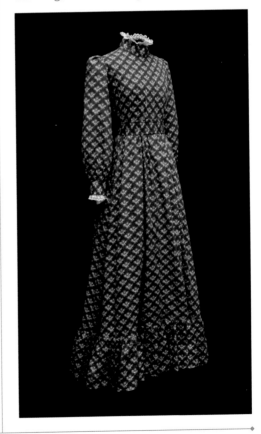

ABOVE: Caroline Peacock, a fan of Laura Ashley's Victorian-inspired dresses, chose one for her 1973 wedding.

ABOVE: Jan Stokes crocheted her own wedding gown,
using a pattern from the *Australian Women's Weekly.*

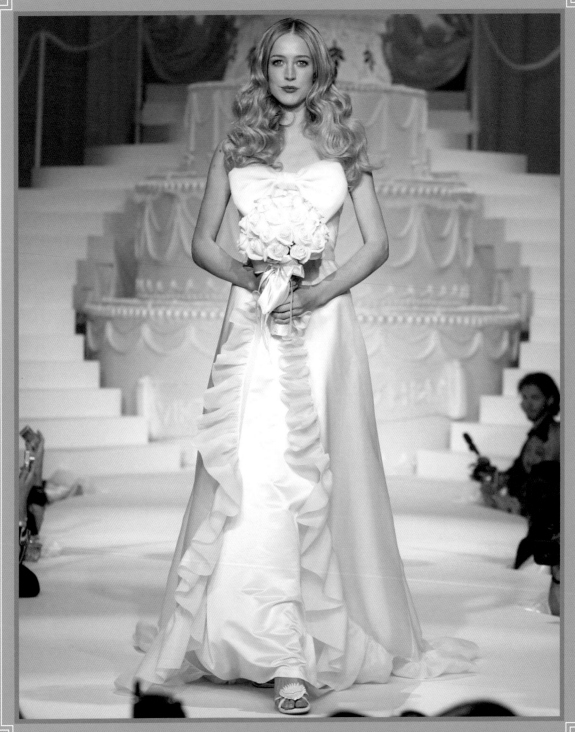

sleeves anchored the dress in wedding tradition, but the colorful floral-printed cotton made it both modern and inexpensive. Peacock wore her hair down, without a veil. Another bride-to-be, Elizabeth Vining, confessed: "I wanted a Gina Fratini dress costing £112 from Harrods. The Laura Ashley option was a bargain £12 for two dresses. It was a white, multi-tiered, cotton and lace paneled dress, with a floral printed cotton pinafore worn on top." Fratini was the hippie-chic fashion designer whose rainbow-colored caftan Elizabeth Taylor would wear for her sixth wedding (see Chapter 9). Ashley offered a similar bohemian aesthetic for a fraction of the price.

American Jessica McClintock designed for a similar label, Gunne Sax, beginning in 1969. Though her dresses—like Ashley's—drew upon the fashions of the past, they were constructed from thoroughly modern fabrics, including synthetic fibers like polyester, acetate, nylon, and rayon. These inexpensive, easy-to-clean materials meant that a Laura Ashley or Gunne Sax dress was both washable and affordable—much like Sarah Maria Wright's cotton gown of 1841. The royal wedding of 1981 was the pinnacle of the historical revival in bridal fashion (see Chapter 2). The once-upon-a-time agelessness of Princess Diana's gown created a feeling that, as the *Daily Express* put it, "the whole world had stopped for the wedding."

The trend for so-called "prairie dresses" coincided with a handcrafting revival in the 1970s, partially spurred by the American Bicentennial (which renewed interest in colonial pastimes like quilting, spinning, and weaving) and the burgeoning environmental movement. In 1976, Jan Stokes made her own wedding gown using a crochet pattern from the *Australian Women's Weekly*. It took her three months to complete the dress at a cost of around $30.

In recent years, bridal lines from midprice fashion chains like J. Crew, Anthropologie, and Whistles—as well as designer collaborations with "fast fashion" retailers—have made it possible for wedding parties on a budget to afford gowns (and suits) with style. Avant-garde Dutch design team Viktor & Rolf created a limited-edition wedding dress as part of a capsule collection for H&M in 2006, calling it "a great opportunity to communicate our vision with such a large audience." The $349 bow-bedecked gown was strongly reminiscent of one they'd created for Prince Johan Friso of Orange-Nassau's bride in 2004 (see Chapter 2), giving new meaning to the phrase "queen for a day." ◆

OPPOSITE: Dutch design duo Viktor & Rolf created a
$349 wedding gown as part of their 2006 capsule collection for H&M.

CELEBRITY WEDDINGS

FROM THE GOLDEN AGE OF HOLLYWOOD to Instagram influencers, celebrities have always set wedding trends. The celebrity wedding is characterized by confidence and image awareness. Fame and fortune may provide a celebrity with the security to take risks, tweaking tradition or rejecting it altogether. But a celebrity must also be mindful of protecting his or her reputation and marketability—what is now called a "personal brand." The high-profile nature of celebrity weddings inevitably means that they set fashion trends, but they also set social trends. Once-controversial practices like remarriage after divorce (see Chapter 9), interracial marriage, and gay marriage have gained acceptance through widely publicized celebrity weddings, which are featured on television and in newsreels, plastered on magazine covers and websites, and discussed around watercoolers and on social media. And bridal trends like outdoor weddings, double weddings, destination weddings, black-tie weddings, surprise weddings, beach weddings, reception gowns, elaborate proposals, and multiday (or even multicountry) celebrations involving several events and outfits frequently spread from celebrities to the civilian population.

Whether celebrities marry quickly and quietly to avoid the paparazzi or dress for the spotlight, their highly personal wedding fashion statements—often created by the same designers who dress them on the stage, screen, or red carpet in their professional lives—become part of their public personae. Personal branding factors into celebrity wedding clothes both deliberately and reflexively. Grunge rocker Kurt Cobain married Courtney Love wearing plaid flannel pajamas and a woven Guatemalan purse. Punk princess Avril Lavigne wore a black Monique Lhuillier gown (and carried a bouquet of black flowers) when she married Nickelback frontman Chad Kroeger, who also wore head-to-toe black. After Ashlyn Harris said "I do" to her US Women's National Soccer teammate Ali Krieger, she rolled up the pants of her custom-made Thom Brown tuxedo to reveal knee-high black athletic socks. And Idris Elba's wife, model Sabrina Dhowre, had one of the actor's tattoos embroidered on the train of her Vera Wang wedding gown.

Just as many famed cinematic fashion statements—like Joan Crawford's *Letty Lynton* dress, Scarlett O'Hara's hoopskirts, Elizabeth Taylor's *Father of the Bride* wedding gown, Julie Christie and Geraldine Chaplin's *Dr. Zhivago* furs, and Vanessa Redgrave's *Camelot* robes—launched bridal-store knockoffs, the clothes worn by actors and other performers at their own weddings have inspired copycats. In some cases, they were designed by the same wardrobe department; for many years, MGM had a policy of paying for the weddings (and providing the gowns) of actresses who got married while under contract, including Elizabeth Taylor, Jane Powell, and Grace Kelly (see Chapter 2). It was a win-win situation for the studio, ensuring that its stars maintained their wholesome reputations while reaping free publicity. Other costume designers, like Irene and Adrian (who was responsible for the *Letty Lynton* dress), went on to launch their own fashion lines, and continued to dress many of their actress clients.

A HOLLYWOOD CIRCUS

◆ ◆ ◆ ◆

Hollywood veteran Howard Greer left Paramount to open his own fashion business in 1927. In 1945, he took on the daunting task of dressing America's sweetheart, Shirley Temple, for her wedding to Air Force Sergeant John Agar in Los Angeles. Temple wanted an "old-fashioned" church wedding, not "a Hollywood circus." Greer had just six weeks to make Temple's ivory satin gown embroidered with pearls, working in strict secrecy. The eight bridesmaids wore dresses by Louella Brantingham. "They were an absolute dream," Nancy Majors Voorheis, one of Temple's bridesmaids, remembered. "They resembled shepherdess costumes and were a periwinkle

blue gathered up in little puffs, each puff with a small blue velvet ribbon in its center." The press dubbed the hue "Temple blue." On their heads, the bridesmaids wore "open-crowned cartwheel hats of blue, shirred net, with scatterings of the same tiny blue velvet ribbons, and we carried old-fashioned bouquets that were just out of this world," Voorheis added. "The dresses were really, really beautiful, and each one cost a bundle.

I remember being staggered by the price." Temple picked up the bill.

The five hundred guests gasped when Temple entered the church, a satin crown in her hair and a small diamond cross around her neck. Her gown was in the so-called "Infanta" silhouette inspired by the paintings of Velázquez, with small paniers at the hips, and a twelve-foot train. The ceremony went off without a hitch, but when

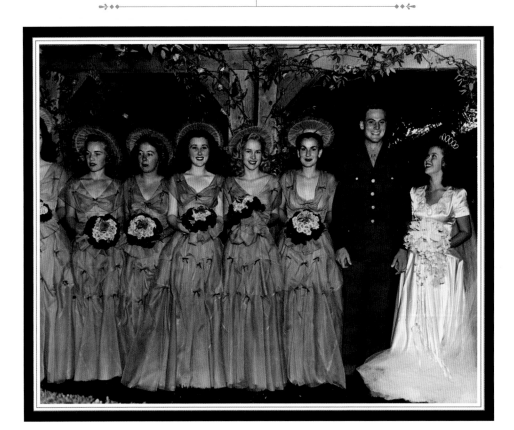

ABOVE: Shirley Temple turned to Hollywood veteran Howard Greer for her 1945 wedding dress, while her bridesmaids wore Louella Brantingham gowns in "Temple blue."

the couple left the church, the throngs of fans waiting outside broke through a police cordon and rushed the bridal party. The Agars eventually made it to their car safely, escorted by officers, but the bridesmaids were not so lucky. "People grabbed at our dresses; they were actually shredding us," Voorheis recalled. "Our hair was in disarray, our gowns torn, our bouquets pulled apart." The circus had overtaken the old-fashioned wedding.

The Hollywood publicity machine dubbed Temple's the "wedding of the decade," but the decade was not even over before the so-called celebrity "wedding of the century" took place in 1949, in a tiny medieval basilica in Rome. There, following a much-publicized courtship, matinée idol Tyrone Power married Linda Christian, a half-Dutch actress born Blanca Rosa Welter in Mexico. Reporters, photographers, and eight thousand swooning teenage fans mobbed the church, held at bay by a thousand *carabinieri*.

Power had come to Rome to film *The Prince of Foxes* at Cinecittà Studios, the epicenter of the American film industry's postwar love affair with Rome, which earned the city the nickname "Hollywood on the Tiber." Lured by exotic locations and low production costs, major studios set up satellite production offices in Rome in the late '40s and '50s, making films like *Quo Vadis* (1951) and *Three Coins in the Fountain* (1954). These, in turn, lured American tourists

to the Eternal City. Power and Christian had met stateside, but they got reacquainted via MGM's Italian office. The multilingual actress offered to give Power Italian lessons, and *amore* blossomed.

The groom's first marriage—to French actress Annabella—had taken place before a justice of the peace; he wanted a "serious" ceremony the second time around, he told the Italian newspaper *Oggi*. "I don't want my marriage to be transformed into an equestrian circus." Unfortunately, no one told his Hollywood handlers, who got special permission to film in the church and "produced" the event like the big-budget blockbuster it was. The set was dressed with two thousand Esther carnations, a variety first seen at the wedding of Princess Elizabeth in 1947. A string quartet, an organ, and a choir provided the soundtrack. An English-speaking American monsignor was procured, though it was not clear whether this was for the benefit of the groom or the home audience. Cables snaked through the sanctuary, powering cameras, spotlights, and microphones hidden in the prie-dieux to broadcast the couple's vows over the airwaves and newsreels.

The union was not without a whiff of *scandalo*; Power had abandoned Lana Turner, Christian's *Green Dolphin Street* costar, for her, and his divorce from Annabella only became final a few hours *after* the ceremony. "This was

all right because he had not married Annabella in the Catholic Church, which regarded his relation to her as one of simple adultery," *LIFE* magazine helpfully explained.

For her gown, Christian turned to the fledgling Italian couture industry. After the war, the American market took note of what *Women's Wear Daily* publisher John Fairchild called the "ease of Italian chic, as smooth and beautiful as a Ferrari and as delicious as steaming pasta." Enterprising Italian fashion designers formed ranks around the American embassy on Via Vittorio Veneto, and homegrown stars like Sophia Loren and Gina Lollobrigida acted as international ambassadors for Italian style. On the menswear side, sharp, skinny suits in the "Continental Look" now posed a serious threat to London's Savile Row. For his wedding, Power wore a dashing morning suit by Italian tailor Caraceni, a favorite of visiting Hollywood luminaries. Christian chose an embroidered satin gown by Sorelle Fontana—the Fontana sisters—featuring a cinched waist; a high neck; three-quarter sleeves; a long, trained overskirt; and an even longer tulle veil attached to a lace Juliet cap, which Christian's two terrified-looking bridesmaids struggled to maneuver. The ladylike yet voluptuous gown epitomized the Italian concept of *la bella figura*. "That day sanctioned our success as a Roman-based fashion house," Micol Fontana remembered.

A BALLERINA BRIDE

◆ ◆ ◆ ◆

A few years later, Sorelle Fontana's growing international reputation attracted another young actress working at Cinecittà: Audrey Hepburn. While filming *Roman Holiday*, she commissioned the Fontana sisters to make her trousseau and wedding gown for her planned marriage to British businessman James Hanson. In the house's archives are photos of Hepburn being fitted for a long, full-skirted ivory satin gown with a boat-neck that emphasized her miniscule waist, her floor-length tulle veil anchored by a headband. But the wedding never took place; Hepburn called it off, and her dress was given to a Sorelle Fontana employee to wear for her own wedding.

Hepburn became an overnight star thanks to the success of *Roman Holiday*. Visiting London for the film's premiere in 1953, she met the actor and director Mel Ferrer at a cocktail party hosted by their mutual friend Gregory Peck. The couple married the following year. Either because her more traditional first gown held negative associations or because Ferrer was a twice-divorced father of four, Hepburn chose a very different, less formal style for their wedding in Bürgenstock, Switzerland. The calf-length Pierre Balmain shirtdress in crisp, diaphanous silk organdy had elbow-length balloon sleeves to balance its full skirt and a narrow waist cinched by a sash. Instead of a veil, Hepburn wore a circlet

OPPOSITE: Actress Linda Christian wore a Sorelle Fontana gown to marry matinée idol Tyrone Power in the "wedding of the century" in Rome in 1949.

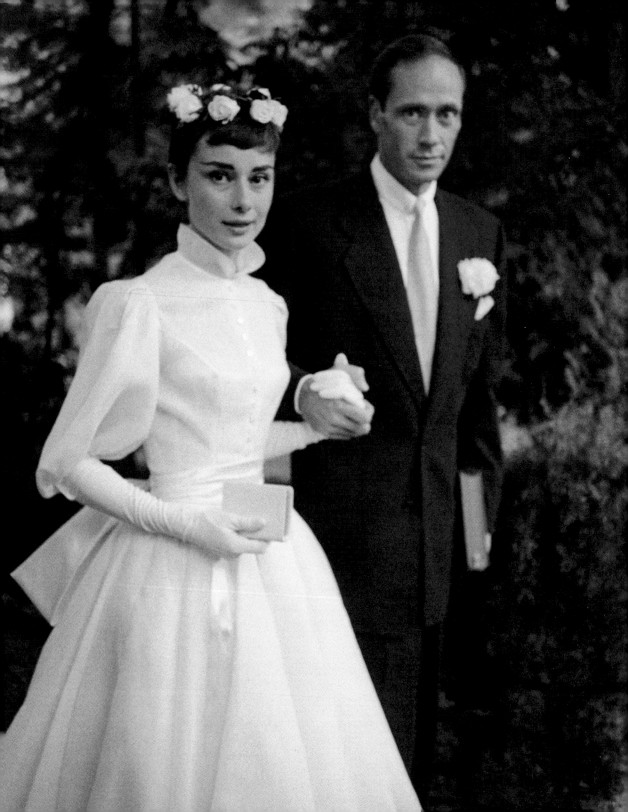

of fresh white roses perched atop her head like a crown; instead of a bouquet, she carried a prayer book in her gloved hands. A standing collar framed her slender neck. Hepburn had trained as a dancer and would wear a similar ballerina-style wedding gown (this one by Givenchy) onscreen in 1957's *Funny Face*, setting a trend for shorter, "ballet length" wedding dresses.

A SWINGING CELEBRATION

◆ ◆ ◆ ◆

The social, political, and sartorial upheavals of the 1960s did not bypass wedding culture. The postwar "Baby Boom" had created a "youth-quake." In the wake of wartime austerity, the global economy boomed, as well. Nowhere was this transformation more evident than in London, where an explosion of art, fashion, and music captured the energy and optimism of the era. In April 1966, *Time* magazine dedicated an entire issue to "the Swinging City." It was there that Polish film director Roman Polanski and American starlet Sharon Tate elected to get married in 1968.

The venue was the Chelsea Register Office, located on the King's Road, the heart of Swinging London. The bride wore an ivory silk moiré minidress trimmed with baby blue velvet ribbon that she had reportedly designed herself, though it bore the label of Hollywood custom dressmaker Alba. With its high collar, empire

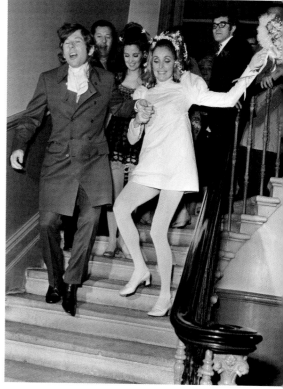

waistline, and long, puffed princess sleeves, the dress reflected the girlish, romantic nostalgia that characterized late '60s fashion: baby-doll ruffles, bows, pie-frill collars, and floral prints. Tate was a fan of hippie-chic designers like Ossie Clark, Betsey Johnson, and Thea Porter. "It's Renaissance until you get below the knees," Tate told reporters, though it was actually more of a Victorian-Edwardian hybrid. Tate "adored miniskirts and looked spectacular in them," her sister Debra remembered. British designer Mary

OPPOSITE: Audrey Hepburn's calf-length Pierre Balmain shirtdress with balloon sleeves set a trend for "ballet length" wedding gowns. ABOVE: Director Roman Polanski and actress Sharon Tate donned neo-Edwardian hippie chic for their 1968 wedding in swinging London.

Quant had coined the term "miniskirt" in 1965, and hemlines continued to climb to ever more scandalous heights. By 1967, one New York designer quipped: "There is the micromini, the micro-micro, the 'Oh, My God' and the 'Hello, Officer.'" The miniskirt became the uniform of the sexual revolution, feminism, and rock and roll. Tights and pantyhose were essential accessories, as short skirts exposed the garters used to hold up traditional stockings. For her wedding, Tate wore sheer white tights and low-heeled white pumps. In lieu of a veil, her elaborate, upswept blonde curls were scattered with pink and white flowers.

Polanski was equally caught up in the neo-Edwardian trend, sporting an olive green frock coat, bell bottoms, and a frilly jabot shirt he'd purchased from Jack Vernon's Hollywood boutique. (Polanski later cast Vernon in a bit part in *Chinatown*.) One observer described the groom as "a cross between Little Lord Fauntleroy and Ringo Starr." After the ceremony—"a media event with photographers outnumbering the guests," Polanski remembered—there followed a brunch reception at the London Playboy Club, "attended by what seemed like the whole of London and half of Hollywood." The star-studded guest list included Joan Collins, Candice Bergen, Warren Beatty, Michael Caine, and maid of honor Barbara Parkins, Tate's costar in *Valley of the Dolls*, who wore a crochet minidress.

A ROCK AND ROLL ROMANCE

◆ ◆ ◆ ◆

The fashion excesses of the late '60s had mellowed by the time Nicaraguan model Bianca Pérez-Mora Macías married Mick Jagger in Saint-Tropez in 1971, wearing a sleek, strikingly modern white suit by couturier Yves Saint Laurent. Although her tuxedo jacket and bias-cut maxi skirt were designed to be worn with a shirt, the bride discovered at the last minute that it no longer fit her; unbeknownst to the public, she was four months pregnant with her daughter Jade. So she decided to go without, instantly transforming a memorable look into a truly iconic one. She wore a large white hat with a tulle veil; instead of a bouquet, she sported a corsage on her wrist. Jagger wore a beige three-piece suit and patterned shirt by Savile Row's rock-and-roll tailor, Tommy Nutter, with sneakers.

The couple had flown in seventy-five friends from London for what they hoped would be an intimate ceremony. But when fans and the media got wind of the famous names on the guest list—Elton John, Eric Clapton, Peter Frampton, half of the Beatles, plus Jagger's bandmates—they swamped the tiny town on the French Riviera, and the two wedding ceremonies—one civil, one Catholic—descended into chaos. The Rolling Stones' publicist remembered it as "the most difficult day in my 21 years in the business."

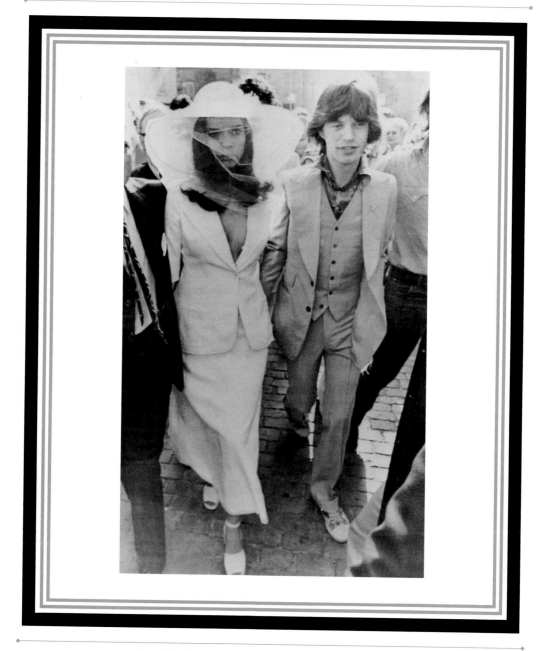

ABOVE: Bianca Pérez-Mora Macias wore a sleek Yves Saint Laurent
suit to marry Mick Jagger in Saint-Tropez in 1971.

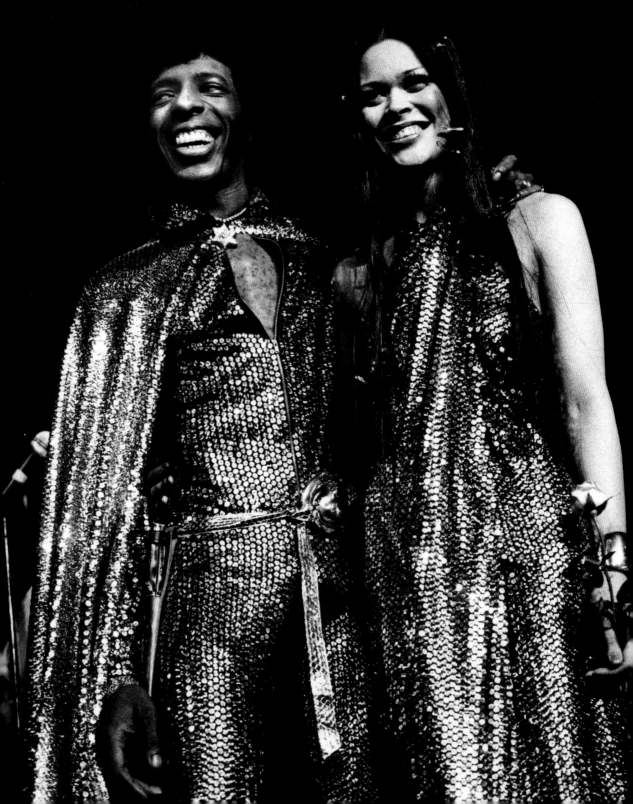

Sly Stone and Kathy Silva—the mother of his infant son, Sylvester Jr.—made their 1974 wedding part of the show when they chose to get married onstage at Madison Square Garden, as the opening act to a near-sellout concert by his band, Sly and the Family Stone. As twenty-three thousand fans watched, "a dozen black fashion models dressed in black glided onstage holding aloft golden palm fronds," the *New York Times* reported. The band played their hit song "It's a Family Affair" as the bridal party entered. Instead of something old, both bride and groom wore something gold: glittering metallic fashions by disco-friendly designer Halston, with a floor-length sequined chiffon cape for Sly and a matching halterneck gown for Kathy. They had already modeled the outfits on television news segments and invited reporters to the fittings; an NBC reporter called the bridal gown a "3-D matrimonial masterpiece." Richard Avedon photographed the couple in their wedding finery for *Vogue*. For a fee of $10,000, Halston dressed not just Sly and Kathy, but their mothers; Sly's three sisters, brother, brother-in-law, and best man; the band members and backup singers; and the twelve models in a harmonious palette of black and gold.

The event was as progressive as the band itself, a multiracial, mixed-gender ensemble that synthesized rock, soul, and funk. The bride's father quipped that her mother had "expected a garden wedding, but not this kind." *Soul Train* host Don Cornelius served as the emcee; the groom kept his sunglasses on during the vows as a laser light show played in the background. Though the mother of the groom told the audience that "this is a sacred ceremony," it was widely perceived as a publicity stunt, and the couple divorced in 1976, after a string of drug-fueled abusive behavior culminated in Sly's pit bull mauling their son, nearly killing him.

SHUNNING THE SPOTLIGHT

◆ ◆ ◆ ◆

Celebrity weddings don't get any more circus-like than Madonna's. On August 16, 1985—her twenty-seventh birthday—the pop star married actor Sean Penn on a Malibu clifftop as twenty paparazzi helicopters hovered overhead, drowning out the vows. "It was like *Apocalypse Now*," one of the guests, artist Andy Warhol, recorded in his diary. "The security people found camouflage-outfitted photographers in the bushes." The bride "wore white, and a black bowler hat" with a white tulle veil attached, Warhol noted, adding: "I don't know what that was supposed to mean." Her strapless tulle gown with a sweetheart neckline, a peplum overskirt, and a garland of handmade pink fabric flowers draped diagonally across the bodice was made by Marlene Stewart, who designed many of the Material Girl's early stage costumes;

OPPOSITE: Sly Stone and Kathy Silva wore matching gold Halston ensembles for their 1974 wedding, held onstage at Madison Square Garden.

it sold for $81,250 at Juliens Auctions in 2014. Her beaded brocade shoes embellished with imitation pearls, iridescent glass teardrops, wisps of tulle, and pink rosebuds were custom-made by Di Fabrizio of Los Angeles.

Even Warhol—who had founded *Interview* magazine and painted portraits of the likes of Elizabeth Taylor and Jacqueline Onassis—was starstruck by the celebrity-studded guest list. "As we were leaving I just couldn't believe my eyes because Tom Cruise jumped into our car to get away from photographers," he wrote. "Those young actors seemed like they were in their fathers' suits, like Emilio Estevez and Tom Cruise. All those movie-star boys with the strong legs who're 5'10" or so. I guess that's the new Hollywood look." Warhol remembered the wedding festivities as "the most exciting weekend of my life."

Perhaps hoping to avoid a similar media scrum, Sarah Jessica Parker took a low-key route when she married Matthew Broderick in May 1997. Instead of a wedding dress, the future *Sex and the City* star bought a black evening gown with spaghetti straps and a full skirt off the rack from a favorite boutique. "I wish it was because I was badass," she said in an interview years later. "I just was too embarrassed to spend any time looking for a wedding dress." If she could do it again, she revealed, "I'd wear a beautiful, proper wedding dress, like

I should have worn that day." The wedding was a surprise to everyone but the couple; the one hundred guests thought they were attending a party. Last-minute or undercover weddings have become increasingly popular among celebrities hoping to prevent details of the event leaking to the media in advance. Indeed, many couples actually cooperate with a single media outlet—selling the rights to their wedding photos and stories—knowing that doing so will ensure secrecy and security, keeping other reporters at bay.

Far-flung destination weddings are another way famous faces avoid the media glare. Casual beach weddings in exotic locales have become such a cliché—among celebrities and commoners alike—that it's difficult to appreciate what a novelty it was when supermodel Cindy Crawford married entrepreneur Rande Gerber barefoot on a beach in the Bahamas in 1998. *Vogue*'s Arthur Elgort photographed the bride, tall and tanned in a lace-trimmed, thigh-skimming white John Galliano slip dress she'd bought off the rack in a Michigan department store, her hair loose, with minimal makeup, carrying a hand-tied bouquet of white frangipani and orchids. The groom had planned to wear a khaki linen Armani suit, but the relaxed atmosphere of the island must have changed his mind because he went with an untucked white linen shirt and navy blue trousers. The laid-back vibe extended to the

ceremony itself. Instead of having her father walk her down the aisle, Crawford arrived hand-in-hand with Gerber. Instead of the "Wedding March," songwriter Bruce Roberts sang "Have a Little Faith in Me," accompanied by Jed Leiber. Fewer than one hundred guests attended, and many didn't know they were going to a wedding; they had to flash special Swatch watches to get into the top-secret event. The weeklong festivities doubled as a honeymoon for the busy couple.

PUSHING BRIDAL BOUNDARIES

♦ ♦ ♦ ♦

Galliano created a very different gown for Gwen Stefani's wedding to Gavin Rossdale at St. Paul's Church in London in 2002. The bride told the Dior designer she wanted something "over the top, but not traditional." For the No Doubt singer, who had famously dyed her hair hot pink in 1999, he created a look worthy of a rock star, spray-painting the skirt of the white silk faille gown with an ombré pink dye. Though the long gown was trained and corseted, and Stefani wore an antique lace veil in her platinum blond hair, its aesthetic was more deconstructed than constructed. It looked as if it had been twisted and torn from the body with an artful asymmetry. The corset hooks careened off to one side, the tulle neckline fell from one shoulder, and the bodice peeled away in back, exposing the corset lacings. Stefani

wore the gown again two weeks later, when the couple renewed their vows in a ceremony in Los Angeles, then loaned it to the Victoria & Albert Museum, saying it was "a work of art. It needed to be seen." Stefani's pink gown started a celebrity microtrend, as shades of pink—from blush to ombré to cotton candy—began appearing in social media friendly wedding photos. Julianne Moore wore a pink gown in 2003; so did Reese Witherspoon in 2011; Blake Lively, Anne Hathaway, and Jessica Biel in 2012; Kaley Cuoco in 2013; and Mandy Moore in 2018. Feminine but not traditional, subversive

ABOVE: Gwen Stefani (with her father, Dennis) married Gavin Rossdale in London in 2002, wearing a punky ombré pink gown by British designer John Galliano.

but not shocking, pink emerged as a photogenic and flattering alternative to white, which is no longer expected to signify virginity.

Indeed, the bride's pink wedding gown was the *least* revolutionary element of Ellen DeGeneres and Portia de Rossi's 2008 wedding. When the Supreme Court upheld the right of same-sex couples to marry in California in May 2008, gay celebrities were among the first who rushed to the altar, fearful (rightfully, as it turned out) that the opportunity would not last. (The ruling was overturned after six months by Proposition 8, which was, in turn, deemed unconstitutional in 2013.) These trailblazers had no road map for what two brides or grooms should wear. Should they match, celebrating their solidarity and compatibility, or display distinct personal styles? Did

ABOVE: Ellen DeGeneres and Portia de Rossi married in 2008, wearing custom Zac Posen ensembles in shades of ivory and pink.

stereotypical notions of masculine and feminine dress—traditionally heightened in wedding ceremonies—apply to them? While Americans had seen gay weddings on television—notably on *Roseanne* in 1995, *Friends* in 1996, and *Six Feet Under* in 2005—most had never attended one in real life, and they had a front row seat to the widely publicized nuptials of LGBTQ celebrities, whose fashion choices were disproportionately influential. Same-sex couples appreciated the personal and public impact of their weddings. Getting married "is not something we've ever taken for granted," de Rossi told *People*. "That we get to do this, it means a lot."

DeGeneres and de Rossi chose to play with traditionally masculine and feminine textiles and silhouettes in their custom Zac Posen ensembles. DeGeneres wore a flowing white pantsuit, and de Rossi donned a pink-tinged tulle gown for the intimate vegan celebration at their Beverly Hills home.

Actress Samira Wiley and screenwriter Lauren Morelli took a similar approach to their 2017 wedding in Palm Springs, wearing ensembles by the same designer, Christian Siriano—an off-the-shoulder white ball gown for Wiley and a lace-trimmed white jumpsuit with a dramatic cape for Morelli. When British Olympic diver Tom Daley and American screenwriter Dustin Lance Black married in Devon in 2017, they wore identical Burberry suits in different shades—navy and burgundy—with white shirts and ties matching each other's suits.

Celebrities famous for their creative endeavors—acting, singing, modeling—bring that creativity to their nuptials, whether to capture the attention of fans and the media or to express their artistic sensibilities. A wedding itself can be a work of art, as singer and DJ Solange Knowles and music video director Alan Ferguson demonstrated in 2014. The couple arrived at their New Orleans ceremony on vintage white bicycles bedecked with roses. The groom wore a white double-breasted Lanvin suit and no tie, and black shoes with gold toe caps. The bride wore a backless cream jumpsuit by Stéphane Rolland, with a plunging neckline and capelike sleeves that fluttered as she pedaled. (The designer had also created a one-legged white organza jumpsuit for the rehearsal dinner.) For the ceremony, which had an all-white dress code, Knowles changed into a dramatic white caped gown by Kenzo designer Humberto Leon, paired with gold wrist cuffs that looked both futuristic and monastic in her artful, unconventional wedding photos, shot by fashion photographer Rog Walker. Her only hair ornament was her signature natural Afro. Though Knowles may not have been as big a celebrity as her older sister, Beyoncé, she owned her moment in the spotlight, and her playful yet elegant wedding photos launched a thousand Instagram imitators and parodies. ◆

FOLLOWING: Solange Knowles, in a Stéphane Rolland jumpsuit, and Alan Ferguson, in Lanvin, arrived at their 2014 wedding in New Orleans on vintage bicycles.

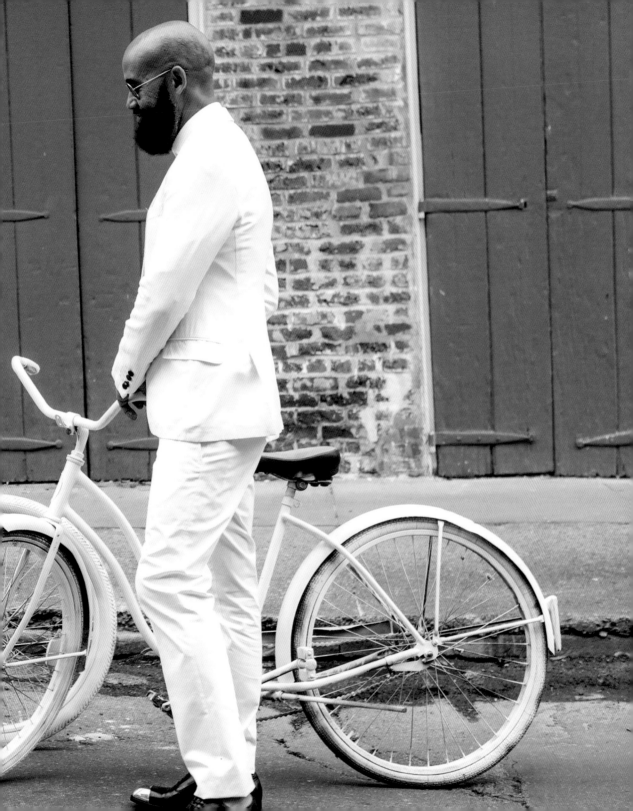

GLOBAL TRADITIONS

A WEDDING IS NOT ONLY A UNION OF two people; it is a union of two families and, often, two cultural identities. Wedding clothes express not just individual tastes and personalities but also communal values: religion, politics, language, and aesthetic tastes. When a wedding spans two—or more—cultures, fashion can act as a bridge or buffer between them. While it would take several books to catalogue the full richness and diversity of wedding traditions and fashions around the world, this chapter will highlight hybrid wedding clothing throughout history that combines different cultures with (or within) mainstream Western wedding traditions.

"Cultural fusion" may be the latest trend in wedding planning, but cross-cultural weddings are nothing new. Royal families have been having them for centuries, celebrating the joining of dynasties, territories, and loyalties more than hearts. Royal grooms might wear the uniform, court dress, or medals and honors of their native land, or traditional regional styles like the Hungarian *mente* or the Bhutanese *gho* (see Chapter 2). Royal brides bring the best of their own countries' manufactures and traditions to their marriages—or pay tribute to their husband's homelands by dressing themselves from head to toe in its fashions.

PIONEER BRIDES

◆ ◆ ◆ ◆

In the nineteenth century—the age of empire and expansion—proxy and "picture" brides acted as pioneers, literally and sartorially. Rosa Criscillo married Antonio Moleta by proxy before traveling with her father and brother from Stromboli, Italy, to New Zealand, where she married him in real life at the Wellington Registry Office on May 5, 1909. She brought her lace-trimmed lilac silk wedding gown, made in Naples, in her luggage. Proxy marriages were especially common in Australia and New Zealand, as the government encouraged female immigration from Europe (primarily Greece and Italy) to redress gender imbalances. But they

also facilitated the influx of Asian women to the United States, to encourage foreign laborers to settle there, ensuring an agricultural workforce. In most cases, these brides were marrying men from their own countries, but they had never met them, and they were beginning their arranged marriages while also coping with a new culture, language, and climate.

Despite strict rules against fraternization, many war brides from Europe and Asia married American servicemen stationed abroad in the

ABOVE: Rosa Criscillo married Antonio Moleta by proxy before traveling from Italy to New Zealand with her lace-trimmed lavender silk wedding gown in 1909.

ABOVE: Yoshiko Ishikawa, a seamstress in Japan, probably made her own cream and silver brocade dress for her wedding to an Australian soldier in 1956.

twentieth century and returned with them to the United States. They often received training in English, American cooking, and fashion on military bases before they left, to ease the transition to their new homes; nevertheless, upon arrival, they were often treated as the enemy. Wedding pictures and surviving garments suggest that these women adopted American fashions for their weddings, though many took their native dress abroad as well, knowing that there was no possibility of returning home once they married foreigners.

This transformation of appearances and allegiances was replayed again and again around the world, as love blossomed from the ashes of war. Yoshiko Ishikawa was a seamstress and likely made the stylish cream and silver brocade wedding dress she wore when she married Australian soldier Victor Creagh in Tokyo in 1956. She was one of approximately 650 Japanese women who migrated to Australia as the wives of servicemen in the years following World War II, helping to relax the country's policy against non-European immigrants.

Neena Gada married her husband, Ram, in India in April 1967, wearing a traditional sari in green silk with metallic gold and orange brocade. It was an arranged marriage, and, just weeks later, in May, she moved to Minnesota, where her husband was already living and working as an engineer. The twenty-four-year-old

ABOVE: Neena Gada repurposed her wedding sari as an evening gown after moving from India to the United States in 1967.

bride "was really homesick," she remembered in an oral history taken by the Minnesota's Immigrants project. "At the time, in the Twin Cities, apparently, I was one of the first newlyweds who came to Minnesota from India." Everything Gada knew about America she'd learned from Perry Mason mysteries. She managed to locate a few other Indian brides, and together they began organizing Diwali celebrations and Gujarati dance classes. "None of us had winter shoes yet, snow shoes, so we went in our thongs," she remembered. Gada wore her wedding sari to Indian cultural events, but eventually converted it to a Western-style evening gown as she assimilated to life in Minneapolis. This allowed her to keep wearing the beautiful and meaningful garment while forging a new identity as a married woman and a proud Indian American.

ETHNIC ECLECTICISM
◆ ◆ ◆ ◆

For artists, activists, and nonconformists, ethnic garments and textiles have historically offered an attractive and "authentic" alternative to mainstream wedding fashions. Painter Frida Kahlo is known for her colorful, traditional, and Mexican and indigenous costumes with flowing skirts, elaborate hairstyles, and dramatic jewelry, immortalized in her many self-portraits. But photos of her before her marriage depict her wearing the plain, functional work wear favored

by young Communists, sometimes even wearing men's clothing. Her style changed on her wedding day in 1929, when she married Diego Rivera at the town hall in Coyocán, Mexico, wearing a traditional Mexican blouse, skirt, and *rebozo* (shawl) she had borrowed from her maid. Kahlo appreciated how the long, full skirt hid her legs, shriveled by childhood polio, and the brace she wore on her right foot, damaged in an accident. After the wedding, with Diego's encouragement, she began wearing similar clothing every day.

Ethnic garments and textiles of all kinds were integral to the counterculture movement and the hippie fashion aesthetic. The Peace Corps, established in 1961, encouraged a generation of young Americans to travel the globe, bringing back sartorial souvenirs that combined luxury and exoticism in a vibrant display of anti-fashion. Women wore caftans, ponchos, and djellabas while men adopted Nehru jackets and dashikis, often mixing ethnic influences indiscriminately. (Debates on cultural appropriation were decades away.) The dashiki, a unisex West African tunic with an ornate printed or embroidered V-shaped collar, became popular among African American activists and musicians as the "Black Power" movement of the 1960s and '70s revived interest in traditional African dress. In 1974, one American couple wore matching dashikis for their wedding, his in the traditional form of a long tunic, paired with a crown-like

OPPOSITE: Frida Kahlo wore traditional Mexican dress for the first time on the day she married Diego Rivera in 1929.

ABOVE: In 1974, at the height of the Black Power movement, this anonymous couple married in matching dashikis, unisex West African tunics with ornate V-shaped collars.

brimless kufi cap, part of the formal dashiki costume, and cuffed Western trousers and lace-up shoes. Her long caftan with dramatic cape-like sleeves had an intricate round collar and used the dashiki's V-shaped neckline as a decorative feature. Both wore their hair in natural Afro styles. Formalwear based on the dashiki continues to be a popular choice for African American brides, grooms, and promgoers.

BREAKING DOWN BORDERS

◆ ◆ ◆ ◆

Sensitive deployment of specific, culturally meaningful garments, designers, and colors can defuse controversy over cross-cultural weddings, signaling mutual acceptance of each other's backgrounds and traditions. The announcement of the engagement of Imran Khan and Jemima Goldsmith in 1995 "whipped up a media frenzy" in the United Kingdom, according to the *Independent.* The groom, forty-three, was a "playboy, aspiring politician and former Pakistan cricketer"; the bride was "the 21-year-old daughter of one of Britain's richest men." Though the half-Jewish bride had converted to Islam, the *Independent* reported that "the Metropolitan Police are prepared for the possibility that Islamic militants . . . may seek to disrupt the ceremony." Meanwhile, British tabloids speculated that the bride would have to adopt a traditional Muslim wardrobe and lifestyle, and even a new name.

For the civil ceremony at the Richmond Register Office outside London, the bride wore a long, white skirt suit by British designer Bruce Oldfield, a favorite of Princess Diana's, and a broad-brimmed hat. The outfit was reminiscent of Bianca Jagger's iconic wedding look, while conforming to Muslim modesty rules. The groom wore a traditional Pakistani *kurta* (a long, loose, collarless shirt) and vest. Later that evening, for the reception at the Goldsmith home, another royal favorite, designer Catherine Walker, dressed

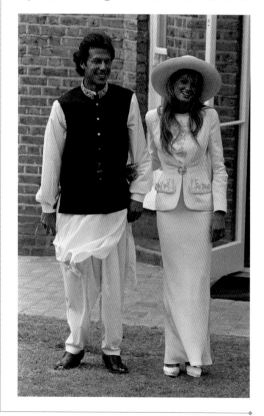

ABOVE: Imran Khan and Jemima Goldsmith honored Muslim tradition and British style in their 1995 wedding clothes.

the bride in a sky blue *salwar kameez* with white embroidery in a "tiara" pattern she'd used in her previous summer collection. The design was inspired by Queen Mary's "festoon and scroll" tiara created by Garrard in 1893 and "represented a European influence to contrast with the traditional dress of Pakistan," the designer wrote in her memoirs. The bride accessorized with a pearl dog collar necklace that echoed the standing collar on the groom's formal white *sherwani* (a knee-length coat) with gold trim. The expected protestors never materialized, and, without saying a word, the attractive, appropriately dressed couple pictured in magazines and newspapers around the world reassured both European and Middle Eastern audiences of their mutual respect as well as their intact individual identities.

Contemporary fashion designers from bicultural backgrounds have been instrumental in raising the bar for cross-cultural wedding attire. Samoan-born, New Zealand–based, half-Chinese bridalwear and pageant gown designer Paula Chan-Cheuk makes traditional Western-style gowns, but she also fuses traditional, organic materials like tapa (barkcloth), pandanus leaf, shells, and coconut fiber; Samoan Skiapo printing techniques; and Western and Eastern silhouettes to create gowns that marry diverse cultural traditions. For Jackie Leota-Ete's 1997 wedding, Chan-Cheuk dressed the bride in an off-the-shoulder, hourglass-shaped gown with

a bow and train in back, entirely made out of barkcloth, with a spray of coconut fiber in the bow. When Patisepa Seraphim Unasa-Samoa Saleupolu and Fiu Uesile Tala'imanu married in Manurewa in 2008, they both wore ensembles by Chan-Cheuk—hers in the form of a strapless gown with floral patterning and a fringed hem, his a Western-style button-front shirt with short sleeves and a sarong-like wrapped waist garment, or lavalava, worn by Pacific Islanders of both sexes. Both outfits are now in the Auckland Museum. Although the trees used to

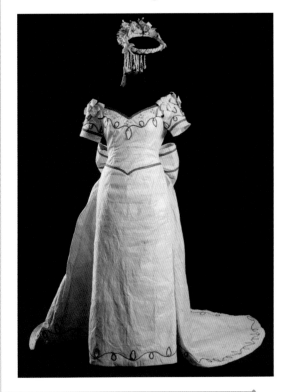

ABOVE: Jackie Leota-Ete wore a barkcloth wedding gown by New Zealand designer Paula Chan-Cheuk that combined diverse cultural traditions. **OPPOSITE:** Dutch artist and designer Claudy Jongstra created a strapless wedding gown inspired by a kimono for Japanese American bride in 2000.

→ 116 ←

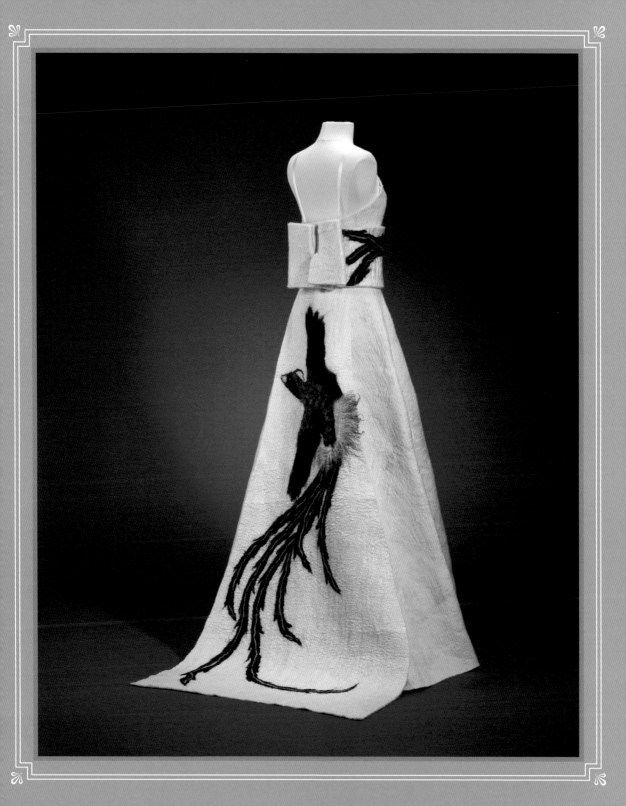

make tapa do not grow well in New Zealand, tapa cloth and garments hold great ritual and daily cultural significance for the Maori people and are imported from other Pacific Islands nations. Traditionally, it was presented as a wedding gift; today, it is more likely to clothe the bride, groom, or officiant.

Another designer fusing multiple cultural references is Dutch artist Claudy Jongstra. In 2000, Jongstra created her *Phoenix Gown* for a Japanese American bride. Its cascading design of a flame-red phoenix on a sweeping train combines the iconography of a traditional bridal kimono with a body-conscious, strapless silhouette in the Western style. While the kimono's volume hides the female form, this gown celebrates it. The train unfurls from an obi at the gown's waist. The phoenix is an auspicious symbol of good luck in Japanese culture, rising from its own ashes. This symbol of rebirth makes it especially appropriate for a transformative garment like a wedding gown. Red and white—the colors of the Japanese flag—are often worn by Japanese brides; together, they symbolize joy, but plain white wedding kimono are also worn to signify that a bride is both pure and a blank slate. Here, the red phoenix is felted into the white silk, literally weaving together Japanese and Western color symbolism.

In China, red is the color of good luck, happiness, and prosperity; brides usually wear a red qipao, or cheongsam. White, on the other hand, is the color of mourning. But Chinese brides are increasingly donning Western-style white gowns for part of their wedding celebrations. For her 2004 marriage to Lord Oxmantown, an Irish aristocrat, Chinese fashion designer Anna Lin Xiaojing designed her own wedding dress, blending Chinese and Western wedding traditions. The made-in-China strapless satin ballgown had an unmistakably Western silhouette, but it was

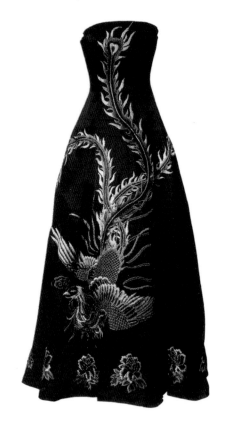

ABOVE: Chinese fashion designer Anna Lin Xiaojing designed her own gown in lucky red for her 2004 wedding to Lord Oxmanton, an Irish aristocrat.

in lucky red, embroidered with a spectacular phoenix motif. The groom, too, wore red satin—a traditional dragon robe and elaborate gauze cap. The couple also had the wedding blessed in Ireland, where the groom wore a morning suit and the bride wore a long, white silk gown of her own design, with dramatic bell-shaped sleeves and forty-five hundred pearls sewn along the seams.

FROM HOLLYWOOD TO BOLLYWOOD

◆ ◆ ◆ ◆

Increasingly, grooms are sharing in the creativity of cross-cultural weddings rather than sticking to those tried-and-true international go-tos: tuxedos, suits, and morning suits. *Walking Dead* actor Steven Yeun and his fiancée Joana Pak chose to honor their shared Korean American heritage at their 2016 nuptials in Los Angeles. While the Protestant ceremony was relaxed and low-key, the fashion was anything but: both wore modern versions of the traditional Korean hanbok. The bride's, designed by MeeHee Hanbok Couture, consisted of a flower-embroidered silver top and white tulle skirt, paired with Céline pumps. Bettl Hanbok designed the groom's charcoal and white robes, which he called "a Korean tuxedo." The guests dined on Korean American fusion cuisine, while a Motown band honored Yeun's other cultural roots: he grew up outside Detroit, Michigan.

When Indian actress Priyanka Chopra and American singer Nick Jonas married in 2018, both bride and groom wore traditional and hybrid Indian and Western wedding clothes in a heavily publicized multicontinent, multimillion-dollar series of ceremonies, showers, and celebrations. For the Christian ceremony at Taj Umaid Bhawan Palace in Jodhpur, the bride wore a custom-made lace Ralph Lauren gown covered in Swarovski crystals and 2,390,000 mother of pearl sequins, which took a total of 1,826 hours to complete. It combined traditional Western styling with the kind of elaborate, handcrafted surface decoration prized in India; though it had long sleeves and a high neck, the diaphanous fabric was anything but prudish. A piece of her mother-in-law Denise Jonas's wedding dress was sewn into it, along with embroidered phrases significant to the couple. She paired the ethereal dress with embellished Jimmy Choo heels and a dramatic seventy-five-foot veil suited to the regal outdoor setting; the groom wore a double-breasted black tuxedo.

For the couple's second, Hindu ceremony, the bride wore a custom-made red *lehenga choli* (an ankle-length, A-line skirt paired with a midriff-baring top) from Indian fashion designer Sabyasachi. "I always knew I wanted a red traditional silhouette for my wedding but Sabya brought in incredible French embroidery to the mix and with incredible jewelry and

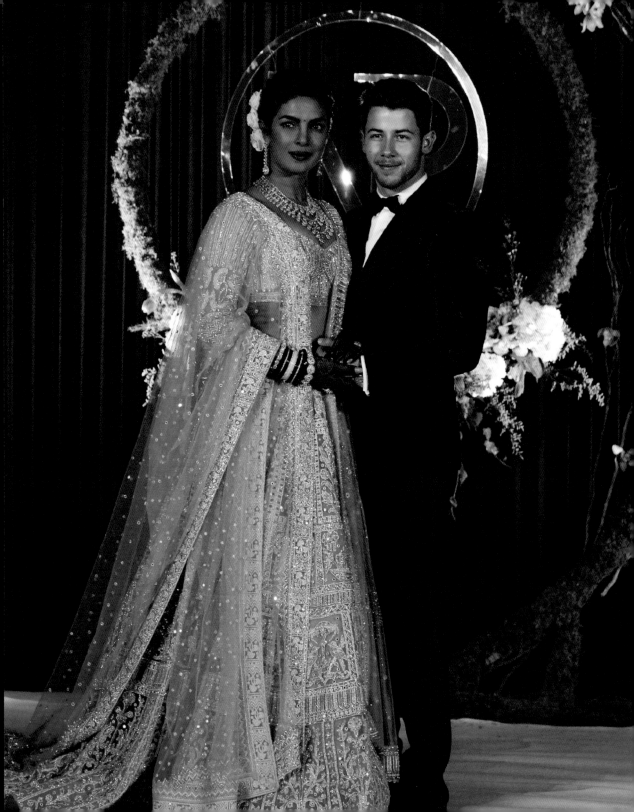

Western-inspired veil it was just such an amalgamation of who I am," Chopra told *People*. According to the magazine, it took 110 embroiderers in Calcutta a total of 3,720 hours to create the detailed garment, which was further embellished with hand-cut organza flowers, French knots in silk floss, Siam-red crystals, and the groom's name and the bride's parents' names sewn into the waistband. In Hindu wedding clothes, red signifies passion, prosperity, and fertility. At this ceremony, Jonas donned a gold, hand-quilted silk *sherwani* with an embroidered *dupatta* (scarf), accessorizing with a diamond necklace, a feathered turban (*safa*), and gold Christian Louboutin loafers. (For a pre-wedding ceremony, the Sangeet, he had worn a dark blue *sherwani*.)

Finally, for their official reception at the Taj Palace in New Delhi, Chopra wore another *lehenga choli* of champagne color by Mumbai luxury label Falguni Shane Peacock. It reportedly took twelve thousand hours to embroider the elephant, bird, flower, and butterfly motifs. She paired it with a show-stopping diamond bib necklace and pendant earrings, with white roses in her hair, and a *dupatta* over her arms. This time, Jonas wore a midnight blue velvet tuxedo, finding a happy medium between Indian luxury and American tradition.

Underlying the recent explosion of cross-cultural weddings is the fact that national dress of various kinds has experienced a revival in recent years, as younger generations have rediscovered *Tracht* in Germany, Highland dress in Scotland, *Hanfu* in China, the sari in India, and the kimono and the monastic *samue* in Japan. Touring museum exhibitions like *Native Fashion Now*, *Contemporary Muslim Fashions*, and *Kimono Refashioned* have introduced audiences to contemporary designers working in a culturally inclusive idiom. The exploitative appropriation of "exotic" weddings past—think Mick Jagger and Jerry Hall's Hindu wedding in Bali in 1989, or Jean-Paul Gaultier's Native American–inspired bridal gown, complete with war bonnet—has given way to a more respectful, personal, and nuanced marriage of tradition, modernity, and beauty. ◆

OPPOSITE: Priyanka Chopra and Nick Jonas blended Indian and American wedding fashion traditions for a series of celebrations on two continents in 2018.

WARTIME WEDDINGS

ALL'S FAIR IN LOVE AND WAR? WHEN it comes to wedding fashion—or, indeed, fashion of any kind—nothing upends hallowed traditions and long-standing social norms like war. Clothes that might be unthinkable for a wedding in peacetime become not just acceptable but patriotic in wartime. And, at times when large swathes of the population are in uniform, military details like decorative braid, frogging, and epaulettes often appear on wedding clothes as well as everyday fashions. Grooms (and brides) in the military may even marry in uniform; alternatively, they might wear clothes created or purchased in haste, amid significant upheaval and deprivation, using considerable ingenuity and unconventional materials. Through bombardments, deployments, and rationing, love conquers all.

The very act of marrying during the chaos and uncertainty of wartime makes a statement. When John Hancock, president of the Continental Congress, married Dorothy Quincy in the midst of the American Revolution, the *New York Gazette* applauded his patriotic confidence in a quick victory as "a great Compliment to American valour." Hancock family tradition holds that John was first attracted to Dorothy's dainty feet, and her low-heeled ivory silk wedding shoes have survived in the Bostonian Society. But their label—from the London firm of Bragg & Luckin—suggests a more complicated narrative. As historian Kimberly S. Alexander has pointed out, "it may seem surprising that Dorothy had donned products made by English cordwainers, but it was not uncommon—even for those who were deeply committed to the American Revolution—to wear goods manufactured in Britain." War makes strange bedfellows.

THE CIVIL WAR

◆ ◆ ◆ ◆

By the time the American Civil War broke out in 1861, wedding fashions had begun to deviate from everyday dress, and the white wedding was so firmly established that wartime exceptions to traditional dress and etiquette were conspicuous. When Dick Maury, commander of the 24th Virginia Regiment, failed to show up for his planned wedding to Sue Crutchfield in 1861,

his sister lamented: "Dick's wedding day and he is not at home! How entirely the condition of the country changes everything. Six months ago, a gentleman who failed to keep such an engagement would have been forever disgraced. Now it is scarcely a matter of comment." (After Dick missed a second wedding date on Christmas Day, the ceremony finally took place the following year, on July 17, 1862.)

On both sides of the conflict, weddings had to be scheduled around troop movements and unpredictable leaves. On April 4, 1863, *Harper's Weekly* reported on the wedding of Nellie Lammond and Captain DeHart of the Seventh New Jersey Volunteers, thought to be the first wedding ceremony performed in a military camp. "Few persons are wedded under more romantic circumstances," the article mused. "He could not get a leave of absence, so she came down like a brave girl and married him in camp" outside Fredericksburg, Virginia. This was no hasty roadside ceremony, but a carefully planned, passable imitation of a church wedding. "The camp was very prettily decorated, and being very trimly arranged among the pines, was just the camp a visitor would like to see." An altar of drums was erected under a canopy, flanked by troops arranged on all sides. The band played the "Wedding March" as the bridal party entered, the ladies appearing "to the unaccustomed eyes of the soldiers, like angels in their light clothing."

FOLLOWING: War correspondent Alfred R. Waud's sketch of the 1863 camp wedding of Nellie Lammond and Captain DeHart was published in *Harper's Weekly* magazine.

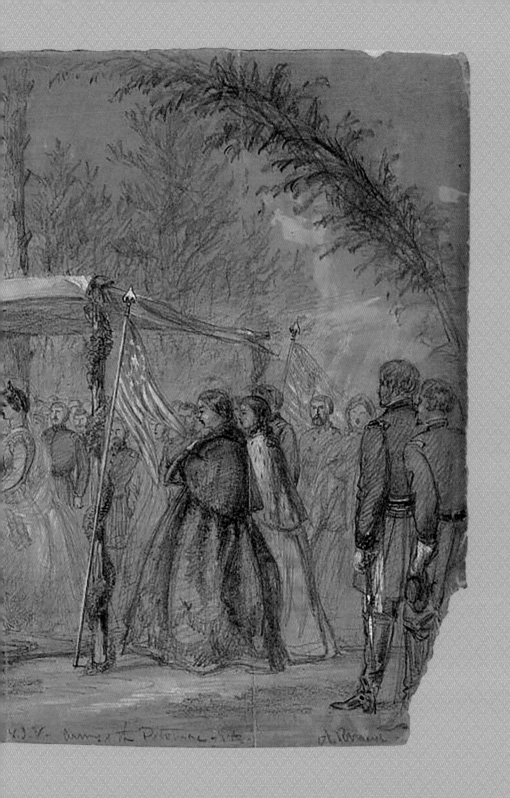

The ceremony was followed by a dinner, a ball, and fireworks. "On the whole it eclipsed entirely an opera at the Academy of Music in dramatic effect." Even allowing for some morale-boosting hyperbole on the part of the reporter, the ceremony demonstrates the importance of keeping up traditions and appearances during wartime, even on the front lines.

As the Civil War progressed, clothing became scarce, particularly in the South, where the North's blockade cut off imports. Struggling civilians scavenged for used clothes or bought overpriced goods on the black market; many sold their jewelry and clothes to survive, or had their homes and possessions appropriated by the Yankees. Some white wedding gowns were cut up to make Confederate flags. When Louisa McCord married, her mother swallowed her southern pride to purchase a few yards of exorbitantly priced white muslin from a Yankee merchant in Columbia, South Carolina—which had been thoroughly ransacked and burned by General Sherman—so Louisa could have a white wedding gown. The wedding took place at the bride's home because the family had no way to get to church, their buggy having been confiscated by the Union Army.

Grooms, of course, could wear their uniforms, perhaps with the addition of a white silk vest or cravat; this was not just a cost-saving measure but a point of pride. Though Captain James Tucker had been wounded in service of the Confederacy, he wore his uniform coat for his 1864 wedding to Virginia H. Bailey in Dioces, Florida. All of his groomsmen were likewise wounded servicemen. He intended to be buried in the coat, but, by the time he died, it was too small; instead, it ended up in the American Civil War Museum.

One of the most dramatic weddings of the Civil War was that of Lieutenant Colonel Walter Taylor, General Robert E. Lee's closest adjutant, in the early hours of April 3, 1865—the night Petersburg and Richmond fell to the Union Army. It was spectacularly bad timing, but Taylor had already secured permission to marry his fiancée, Bettie Saunders, and Lee allowed him leave to travel from Petersburg to Richmond so he could give Bettie "the protection of his name" before it was too late. "As his wife I could pass more safely through Union lines," Saunders wrote years later, in a pamphlet titled "My Wedding." Knowing an evacuation was likely, the couple had agreed to marry "at once" if it transpired, but the end came much sooner than anyone had expected. Walter telegraphed his brother in Richmond on Sunday morning: "I will be over some time today. See Betty and have her explain. Make all needed preparations." His brother found Bettie and asked what the message meant. "I have promised Walter to marry him if Richmond

has to be left to the enemy," she told him. "This means our capital is to be evacuated." She then went to Sunday services at St. Paul's Church, where she saw Confederate President Jefferson Davis being summoned from his pew, for reasons only she knew. Soon, however, alarm bells began to toll all over the city. Bettie went home and spent the rest of the day handing out food to retreating soldiers while she waited for Walter.

Meanwhile, in Petersburg, Walter ran to the station only to find that the last train for Richmond had already left; capitalizing on his status as Lee's right-hand man, he ordered the station agent to detach his only remaining engine from an ambulance train waiting to evacuate Petersburg's wounded soldiers to Richmond. Once aboard the locomotive, he instructed the engineer to overtake the Richmond train, which he finally caught and boarded three-quarters of the way to Richmond. He collected his family and the minister, arriving at the bride's house at 12:30 a.m. Instead of a simple, traditional church service, then, the ceremony was performed at home, in the dead of night, as retreating Confederates burned the city and looters ran wild in the streets. "Tears and sobs were the only music," Bettie remembered.

Bettie's friends had helped her find "a new black mouselaine [muslin], lined with grey linen that shone through" to wear as a wedding dress; one contributed a pair of white kid gloves. After

a "delicious repast," Walter—still wearing his uniform—returned to duty with the Army of Northern Virginia; he and Bettie's brother "were about the last persons to pass over the bridge to Manchester before it was set on fire." Hours later, the city surrendered to the Union Army. "No one who was in Richmond on Monday, the 3rd of April, 1865, can ever forget the terrors that beset us," Bettie remembered. "Shells were exploding everywhere, mothers were weeping for their boys and absolute misery reigned. . . . Words fail to depict the sorrow and woe that everyone felt." It was just a week later that General Lee surrendered at Appomattox, and Taylor returned to Richmond to collect his bride for their honeymoon.

Bettie was not the only Civil War bride to marry in black and gray, the colors of half-mourning. A half-mourning gown of gray silk wool poplin and black silk faille in the Metropolitan Museum of Art's collection was worn as a wedding gown—not because the bride was in mourning for a close relative, which would have precluded her marrying, but out of general mourning for the war's many casualties. It was a wordless and empathetic acknowledgment of the grief so many around the happy couple must have been feeling, and a reflection of the pervasive role mourning played in nineteenth-century lives and wardrobes, especially during wartime.

ABOVE: Amelia Jane Carley chose a gown in half-mourning colors for her wedding
to William Edward Chess in West Virginia in 1868, to honor the Civil War dead.

Before the Emancipation Proclamation, the marriages of the enslaved were not recognized by law, although many slavers promoted them because they believed they encouraged morality—and made running away less attractive. Enslaved people went through the motions of a religious ceremony, often dressed in sumptuous clothes borrowed for the occasion. When the Civil War ended, emancipated couples rushed to marry or legalize their marriages. Alfred R. Waud, an artist correspondent during the American Civil War, sketched the wedding of an African American soldier performed by a chaplain at the Freedmen's Bureau in Vicksburg, Mississippi; the Freedman's Bureau was established by Congress in 1865 to provide food, housing, medical aid, education, and legal assistance to the formerly enslaved. The sketch was subsequently engraved and published in *Harper's Weekly.* "A lady, looking at the sketch, thought the decent appearance of the party and the taste shown in the bride's apparel exaggerated for the sake of appearances," Waud wrote. "This however was not the case; the scene is just as it appeared." The groom wore "his best uniform" and the bride "a dress low enough to meet the requirements of the fashionable society of New York," Waud wryly noted.

Long after the war ended, the military influence on women's fashion persisted. When Louise Gertrude Jacobs married Harry G. Reyner in

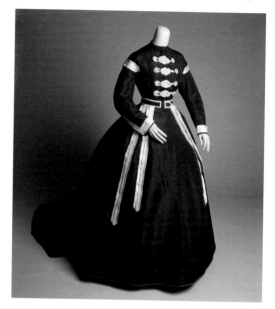

Macon, Missouri, in 1868, she chose a gown of red and white silk faille trimmed with swans down that combines a fashionable, ultra-feminine crinolined silhouette with military-influenced details like decorative braid and frogging. Though women did not serve in the military, wearing uniform-like clothing expressed their patriotism and solidarity—and commemorated their shared sacrifices.

THE WORLD AT WAR

◆ ◆ ◆ ◆

At the outset of World War I, brides were encouraged to dress well to boost morale. But there was a subsequent backlash against the perceived frivolity of fashionable finery, as well as a

ABOVE: Gertrude Jacobs' 1868 wedding gown illustrates the fashion for military styling that persisted even after the Civil War ended. **FOLLOWING:** Harper's Weekly printed Alfred R. Waud's depiction of the wedding of an African American soldier in Vicksburg, Mississippi, in 1866.

shortage of materials. The tiny buttons beloved by Victorian and Edwardian brides were replaced by loose-fitting gowns that slipped on over the head, cinched by a sash at the waist. With servants conscripted for the war effort, elaborate corsetry and coiffures fell from fashion. The slimmer silhouettes and simpler hairstyles demanded close-fitting veils, perched low on the forehead. Grooms wore uniforms.

Although marriage rates dropped alarmingly during and immediately after World War I as immense casualties caused a shortage of eligible young men, there was widespread concern about "hasty" wartime marriages. Thanks to the popularity of pen pal programs and "lonely hearts" or "matrimonials" classified ads, these marriages often took place between couples who had never met face-to-face. "Should soldiers propose to girls they have not seen?" the *Liverpool Echo* asked in July 1918.

The unpredictable deployments and material privations common to wartime were heightened and magnified on a global scale during World War II, when breaks in both local and international supply chains wreaked havoc on wedding traditions. Silks from China and Japan were unavailable to Western brides; nylon and leather were also scarce, being reserved for military use. Many brides walked down the aisle in shoes with clunky wedge heels of cork or wood. Couples resorted to leaving church on pedicabs and donkeys because gasoline was precious. Receptions were often potluck affairs. Even wedding cakes were a rare luxury, due to the scarcity of ingredients like eggs and food coloring. Throwing rice and pealing church bells were casualties of war.

There were more weddings in Britain in 1939 than in any other year in recorded history, as war loomed and finally broke out, and couples rushed to marry, not knowing what the future held. In war-torn London in April 1941, at the tail end of the Blitz, Deborah Mitford—the youngest of the six "Mitford sisters"—married Andrew Cavendish, the second son of the 10th Duke of Devonshire; he would unexpectedly inherit the title and the family seat, Chatsworth House, after his older brother was killed in action.

Their wedding plans came together in a climate of austerity and uncertainty. The church had narrowly escaped the Blitz, but the ballroom where they planned to hold the reception suffered damage when an air raid shattered the windows, shredding the curtains. The bride's mother tacked up sheets of wallpaper to cover them. She also managed to get hold of some champagne, though the wedding cake had no icing because of sugar rationing. There were no pages or bridesmaids, but the bride wore a gown from London's preeminent designer. "Victor Stiebel made me a dream of a dress from eighty yards of white tulle," Mitford recalled in her

memoirs. "I never thought I should own such a thing, and had we been married six weeks later I could not have done: clothes rationing came in and my dress would have taken several years' worth of coupons." Her father gave her away in his Home Guard uniform, and Andrew wore his Coldstream Guards uniform.

After the wedding, the groom had to report for duty and the bride for war work, but they squeezed in a quick honeymoon at Compton Place, the groom's family's country home in East Sussex. Because of its strategic location, access to the area was restricted, and the estate's lawns and tennis courts were overgrown as all the gardeners had been conscripted. It was "a week of intensive air raids," Mitford remembered. "All night long the German planes throbbed overhead on their way to London—a constant drone of engines bent on their mission to destroy."

WEDDINGS ON THE RATION

◆ ◆ ◆ ◆

Due to the demand for uniforms and other military textiles during World War II, civilian clothing supplies were highly regulated and restricted. The United Kingdom began rationing clothes on June 1, 1941, having already put gas and certain foodstuffs "on the ration." To buy clothes, you needed coupons as well as cash. Each type of clothing had a coupon value: eleven coupons for a dress, for example, or two

for a pair of stockings. By the end of the war, the adult coupon allowance had shrunk to just thirty-six per year. Furthermore, clothes produced during the war had to conform to the Utility Scheme—a government program designed to minimize material wastage while ensuring fair prices and consistent quality standards. The Utility Scheme placed strict limits on sartorial extravagances like pockets, trimmings, pleats, linings, cuffs, and seam allowances. Though the war ended in 1945, rationing continued until March 15, 1949.

Clothing rationing hit brides particularly hard. When Princess Elizabeth announced her engagement to Philip Mountbatten in 1947, people across the country sent her their coupons for her wedding dress. She returned them all, using her own (plus two hundred gifted by the British government) to purchase her satin and lace Norman Hartnell gown. Her royal wedding was the exception, however; most wartime weddings were more subdued affairs, out of tact if not necessity, and this austerity lingered long past the armistice. Many war brides borrowed gowns from friends, rented them, made them out of unconventional materials like silk or nylon parachutes, or chose day dresses that could be worn again. While some brides happily married in uniforms or simple skirt suits, others went to creative extremes to obtain long, white wedding gowns.

Audrey Stokes had just a week to plan her 1940 wedding to RAF Flying Officer Hugh Verity when he was granted a rare forty-eight-hour leave. Though they had a church ceremony in Gloucestershire, she felt that a white gown would be inappropriate, so she chose a dress, jacket, and matching hat of Air Force blue lined in pale pink; hats, which were not rationed, were popular among wartime brides. Her bouquet included red cabbage leaf, commonly grown in Victory Gardens. The groom wore his uniform.

When florist Elizabeth King married Rowland Absalom in London in 1941, her dressmaker, Ella Dolling, made her gown out of curtain material, which wasn't rationed. King later removed the sleeves from her yellow and white flowered brocade gown so she could wear it as an evening gown—an example of the "make do and mend" mentality promoted by the British government.

Couturier Pierre Balmain traveled back and forth from Paris to London in 1946 to make his first wedding gown. As the daughter of the Argentine ambassador, the bride, Stella Carcano y Morra, was exempt from the currency restrictions introduced at the beginning of the war to prevent large quantities of sterling from leaving the country; these "exchange controls" had made it virtually impossible for English brides to buy French couture gowns. That wasn't all they couldn't get. As well as the bride's and bridesmaid's dresses "in huge boxes bearing the embassy's diplomatic seals," Balmain delivered three hundred bottles of French champagne for the reception, he remembered in his autobiography. "I reveled in the reflected prestige of the numerous seals, the official documents, the diplomatic privileges ensuring the entry of these treasures into a London still in the grip of austere rationing." The gown was "white faille, with the corsage quilted in diamond shapes and richly embroidered with pearls." Instead of a crown of flowers in her hair, the bridge wore "an embroidered silk pillbox to which was fixed a long tulle veil"; instead of a bouquet, "the bride's hands were hidden in a large ermine muff." The bridesmaid wore "a simplified version of the same dress," while the groom, Viscount Ednam, wore his uniform. The wedding, Balmain testified, was "a ray of sunshine in the grey, austere London life of 1946."

Rachel Ginsburg married Walter Foster in London's Brondesbury Synagogue on January 4, 1949, just weeks before the end of rationing. Ginsburg had served in the Women's Auxiliary Air Force (WAAF) but found her secretarial duties "extremely boring," she confessed in a 2008 oral history taken by the Imperial War Museum. When the war ended, she seized the chance to study social science at the London School of Economics, funded by a modest government grant. Most of the students were fellow veterans. "That was a wonderful time, after the war," Ginsburg

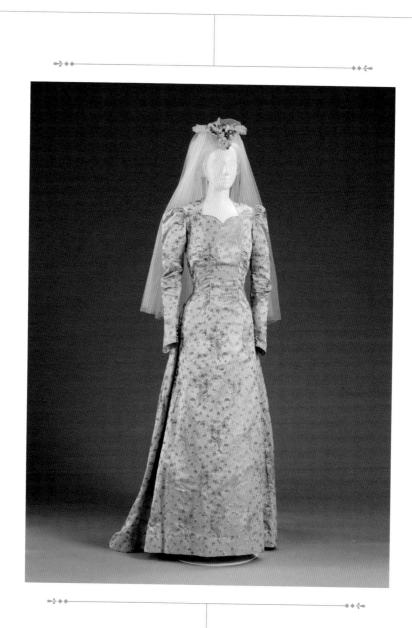

ABOVE: Ella Dolling used curtain material, which wasn't rationed, to make
Elizabeth King's World War II wedding gown, later altered for evening wear.

remembered. "You were still alive! For me, life was beginning." Ginsburg met her future husband, Walter, through the school's Jewish Society. He had his own war stories: born in Vienna, he had come to England as a fifteen-year-old refugee in 1938. When war broke out, he was interned as an "enemy alien" before being allowed to enlist, serving as an interpreter in occupied Germany.

Like all demobilized servicemen and servicewomen, Ginsburg received a sensible "demob" suit. "You had to go to a depot, give back your wonderful uniform," she remembered. "You could choose from a rail of various rather disgusting-looking clothes"—in her case, "a brown tweed suit which Walter always hated. It wasn't very nice, but it was the only one I had." Small wonder, then, that Ginsburg selected a stylish, sophisticated, anything-but-sensible red ensemble for her wedding. She purchased the £22 wool and mohair suit at Liverpool's Bon Marché department store, using clothing coupons donated by the couple's classmates. The straight skirt and unlined jacket conform to wartime austerity regulations, and the black silk braid gives it a military air. But the shawl collar, pinched waist, and extravagant peplum betray the influence of Christian Dior's New Look, launched in 1947. Ginsburg had never seen anything like it. She wore this glamorous garb with a small net veil on her wedding day and, undoubtedly, on many days afterward.

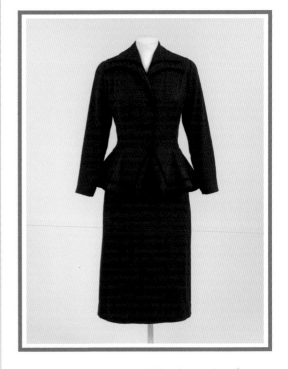

When a white gown could be obtained, it often did double duty, serving several brides or outfits. Winifred Maryon, who worked for the Royal Navy in a civilian capacity, borrowed a gown of patterned white velvet from a coworker's sister, and "a long, trailing veil with embroidery" from a different coworker. She used extra coupons, "which I had begged from someone" to buy her bridesmaid's dress, and a cousin gave her fabric for her going-away dress. "Was it the wedding I dreamed of? Oh no!" she recalled. "To cap it all, we discovered when we arrived at the church that it had been bombed the previous Wednesday. It was

ABOVE: Rachel Ginsburg swapped her drab demob suit for this glamorous red ensemble to marry Walter Foster in London's Brondesbury Synagogue in 1949. **OPPOSITE**: Evelyn Higginson loaned her white wedding gown—a rarity in wartime—to more than a dozen other brides.

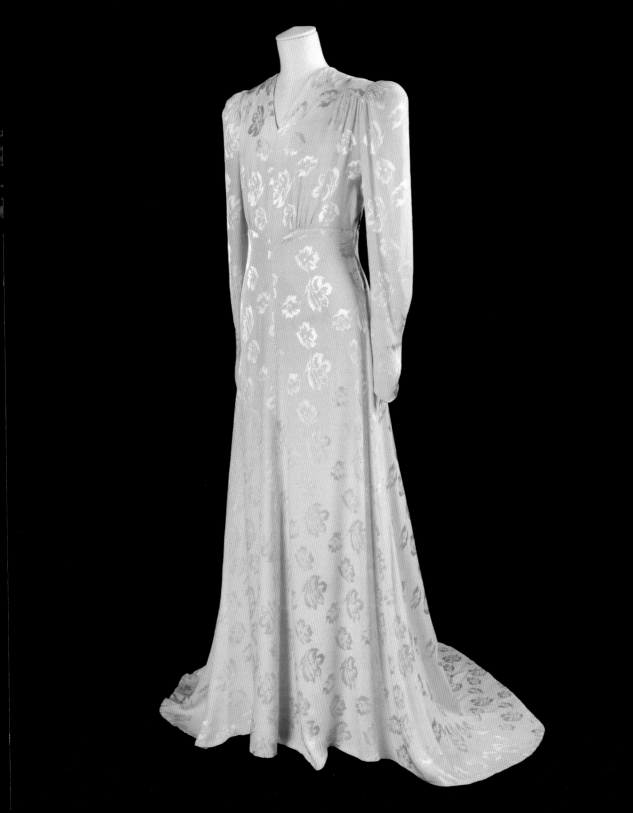

badly damaged, certainly enough to let the rain in, so while we were standing at the altar the verger was behind me with a broom, sweeping the rainwater to keep it away from the hem of my dress."

Eileen Stone, who served in the Land Army, made her wedding dress from a parachute used by her fiancé, Leslie Speller, a Royal Air Force pilot; after their 1945 wedding, she cut it up, dyed it brown, and used it to line a coat, reserving an undyed piece to make an embroidered handkerchief—a small souvenir of her wedding day. In 1943, Evelyn Higginson secured some pre-war silk intended for petticoats to make a long, V-necked gown for her wedding to sailor Charles Butterfield. It was subsequently worn by her sister, a family friend, and at least twelve other women—most of them WRENS (members of the Women's Royal Naval Service), who needed a dress on short notice before their servicemen fiancés deployed.

Another Land Girl, June Barrow, married at the Norwich register office on May 5, 1945. She chose the date because it was her parents' wedding anniversary; as it turned out, it fell three days before VE Day. "There was no question of a big church wedding in white with bridesmaids, which of course I had always dreamed about," Barrow remembered. "First of all you couldn't buy the material for a wedding dress, there wasn't any around. You couldn't get any

dress at all—by 1945, you only got 45 coupons a year for your dress ration and a coat and a dress cost over 30." Instead, her mother made her a blouse "out of a silk tea gown of hers that she had hardly ever worn, and over it I wore a grey suit with a peplum and a plum-coloured felt hat, one of those saucy peek-a-book hats with the dipping brim." The groom borrowed an army uniform from a friend because "his own was in tatters"; he had been shot in both legs and walked to the ceremony on crutches.

AMERICA AT WAR

◆ ◆ ◆ ◆

The United States took a different approach to clothing shortages. Regulation L-85, issued by the War Production Board in 1942, limited color and fabric options and placed restrictions on yardage usage, in a conservation effort similar to the Utility Scheme; rubber, silk, nylon, and leather virtually vanished from civilian dress. But while gas and food were rationed in America, clothing never was. And wedding dresses were declared exempt from Regulation L-85 after the American Association of Bridal Manufacturers lobbied Congress to ease restrictions in the name of boosting morale. In 1943, the New York Dress Institute took out a full-page ad in *Bride's Magazine* declaring: "Your government has recognized the importance of preserving the traditional bridal gown." Rather than a selfish

indulgence, a white wedding was presented as a patriotic imperative, and marriage rates soared during the war. In 1942 alone, 1.8 million weddings took place, up 83 percent from ten years before, to take advantage of short leaves as well as draft deferments for married men. The nationwide rush to the altar prompted one rector, Rev. Dr. Randolph Ray, to publish a book titled *Marriage Is a Serious Business*, warning young couples that "the hasty marriage, caused by glamour and excitement rather than by genuine affection, is one of the evil products of war." By implication, white weddings—with all the trappings of tradition and respectability, and the attendant expenses—led to happier, more stable marriages.

Nevertheless, many American women chose to be married in day dresses or military uniforms, either out of thrift or patriotic austerity; even *Bride's Magazine* proposed "bridesy" suits as an alternative to white gowns. Formal wedding gowns disappeared from the Sears catalog after 1942. Unpredictable deployments meant many weddings were small, last-minute affairs. When Theodora Roosevelt—granddaughter of former President Theodore Roosevelt—married Tom Keogh in 1945, the *New York Times* noted approvingly that the couple had "dispensed with attendants" in a ceremony "witnessed only by immediate relatives" followed by "a small reception" at the bride's aunt's home. Instead of a white gown and veil, the bride wore "a brown faille suit, and straw hat with brown veiling."

At a time when the movies offered Americans both patriotism and escapism, many brides chose designers with cinematic connections for their moment in the spotlight. Jeanne LaSalle bought a gray rayon dress by Hollywood costume designer turned fashion designer Adrian at Marshall Field in Chicago for her 1945 wedding at the Drake Hotel. And Marilyn Maxwell turned to another Hollywood veteran, Irene, for a suit for her 1948 wedding to Dr. Harry Fox at the Netherland Plaza Hotel in Cincinnati.

For her 1944 wedding to Merchant Marine Herbert Alan Leeds, Dorothy Samuelson wore her Navy WAVES uniform; the acronym stood for Women Accepted for Voluntary Emergency Service. Dorothy was the WAVES officer in charge of uniforms; she recalled that "between February 1943 and August 1945, my department put 90,000 women in navy blue." While a uniform was a patriotic choice for those who enlisted in the newly created women's service branches, the WAVES uniform had unique fashion cachet. Hoping to avoid the negative press that had greeted the army's ill-fitting and unattractive Women's Auxiliary Corps (WAC) uniforms, the navy had recruited Chicago-born couturier Main Rousseau Bocher—known in Paris as Mainbocher—to design uniforms that were both fashionable and functional. With its

navy blue hue, brass buttons, and embroidered propeller and anchor, the officer's uniform drew upon naval tradition without mimicking men's uniforms—or sacrificing style. The padded shoulders, pinched waists, and shapely collars—Mainbocher's signature—were fashion details that set the WAVES apart from the WACs. "We . . . loved those uniforms, as did the public," Captain Winifred Quick Collin testified. "My earlier concern about wearing a man's uniform vanished the moment we received our attractive, feminine Mainbocher designs." This chic uniform was the navy's secret weapon for

recruiting women to its new service branch. In January 1943, the *New York Times Magazine* declared: "The 'best dressed women of the year' are the women who are wearing uniforms." And syndicated fashion columnist Dorothy Roe quipped: "Uncle Sam's sailor girls can now look the Duchess of Windsor in the eye and say: 'I believe we have the same dressmaker.'"

The parachute gown was another patriotic option that didn't sacrifice style. When Ruth Lengel took the leap with Major Claude Hensinger in Neffs, Pennsylvania, in 1947, she wore a gown made from the same nylon parachute that had saved Hensinger's life after the B-29 he was piloting caught fire following a bombing raid on Japan in 1944. When he proposed to Ruth, he offered her the material for her gown. Ruth hired a local seamstress to make the bodice; the skirt, which Ruth made herself, had a train created by adjusting the parachute strings.

Similarly, radio operator Les Bourland had to bail out over Germany when his plane was hit during Operation Varsity in 1945. His parachute sustained several bullet holes and served as a blanket until he was rescued by Allied troops. Upon returning home to San Antonio, Texas, he met Rosalie Hierholzer. When they got engaged, Rosalie's aunt offered to make her wedding dress out of Les's battle-scarred parachute, carefully cutting around the bullet holes.

ABOVE: Dorothy Samuelson married Merchant Marine Herbert Alan Leeds in a suit designed by the famed couturier Mainbocher: her Navy WAVES uniform.

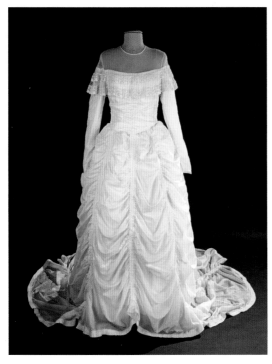

Joyce Adney's boyfriend, a marine, found several unused Japanese cargo parachutes when he participated in the invasion of Saipan in 1944. He sent one to Joyce; when he was discharged the following year, he proposed, and Joyce's mother made her wedding gown out of the parachute silk.

TRADITION AND TURMOIL

♦ ♦ ♦ ♦

Some wartime wedding gowns tell heartbreaking stories, like that of Violet Lloyd, who married Alan Glover just five days after he enlisted in the Second Australian Imperial Force in 1941. After a ten-day honeymoon, he left for basic training, then shipped out for Malaya. It was the last time the couple saw each other. Alan was captured by the Japanese in March 1942 and executed after attempting to escape from a Burmese labor camp on June 6. Violet did not learn his fate until December 1944. She never remarried, keeping her white lace wedding dress in its original box until her death in 2003.

Family separation and displacement are grim features of civilian life during wartime, yet weddings bring joy even in these sad circumstances. In Manzanar in the California desert—one of the ten internment camps opened for Japanese Americans after Pearl Harbor—Chiyomi Marumoto married James Kaz Ogawa in 1944, wearing a gown designed and made by her aunt, a professional seamstress, from fabric ordered by mail. Five other women detainees would wear the dress before the camp was emptied in 1945.

Lili Lax's wedding dress saw even more use; it was worn by her sister, her cousin, and several more women in the Bergen-Belsen displaced persons camp, primarily occupied by Jews liberated from the Bergen-Belsen concentration camp. Lili—who had been sent to Auschwitz twice, as well as Bergen-Belsen—stopped counting at seventeen brides. Lili dreamed of being married in a white dress,

ABOVE: Ruth Lengel made her wedding gown out of the nylon parachute that had saved the life of her fiancé, a B-29 bomber pilot, during World War II.

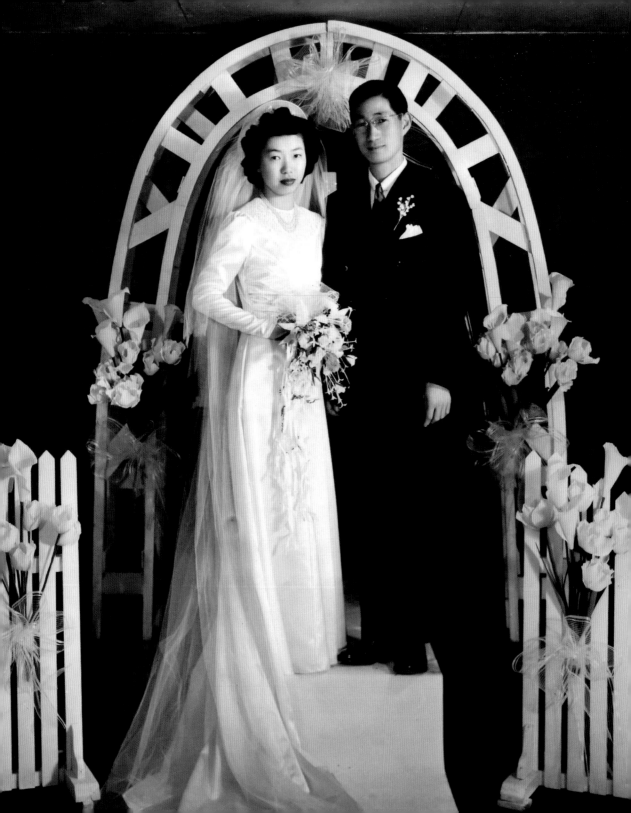

so her fiancé, Ludwig Frydman, a fellow Czech she met in the camp, bartered two pounds of coffee and cigarettes for a white silk parachute from a former German airman. Lili used her cigarette rations to hire a fellow survivor who had been a professional seamstress to sew it into a gown with a high neck and full sleeves, using the leftover material to make a shirt for Ludwig. They married on January 27, 1946, in a synagogue in Celle, which had somehow survived the war more or less intact.

Tradition is a powerful antidote to turmoil; in extraordinary circumstances, mere ordinariness feels like a victory worth fighting for. When

Ruby Britsch married Gary Scheuing in 1968, the bride wore a long white gown of satin and lace and a matching veil, the bridesmaids wore dresses from Sears, and the guests celebrated with a champagne toast, cake, and dancing to a live band. But the venue was an air base chapel in Plieku, Vietnam, where the bride, an army nurse, and the groom, a major in the 20th Engineer Battalion, were both stationed. Instead of her father, the bride was escorted down the aisle by the lieutenant colonel in charge of her MASH unit; instead of a getaway car, the couple rode an army bulldozer. Amid the fog of war, a ray of light. ◆

OPPOSITE: Chiyomi Marumoto married James Kaz Ogawa in the Manzanar internment camp in 1944, wearing a gown her aunt, a fellow detainee, made from mail-order fabric. ABOVE: Ruby Britsch and Gary Scheuing rode to their 1968 wedding reception in Pleiku, Vietnam, on a bulldozer, an army engineer tradition.

REMARRIAGE

wedding. Brides and grooms feel free to dress according to their own preferences rather than strict social etiquette, regardless of how many times they've been down the aisle. Once again, however, this is not an entirely modern phenomenon. Before the twentieth century, it was depressingly common to lose one's spouse to war, disease, or child-birth. Early marriages and large age discrepancies between husband and wife were common, leaving many women young widows. Remarriage was expected and encouraged, as long

It was only with the growing popularity of the white wedding—which solidified in the 1890s—and the growing availability of divorce in the early twentieth century that remarriage became a controversial matter to be mitigated by fashion. It was divorce, not remarriage, that was taboo; hence, a sharp divergence emerged between the clothes worn for first marriages and later marriages. In the modern era of "conscious uncoupling," it may be difficult to appreciate just how stigmatized divorce once was. Despite King Henry VIII's best efforts, divorce and its corollary, remarriage after divorce, remained controversial, partly because a divorce could only be obtained by providing evidence of truly deviant behavior: adultery, cruelty, rape, drunkenness, insanity. Most churches refused to marry divorced people; divorced women, especially, were ostracized in social settings, but men's careers could suffer from the scandal. As the 1947 book *ABC of Divorce* pointed out, employers perceived "with some justification, that a divorced person is not as steady or satisfactory an employee as a married one." Outside the office, divorce was viewed as not just a personal moral failing but a disgrace to one's entire family.

The political arena is a useful barometer of changing attitudes toward divorce in America. When the future President Gerald Ford—then running for the House of Representatives— married his wife, Betty, in 1948, he worried that

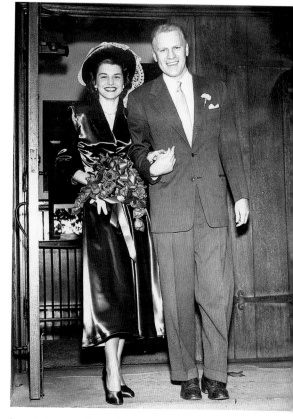

her status as a divorcée might harm his chances of getting elected. When he ran for president in 1952, Illinois Governor Adlai Stevenson was thought to be unelectable due to his divorce; New York Governor Nelson A. Rockefeller's divorce (and subsequent remarriage to a divorcée) likely cost him the Republican nomination in 1964. It was not until 1980 that Ronald Reagan became the first divorced man elected to America's highest office.

ABOVE: Gerald Ford worried that marrying Betty Warren, a divorcée, in 1948 might hurt his fledgling political career.

REWRITING THE RULES

◆ ◆ ◆ ◆

Without any clear playbook for the growing new bridal demographic of divorced men and women, early twentieth-century fashion magazines and etiquette manuals began offering advice on appropriate dress, accessories, and attendants. After the crushing losses of World War I, mourning etiquette had been relaxed to the point that widows were able to cease wearing black and remarry quickly; one year was generally considered sufficient. Existing etiquette for widows and widowers was merely extended to divorcés and divorcées; whatever the reason for the remarriage, it was agreed that the dress of all the parties involved should be distinct from a first marriage. In April 1920, *Vogue* counseled that neither a widow nor a divorcée should "claim any of the prerogatives of the maiden bride. Neither snowy robe and veil nor orange-blossoms may appear on the scene, but the bride for a second time may present a charming picture in a very lovely afternoon gown and an appropriate hat." Etiquette books frequently proposed similar alternatives to traditional symbols of youth and virginity: a hat or flowers instead of a veil, a corsage or prayer book instead of a bouquet, a dress of gold or silver brocade instead of white. "She need only avoid girlish clothes," *Vogue* advised in 1922. Bridesmaids, too, were considered inappropriate: "It is more suitable for her

to appear alone with her father, or brother, or whatever relation is to give her away," though the groom, "even if he were a widower, might have a best man."

By 1930, however, public opinion of divorce (and specifically divorcées) had "broadened considerably," *Vanity Fair* admitted. "No longer is the divorced woman looked at askance by moral people, no longer is she shunned by them." This was partly due to social factors: as women gained the vote and entered the workforce, they no longer needed men for financial stability and legal protection. Many young women postponed marriage or rejected it altogether; divorce rates spiked. But the trend was also the result of the mediating influence of Hollywood films, which frequently played divorce for laughs. Norma Shearer won an Oscar as *The Divorcee* in 1930. *The Gay Divorcée*—a movie about a woman who hires a fake lover to obtain a divorce from her boring husband—was released in 1934, as was *It Happened One Night*, in which a spoiled heiress elopes with one man, immediately falls in love with a different one, obtains an annulment, and remarries. In 1940, Cary Grant remarried his antagonistic ex-wife in both *The Philadelphia Story* and *His Girl Friday*—a plotline that conveniently both normalized divorce and reinforced traditional marriage.

Onscreen, divorce was glamorous, sophisticated, and—usually—temporary, because a

Hollywood ending depended on the divorced characters either remarrying or reconciling. Offscreen, too, divorced women had the freedom to remarry in fashionable clothes they actually wanted to wear (and expected to wear again) rather than lamenting the elaborate trappings of a traditional church wedding. Divorcées chose wedding dresses in novel colors and textures and trendy silhouettes. As older, more mature, and financially independent women, they embraced expensive designer labels and daringly sensual styles. Again, Hollywood led the way; when, in 1920, matinée idols Mary Pickford and Douglas Fairbanks divorced their respective spouses and promptly married each other, adoring crowds mobbed them on their honeymoon. (Their Beverly Hills marital home, dubbed Pickfair, was an early celebrity-couple portmanteau.) The much-publicized remarriages of divorced stars like Marilyn Monroe, Ava Gardner, and Elizabeth Taylor lent second-time brides social acceptance as well as providing them with fashion role models.

A FOUR-TIME BRIDE

♦ ♦ ♦ ♦

Postum cereal heiress Marjorie Merriweather Post married (and divorced) four times between 1905 and 1964. In fact, she and her three daughters had sixteen marriages between them. With all the attendant, mother-of-the-bride, bridesmaid, and flower girl dresses, their wardrobes encompassed an entire century's worth of elite wedding fashion—much of it still preserved at Hillwood, Post's Washington, DC, estate.

For her first wedding—to Edward Bennett Close in 1905—the eighteen-year-old bride wore a high-necked gown steeped in Edwardian fussiness and formality. The white satin and silk organza confection by prestigious New York dressmakers Hitchins & Balcom was overlaid with *point d'Angleterre* lace; it had girlish short, puffed sleeves, floral appliqué, a bow of rhinestones and pearls at the waist, and a discreetly bustled train. A lace-trimmed ivory damask corset with whalebone ribs and gold hooks created the fashionable "monobosom" silhouette. White kid gloves modestly covered Post's arms. As befitting "the richest young woman in the United States," as the *New Yorker* called her, she wore diamond earrings (a gift from her father), a strand of pearls, and a diamond sunburst necklace (a gift from "Eddie"). A wreath of wax orange blossoms perched atop her Gibson Girl pompadour, anchoring a full-length silk tulle veil. Ironically, the couple chose to have a small ceremony at Manhattan's Grace Church, with no reception, because the bride's father, C. W. Post, had recently married his much-younger mistress after divorcing Marjorie's mother—an outrageous scandal at the time.

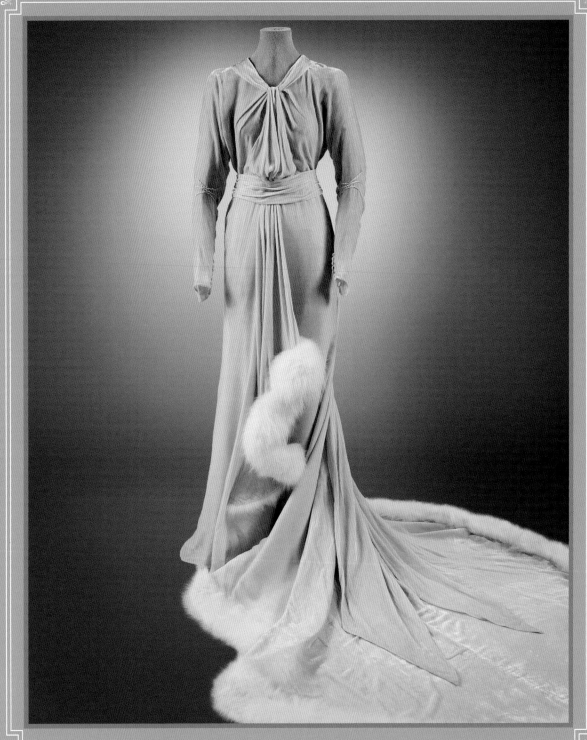

For her second wedding, to widowed stockbroker E. F. Hutton in 1920, Post embraced the dramatically different silhouette of the postwar era, ensuring a stylistic divorce from her first marriage. Instead of a long, white gown, she chose a diaphanous, tea-length afternoon dress of periwinkle blue organza by London designer Lucile, the pioneer of the so-called "lingerie" dress. While it had appliquéd flowers and inset bands of lace, the sheer fabric and low, lace-trimmed neckline was anything but virginal. Instead of a veil, Post wore a broad-brimmed picture hat; her two young daughters, who served as attendants, wore matching Lucile dresses and hats of a similar style. The wedding was a quiet ceremony at home—in Post's fifty-four-room Fifth Avenue penthouse, that is.

The penthouse was once again the venue for Post's third wedding, to Washington lawyer Joseph E. Davies, in 1935. For the December nuptials, Post wore a glamorous long-sleeved gown of peach velvet trimmed in white fur. With its seven-foot fan train, the Bergdorf Goodman creation combined Hollywood glamour and fairy-tale fantasy. Though the V-neckline was modest, the dramatically draped, gored, and gathered silk velvet clung to the forty-seven-year-old bride's statuesque figure. She wore no veil, but carried an enormous, cascading bouquet of moth orchids. Her two youngest daughters served as attendants, wearing shimmering empire-style

gowns of ice blue satin with short tulle veils anchored to crescent-shaped, beaded headdresses—all created by Veronica, a theatrical costume house. For her fourth and final wedding, to Herbert A. May in 1958, Post wore a knee-length pale blue dress trimmed with lace by Czech-born New York designer Oldric Royce.

THE GREATEST LOVE STORY OF ALL TIME

◆ ◆ ◆ ◆

Pastel wedding gowns were in vogue in the late 1930s, for first-time brides as well as divorcées (see Chapter 4). The trend was undoubtedly fueled by one of the most famous divorcées of the day, Wallis Simpson, who married her third husband, the former King Edward VIII, on June 3, 1937. He had abdicated the British throne to marry the American, famously declaring: "I have found it impossible to carry the heavy burden of responsibility and to discharge my duties as king as I would wish to do without the help and support of the woman I love." The abdication crisis unexpectedly put his brother, George VI, on the throne—and, later, George VI's daughter, Queen Elizabeth II.

"I'm not a beautiful woman," Simpson once confessed. "I'm nothing to look at, so the only thing I can do is dress better than anyone else." Long before her wedding, she was a fashion icon. Even with a coronation looming, *LIFE*

OPPOSITE: Marjorie Merriweather Post wore a peach velvet Bergdorf Goodman gown trimmed in white fur for her winter wedding to her third husband in 1935.

magazine reported, "women of the world were little absorbed in the conventional satin gowns of England's new queen. What Mrs. Wallis Warfield Simpson would wear, however, roused their avid curiosity." Although she patronized a who's-who of couturiers, including Elsa Schiaparelli, Hubert de Givenchy, and Madame Grès, legendary *Vogue* editor Diana Vreeland testified that the Chicago-born, Paris-based

couturier Mainbocher "was responsible for the Duchess's wonderful simplicity and dash," and it was he who made her trousseau and wedding ensemble: a simple, floor-length gown and matching long-sleeved jacket of bias-cut silk crêpe. The cornflower color was chosen to match her eyes; Mainbocher called it "Wallis blue." The pale hue and supple fabric softened the severe lines of the dress. (The dye has faded over time.) Instead of a veil, Simpson wore a hat resembling a halo of blue feathers backed by tulle, along with a brooch at her neck and a diamond charm bracelet with nine crosses, each engraved with a significant event in the couple's history.

Although *Vogue* editor Edna Woolman Chase found Simpson's outfit "dull . . . to look at" with its "tight little uneventful jacket" and felt that "for such an occasion as her wedding to a former English king, she and Mainbocher might have done better than they did," the ensemble struck a chord with women around the world entranced by the "greatest love story of all time." Demure without being prudish and formal without being overtly "bridal," it epitomized the duchess's understated elegance. Cheap knockoffs of "The Wally" went on sale in New York department stores within days, in a variety of colors and materials. From then on, the couple would reign over fashion as the Duke and Duchess of Windsor.

ABOVE: The blue Mainbocher gown American divorcée Wallis Simpson wore when she married the Duke of Windsor in 1937 has faded over time. **OPPOSITE:** First-time bride Lauren Bacall wore a beige doeskin dress when she married fourth-time groom Humphrey Bogart in 1945.

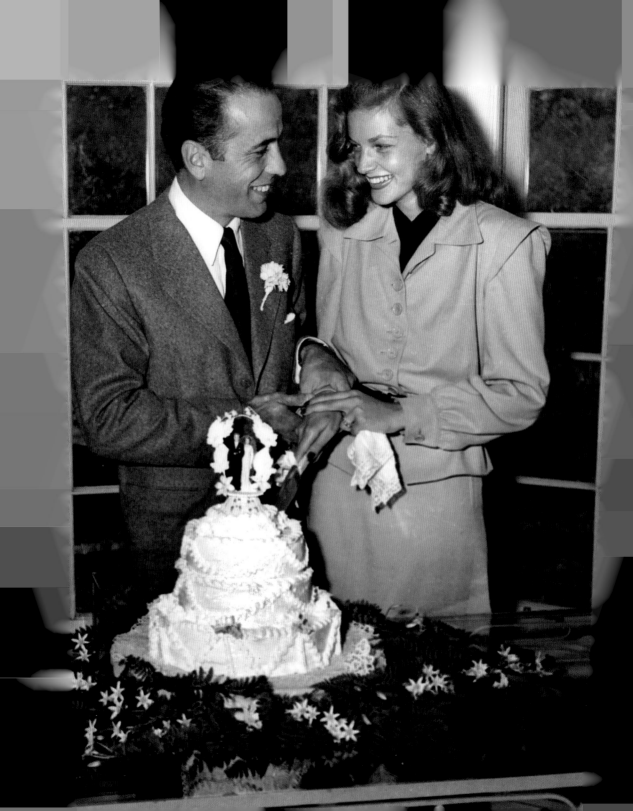

POSTWAR PROPRIETY

◆ ◆ ◆ ◆

The sleek, figure-hugging gowns of the 1930s were swept away by the fashion upheavals of World War II. Weddings of all kinds became more modest in the climate of wartime austerity, with even first-time brides choosing suits or day dresses that could be repurposed. When she married Humphrey Bogart in 1945, Lauren Bacall wore "a doeskin beige dress," according to *LIFE* magazine. Although it was nineteen-year-old Bacall's first wedding, it was forty-four-year-old Bogart's fourth. Their informal attire, however, was typical of wartime weddings.

After the war ended, Christian Dior's New Look of 1947 popularized an hourglass silhouette created by waist cinchers, petticoats, and yards of fabric. As the wife of the British naval attaché to Paris in the postwar years, Lady Alexandra Howard-Johnston developed a taste for the ultra-feminine designs of Dior's rival, couturier Jacques Fath. When she divorced Captain Howard-Johnston and married Hugh Trevor-Roper in 1954, she turned to Fath for her wedding dress. Instead of a traditional gown, however, she commissioned a day dress with a wide collar, a narrow waist, and a full skirt ending just below the knee. In addition to being more appropriate for a second marriage, it was more practical. As she told Cecil Beaton: "That dress was worn and worn." The dress

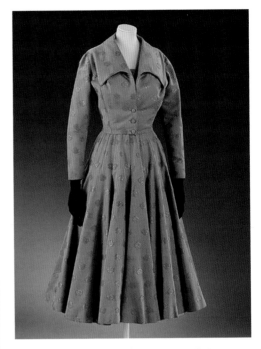

"was made up on the wrong side of the material," a pale brown worsted, which was "my idea because the colour of the right side did not suit me," the bride revealed.

Heiress Gloria Vanderbilt's first wedding was the social event of the season, but it ended in divorce after four years. A second, hurried marriage to conductor Leopold Stokowski—forty-two years her senior—in Mexico lasted ten years, producing two sons. For her third wedding, to director Sidney Lumet in 1956, Vanderbilt chose a look that was very different from the white satin Howard Greer gown with the sweetheart neckline and thirty-foot train she'd worn at the

A B O V E : Lady Alexandra Howard-Johnston wore a tan day dress by her favorite couturier, Jacques Fath, for her second wedding in 1954, and many times thereafter. **O P P O S I T E :** Gloria Vanderbilt's third wedding gown was made from unbleached antique French linen, a hue considered more appropriate than white for divorcées.

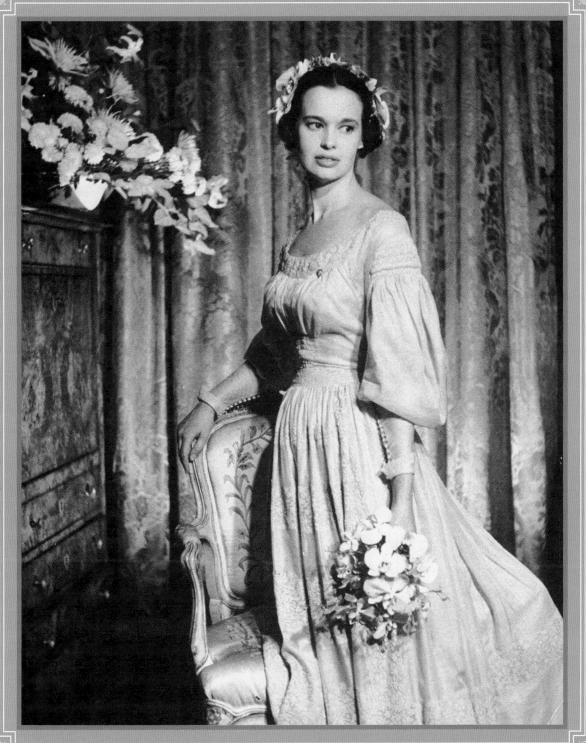

age of seventeen. But it was equally memorable: a romantic off-the-shoulder gown made from upcycled French linen from the 1830s. The unbleached linen had a beige hue considered more suitable than white for divorcées, and the scoop-neck, ankle-length dress was less formal than a traditional, trained gown. The venue, a friend's New York apartment, was an acceptable secular alternative to a church, and the groom (who was on his second wedding) wore a suit and tie rather than formal wear. Instead of a veil, Vanderbilt wore a face-framing coronet of orchids, which matched her orchid bouquet. The marriage lasted seven years; Vanderbilt married her fourth and final husband, Wyatt Cooper, in 1964.

NO-FAULT FASHION

◆ ◆ ◆ ◆

The cardinal rule about divorcées and white weddings remained in effect in 1960, when Emily Post's *Etiquette* stated: "She of course may not wear a typical white bridal dress and veil, nor orange blossoms." But as the uninhibited postwar generation began to grow up and get married, and the widespread adoption of no-fault divorce laws in the 1960s and '70s caused the American divorce rate to double, cracks in the longstanding etiquette of remarriage began to show. White, for example, was now on the table for divorcées, if not widows,

as long it was "a simple street-length gown worn with a hat." Beyond that, the divorcée could choose "any style of dress she prefers"— a sweeping go-ahead many second-time brides took to heart.

ABOVE: The pink gingham shirtdress Brigitte Bardot wore for her second wedding in 1959 was copied by brides and nonbrides alike.

The actress Brigitte Bardot, for example, chose a knee-length pink gingham shirtdress by Jacques Estere for her second wedding, to her shirtsleeves-clad costar Jacques Charrier in 1959. Though it flew in the face of *Vogue's* advice to "avoid girlish clothes," Bardot was only twenty-five years old, and the eyelet-trimmed dress was perfectly in keeping with her ingenue image. (Luckily, the full skirt hid her pregnancy.) Though the silhouette resembled the white wedding gown she had worn onscreen in *And God Created Woman*, the divorcée's unconventional dress wielded an influence that a more traditional gown could not have achieved. It was immediately knocked off by Seventh Avenue, and widely imitated by brides and nonbrides alike. (Bardot herself referenced it in her 2016 capsule collection for French fast-fashion retailer La Redoute.)

Audrey Hepburn, too, wore pink when she married her second husband, Andrea Dotti, in 1969: a long-sleeved wool Givenchy minidress and a matching headscarf rather than a veil, paired with white tights, ballet flats, and gloves. In the chic, simple ensemble, she looked much younger than her thirty-nine years.

Not to be outdone, Raquel Welch wore a daring white crochet minidress to marry her second husband, producer Patrick Curtis, in 1967—a fashion-forward take on traditional lace. Her knee-length white fur coat was

significantly longer than the "peek-a-boo" dress, which "created pandemonium" among the waiting photographers, *LIFE* magazine reported. While their casual day dresses might have looked out of place in a church, as divorcées, all three actresses married at city hall—Bardot in Louveciennes, France; Hepburn in Morges, Switzerland; and Welch in Paris. In most European countries, all couples were required to have a civil ceremony in addition to the optional religious ceremony, and the practice further normalized the small, informal second wedding.

ABOVE: Audrey Hepburn wore Givenchy onscreen and off, including the pink minidress and headscarf she wore for her second wedding (to Andrea Dotti) in 1969.

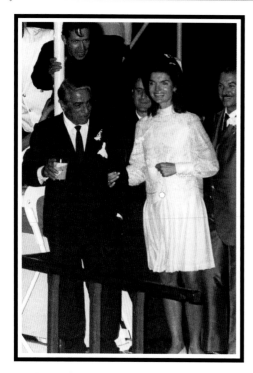

Jacqueline Kennedy, who had been coerced into wearing an unflattering and uncharacteristically fussy white gown for her first wedding, got the modern couture gown she had always wanted when she married Aristotle Onassis in a Greek Orthodox ceremony on his private island, Skorpios, in 1968. The newly minted "Jackie O" chose an ivory chiffon dress from Valentino's "White Collection" of spring/summer 1968, with a high collar, knee-length pleated skirt, and long sleeves, inset with lace panels. But the eye-catching dress was overshadowed by the general public outcry over

the former First Lady's marriage to the controversial foreign shipping magnate twenty-three years her senior (and two inches shorter). As the *New York Times* reported: "The reaction here is anger, shock and dismay."

When Sara Donaldson-Hudson planned her wedding to Nicholas Haydon at the Caxton Hall Registry Office in London in 1971, her mother Dorothy—who was the only woman to own a Savile Row tailoring shop, and thus deeply steeped in the etiquette of dress—insisted that she could not wear white, as the groom had been divorced. Instead, she convinced Sara to wear Bellville Sassoon's hand-painted wool "Rajaputana" coat, inspired by Indian art in the Victoria and Albert Museum's collections, which she had spotted in the November 1970 issue of British *Vogue*. The colorful ensemble was the opposite of a blank slate. The coat's Mandarin collar and A-line skirt were reminiscent of an Indian man's *achkan*, a formal coat popularized in the West as the so-called "Nehru" jacket in the mid-1960s. Sara paired it with an orange shift dress and knee-high boots of orange satin to match the coat's lining; her mother wore a coordinating orange skirt suit and shoes.

Elizabeth Taylor had been just eighteen when she married hotel heir Nicky Hilton in Beverly Hills, wearing a white satin and lace confection designed by Helen Rose, the head of

ABOVE: Jacqueline Kennedy got the modern couture wedding gown of her dreams when she married her second husband, Aristotle Onassis, in Valentino in 1968. **OPPOSITE:** At her fifth wedding in 1964, Elizabeth Taylor married her *Cleopatra* costar Richard Burton in a dress made by the film's costume designer, Irene Sharaff.

→ 160 ←

the MGM Studios costume department, who'd dressed Taylor in a similarly traditional look for *Father of the Bride*. Taylor would go on to wed seven more times—including two marriages to the same man, actor Richard Burton. For their first wedding, Taylor once again turned to a costume designer, Irene Sharaff, who dressed her in sixty-five distinct costumes for *Cleopatra*; Taylor and Burton had met on the set. Sharaff created a canary yellow baby-doll dress topped by a dramatic upswept hairdo worthy of the Queen of the Nile herself, with a hairpiece woven with hyacinths and lilies of the valley falling to her waist. It combined elements of the traditional bouquet and veil while being something entirely new. Taylor accessorized with a diamond and emerald Bulgari brooch, a gift from Burton.

Taylor and Burton divorced after ten tumultuous years, only to remarry sixteen months later at the Chobe Game Lodge in Botswana on October 10, 1975. Taylor wore a suitably exotic gown by Gina Fratini, a British designer born in Japan and raised in Burma and India. Fratini's hippie-chic aesthetic was perfectly in tune with the times. Taylor's caftan of sheer, shade-dyed chiffon had long, trailing sleeves reminiscent of a Japanese wedding kimono or *furisode*. Burton wore a red turtleneck and white bell-bottoms. The couple would divorce again the following year.

When she married playboy Alexis Mersentes in 1992, sixty-seven-year-old Dallas socialite Doris Dixon, the multimillionaire widow of a defense contractor, boldly followed her own preferences rather than tradition. Not just her dress—an off-the-shoulder confection of net with a high-low hemline by Dallas-based designer Victor Costa—but also the decorations at the reception at Brook Hollow Golf Club were her favorite color, cotton-candy pink. Dixon had every right to do things her way; she paid for the entire wedding, including her $20,000 ring.

REINVENTING TRADITION

♦ ♦ ♦ ♦

The era of the conspicuously subdued, stylish, or whimsical second wedding—which commenced as divorce rates rose in the 1920s—is already over. Today, when it is no longer the expected

ABOVE: Elizabeth Taylor wore a Gini Fratini caftan with kimono-style sleeves when she remarried Richard Burton in Botswana in 1975.

norm for brides to be virgins at their first weddings, there is no reason to avoid wearing white at the second. Indeed, remarriage ceremonies are often even more elaborate than those for first marriages, as they involve the merging of entire nuclear families rather than just the bride and groom. And, just like Katharine Hepburn's character in *The Philadelphia Story*, brides who skipped a white wedding the first time around may seize the opportunity for a more traditional do-over.

For her first marriage to Jonny Lee Miller at a Los Angeles registry office, actress Angelina Jolie wore black rubber pants and a white shirt with Jonny's name written in her own blood on the back; the groom wore black leather. For her second, to Billy Bob Thornton in a Las Vegas wedding chapel, Jolie wore a sleeveless blue sweater and jeans. Though her third wedding was equally intimate, the setting was much grander, and so was the bride's outfit. In 2014, she married Brad Pitt in the chapel of the couple's French château, wearing a full-skirted white satin gown by Luigi Massi for Atelier Versace. Her floor-length tulle veil was embroidered with drawings created by the couple's six children, who accompanied their mother down the aisle, lending sentimental charm to an otherwise classically elegant bridal gown. Pitt and Jolie had been together nine years and, like many couples with children (whether from previous relationships or their own), they included them in the ceremony, just as Marjorie Merriweather Post had. Combining traditional elements with highly personal touches, modern remarriage has come full circle. ◆

ABOVE: Dallas widow Doris Dixon, sixty-seven, chose a Victor Costa dress in her favorite color for her second wedding in 1992.

THE BRIDAL PARTY

THE BRIDE AND GROOM MAY BE THE stars of the show, but bridesmaids, flower girls, and pageboys have always been important, gorgeously costumed actors in a carefully choreographed performance. No one understood their role in creating an unforgettable tableau better than Cecil Beaton, the acclaimed British set and costume designer for film and theater. His greatest production, perhaps, was his sister Nancy's wedding to Sir Hugh Smiley, which he costumed and choreographed himself in 1933. With only six weeks to prepare, he pulled off an Instagram-worthy wedding long before anyone had ever thought of Instagram.

Even before they happened, Nancy's nuptials were making news as far as Canada, where the *Winnipeg Tribune* reported that her bridesmaids would wear "headdresses . . . copied from those worn by medieval ladies" and "carry between them two garlands of white flowers" in lieu of bouquets. The pageboys would be dressed in "sky blue toreador coats over eighteenth century white satin waistcoats and knee breeches, and they are to have red heels on their shoes to match their epaulettes." After it was all over, *Vogue* devoted five pages to Beaton's insider account of the nuptials. He described his designs for the eight bridesmaid gowns as "slightly Edwardian, slightly Empire, slightly medieval." The whole thing was "chalk-white" apart from the three pageboys' blue velvet coats and silver lace trimmings; even the floral garlands were

ABOVE: Cecil Beaton costumed and choreographed the "bridal cortège" at his sister Nancy's 1933 wedding to Sir Hugh Smiley in London.

whitewashed to give the effect of a snow queen and her maidens. The bridesmaid dresses had swags of white flowers across the bodice, making it look as if they were roped together by the garlands. "I shall never forget the poignant beauty as the bridal cortège reverently, and as if in slow motion, trooped out into the cold winter afternoon, passed through into the court with the leafless trees against the blue stone of Saint Margaret's Church, the bride and her maids like Mélisandes in their long white draperies and dragging garlands," Beaton wrote.

The tradition of dressing bridesmaids in white derives from their original function as decoy brides, intended to fool evil spirits or thwart kidnappers. Their clothing still reflects this role; ideally, they are the second best-dressed women at any wedding. And their dresses may echo the bride's in more than just appearance. During World War II, brides and bridesmaids alike wore gowns made out of parachute silk (see Chapter 8). In the 1960s, it was paper (see Chapter 5).

ROYAL BRIDESMAIDS

♦ ♦ ♦ ♦

At royal weddings of the eighteenth century, the bride wore silver, not white—and so did the bridesmaids (see Chapter 2). Lady Fanny Montague was a bridesmaid in the wedding of King George II's daughter Anne, the Princess Royal, and Prince William IV of Orange, which took place in the chapel of St. James's Palace in 1734. Diarist Mary Delany attended the wedding and declared the bride's gown "the prettiest thing that ever was seen" and "a most becoming dress." The eight bridesmaids who carried the princess's train wore similar gowns. Montague had her portrait painted in her silver and white bridesmaid dress, providing a hint of the glittering spectacle formed by the princess and her attendants. It is a rare early image of a bridesmaid, and an equally rare image of English court dress of the eighteenth century.

Montague wears a type of gown know as a stiff-bodied gown, also called a "royal robe," because it was, in general, reserved for use by female members of the royal family. But there were rare circumstances in which lesser mortals were allowed to don the royal robe: specifically, when they served as bridesmaids or trainbearers at royal weddings and coronations. Though there must have been a certain amount of discomfort and inconvenience involved in wearing the heavily boned, off-the-shoulder bodice and a long train—the English equivalent of the *grand habit* (see Chapter 2)—there is every reason to believe that these ladies, usually chosen from the unmarried daughters of peers, relished the opportunity to play queen for the day. Some, like Montague, had their portraits painted in the precious garments; others preserved them for posterity.

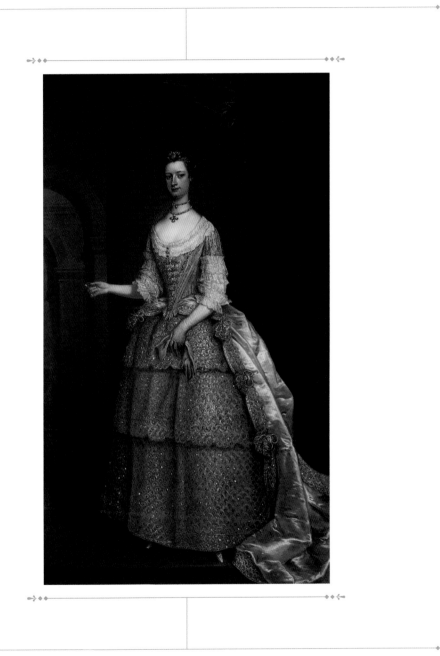

ABOVE: In her portrait by Charles Jervas, Lady Fanny Montague wore the silver and white ensemble she had worn as a bridesmaid in the 1734 wedding of Anne, the Princess Royal.

Queen Victoria's twelve bridesmaids, too, were all the eldest daughters of peers, per tradition. When she married Prince Albert in 1840, the queen, a talented artist, designed her bridesmaids' dresses herself. The simple gown she sketched was white, trimmed with sprays of roses on the bodice and skirt. The queen gave her sketch to her Mistress of the Robes, the Duchess of Sutherland, who supervised the making of the dresses. When she arrived at St. James's Palace on her wedding day, Victoria recorded in her diary, "my 12 young Train Bearers were waiting, dressed all in white with wreaths of roses in their hair which had a very pretty effect."

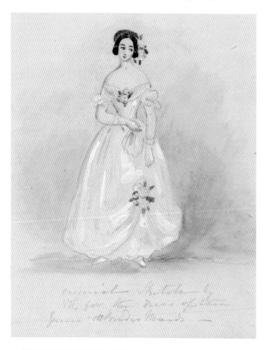

Because her trainbearers had become hopelessly entangled in their own trains at her coronation, Victoria decided that her bridesmaids would wear no trains. Nevertheless, one of them, Lady Wilhelmina Stanhope, complained: "We were all huddled together and scrambled rather than walked, kicking each other's heels and treading on each other's gowns."

The 1862 wedding of Victoria's second daughter, Princess Alice, to Prince Louis of Hesse took place under much different circumstances. Prince Albert had died seven months earlier, and the court and royal family were still in deep mourning. Rather than a grand state occasion, the wedding was a small, subdued affair in the dining room at Osborne House, on the Isle of Wight. There were only four bridesmaids—Alice's sisters Louise, Helena, and Beatrice, and Princess Anna of Hesse—and they wore lilac ribbons on their white gowns and in their hair, the color of half-mourning. The guests, too, wore half-mourning; the men were requested to wear "black evening coats, white waistcoats, black neckcloths" and the women "grey or violet morning dresses, grey or white gloves." Before the ceremony, Victoria wrote to her daughter Vicky and warned her: "I think decidedly none of you ought to be in colours at the wedding but in grey and silver or lilac and gold and so on but not merely gold and white." Even the groom wore a black tailcoat rather than the customary

ABOVE: Queen Victoria herself designed the dresses for her twelve bridesmaids when she married Prince Albert in 1840.

colorful uniform. Although the strict mourning etiquette of the nineteenth century permitted widows to set aside their black widow's weeds for weddings, so as not to cast a gloom over the happy event, Queen Victoria wore her habitual black, with a white cap. Afterward, the queen commented that the wedding had been "more like a funeral." Even the bride's trousseau had "nothing but black gowns," she noted.

FASHIONABLE FANCIES

❖ ❖ ❖ ❖

The tradition of dressing bridesmaids in white began to wane in the 1880s, when English author and illustrator Kate Greenaway published a series of wildly popular children's stories and fairy tales depicting young women and girls in bucolic rural settings wearing colorful floral dresses inspired by eighteenth-century

ABOVE: The four bridesmaids in the 1862 wedding of Princess Alice and Prince Louis of Hesse wore mourning for the bride's late father, Prince Albert.

fashions. Brides took note, dressing their attendants in pretty floral prints paired with straw hats or beribboned bonnets. It was a romantic, pastoral aesthetic later updated by Laura Ashley and Gunne Sax.

Pageboys were popular and picturesque additions to weddings from the mid-1880s, when the royal British tradition was imitated around the world. Young boys dressed in fanciful costumes like sailor suits, eighteenth-century knee breeches, Highland dress, or miniature military uniforms were often charged with carrying

the bride's long train. In 1896, Walter Russell Bradford served as a pageboy at a wedding in Granby, Quebec. He wore a green silk velvet jacket and knee breeches, exuberantly trimmed with old-fashioned white lace, with a jabot shirt and a sash at his waist. Such costumes became popular as formal dress for young boys after the publication of Frances Hodgson Burnett's 1885 novel *Little Lord Fauntleroy*, in which the protagonist wears "a black velvet suit, with a lace collar, and with lovelocks waving about the handsome, manly little face." So-called "Fauntleroy suits" were based on the romantic costumes Burnett made for her own sons, Vivian and Lionel. The author adapted the novel into a successful Broadway play in 1888, perpetuating the popularity of the suit, especially in America. Pageboys are seldom seen in the United States today, however; young boys typically serve as ring bearers in American weddings instead.

Similarly, young American girls are generally relegated to the role of flower girl rather than the child bridesmaids still popular abroad. Three-year-old Nedenia Hutton, youngest daughter of the heiress Marjorie Merriweather Post, wore an ivory organza dressed trimmed with rabbit fur as the flower girl in the 1927 winter wedding of her older sister, Adelaide, described by the *Pittsburgh Daily Post* as "the most brilliant wedding of the New York society season." She had a matching bonnet of ivory silk taffeta trimmed in

ABOVE: Walter Russell Bradford wore a velvet Little Lord Fauntleroy costume as a pageboy in a wedding in Quebec in 1896. **OPPOSITE:** Three-year-old Nedenia Hutton (later known by her stage name, Dina Merrill) wore a rabbit-fur-trimmed dress as the flower girl in her sister's 1927 wedding.

rabbit fur. As with the Fauntleroy suit, the outfit's charm lies in the concentration of so many luxurious and grown-up materials in such a small, adorable package.

Kate Greenaway notwithstanding, Lucile claimed to be the first designer to break bridesmaids free from their traditional color palette when she dressed her sister, novelist Elinor Glyn, and her bridesmaids for her 1892 wedding in London. "I forget now what they were like," she wrote in her autobiography, "but I know that the child bridesmaids had touches of yellow on their dresses, which caused a lot of comment, for it was the first fashionable wedding to make a departure from the traditional white." It was not the last; colored bridesmaid dresses became especially popular in America, where Lucile built a loyal following. The need for decoy brides had long since passed, and the thought of anyone mistaking someone else for the bride was horrifying, not reassuring. Indeed, it was considered a breach of etiquette to wear white to a wedding.

SUPPORTERS IN THE SPOTLIGHT

◆ ◆ ◆ ◆

For her 1956 wedding to Prince Rainier of Monaco, Grace Kelly famously dressed her own bridesmaids and four flower girls in yellow, her favorite color (see Chapter 2). While Helen Rose of the MGM wardrobe department made her wedding gown, Kelly chose Joseph Hong, a young designer from California who worked for Neiman-Marcus, for the bridal party's dresses. The bridesmaids' simple yet romantic floor-length shirtdresses of sheer organdy with high necks, pleated sashes, bishop sleeves, and short trains were layered over strapless taffeta underdresses, echoing the silhouette and construction of Kelly's own lace gown. The flower girls mimicked the adult attendants, with pleated sashes and sheer organdy dresses layered over taffeta underdresses, but they wore age-appropriate puffed sleeves, Peter Pan collars, and full, short skirts. They carried bouquets of daisies and wore daisy wreaths on their head instead of the yellow hats worn by the bridesmaids; their dresses were embellished with machine-embroidered daisies. The yellow dresses enlivened the gray stone of Monaco's St. Nicholas Cathedral.

When First Daughter Luci Johnson married in 1967 (see Chapter 3), her bridesmaids wore short-sleeved versions of the bride's own long-sleeved, high-waisted Priscilla of Boston dress in cotton-candy pink, complete with long veils. Luci's maid of honor—her older, single sister Lynda—wasn't happy with her dress; according to Priscilla Kidder, she thought she blended in too much with the other bridesmaids and kept complaining that it needed something to make her stand out. In frustration, Priscilla grabbed her scissors and chopped off the floor-length

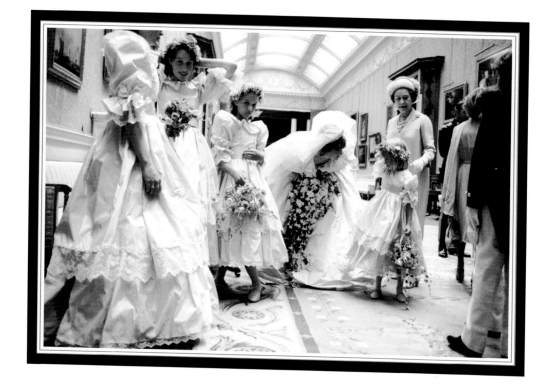

veil to elbow length. "THERE," she said. "Now you stand out!" Lynda was horrified, and a replacement long veil was quickly found. When Lynda married the following year, Kidder was not asked to make her dress nor her bridesmaids' dresses.

India Hicks, a thirteen-year-old bridesmaid in the 1981 wedding of her godfather, Prince Charles, wrote about the experience in *Harper's*

Bazaar in 2011. The self-described "tomboy from rural Oxfordshire, never out of jodhpurs" was "horrified" to learn that she "was going to have to wear a dress" in order to be in the royal wedding. It was a family tradition, however; her mother had served as bridesmaid to Charles's mother, Queen Elizabeth II. The dress fittings took place at the studio of designers David and Elizabeth Emanuel. "Frill after frill, pin after

ABOVE: Princess Diana's child bridesmaids wore dresses by her wedding gown designers, David and Elizabeth Emanuel. **FOLLOWING:** First Daughter Luci Johnson's bridesmaids wore short-sleeved pink versions of the bride's high-waisted, high-necked gown, all designed by Priscilla of Boston.

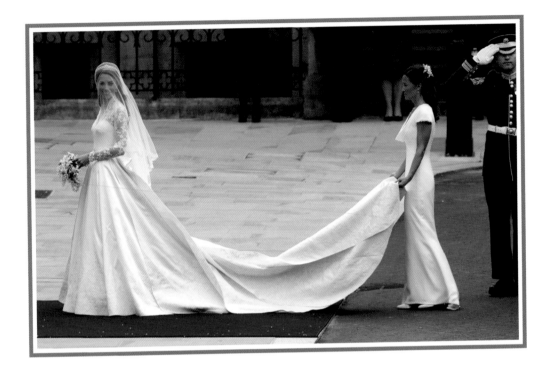

pin, hour after hour, we stood silently as minions brought the Emanuels' creations to life," Hicks remembered. "I found all those petticoats, puffed sleeves, and bows hard to forgive." By contrast, the ceremony itself passed in a blur: "I only really remember my buttercup-yellow satin shoes pinching; they were a size too small." In return for their service, Princess Diana's bridesmaids received "a pretty gold-rimmed

Halcyon Days china box. Inside were two of the silkworms that had spun the silk for her wedding dress." Later, the princess sent them each a rose from her bouquet, set in Perspex to act as a paperweight.

Like his parents, Prince William had five bridesmaids and two pageboys in his wedding party when he married Kate Middleton in 2011. But one of those bridesmaids was not like the

ABOVE: Kate Middleton's sister, Pippa, single-handedly made white bridesmaid dresses chic again in her formfitting Alexander McQueen gown.

others: Pippa Middleton was the lone adult bridesmaid in a sea of children. As if that wouldn't have been enough to put her in the spotlight, the bride's sister wore a formfitting white Alexander McQueen gown with a cowl neck and a fishtail skirt. While it had the same tiny buttons and lace trim as the bride's dress, there was no chance of mistaking her for the bride, in her beautiful but conservative full-skirted, long-sleeved gown. In an interview with the *Today Show* after the wedding, Pippa claimed that the attention her gown received "was completely unexpected. You know, I think the plan was not really for it to be a significant dress, really just to sort of blend in with the train."

Pippa's showstopping turn started a trend for white bridesmaid dresses in the United States, where Kim Kardashian and Kanye West subsequently dressed their adult bridesmaids in white. Middleton's younger bridesmaids wore white dresses designed by Nicki Macfarlane, in the same fabrics as the bride's gown, trimmed with English lace. The pageboys wore Regency-style Foot Guards uniforms by military tailors Kashket and Partners, personalized with insignia from the Irish Guards, William's regiment. They wore tasseled gold and crimson sashes around their waists, like officers of the Irish Guards do in the presence of the Royal Family. (Charles and Diana's pageboys, too, had worn miniature uniforms.)

CELEBRATING INDIVIDUALITY

◆ ◆ ◆ ◆

Just as modern brides are guided by their own tastes and personalities rather than tradition when selecting a dress, bridesmaids are no longer expected to be cookie-cutter copies of the bride—or each other. In 2008, Lauren Davis (see Chapter 4) invited each of her nine bridesmaids to choose a different dress by a different designer, as long as they were apricot or cornflower to complement the interior of the church. And, in 2016, singer Ciara's wedding to Seattle Seahawks quarterback Russell Wilson at Peckforton Castle in Cheshire, England, combined Old World romanticism with modern red-carpet glamour. While the bride wore a white lace Roberto Cavalli gown straight out of a flirty fairy tale, each of her eight bridesmaids wore unique, custom-made black evening gowns designed by Michael Costello. "Every girl's individual style is implemented in the design of their dress, as well as their personality," Costello told *US Weekly*. Wearing black to a wedding has historically been as much of a taboo as wearing white, but the elegant black and white palette of the Wilsons' wedding made a powerful argument for drop-kicking tradition—and for wearing bridesmaids' gowns again and again. ◆

THE
GUEST LIST

WEDDING GUESTS HAVE ALWAYS GONE to great lengths to look their best, in order to honor the hosts as well as burnish their own public images. At the same time, they must be careful not to overshadow the happy couple or overstep the bounds of etiquette. The Duchess of Cambridge, a frequent wedding guest, tends to re-wear old outfits to weddings, so as not to distract attention from the main event. Garments worn to significant weddings throughout history have been preserved by their wearers, memorialized by artists, and collected by museums as souvenirs of history-making marriages—and legendary parties.

Just as clothing has always played a significant role in wedding rites, the tradition of distributing wearable favors to wedding guests dates to back to Shakespeare's time, when gloves were the preferred party favor. In the eighteenth century, the bride's family was responsible for providing these extravagant gifts; popular favors included sword knots and gold military epaulettes for men, and bouquets, fans, and ornamental tassels for women. All of these could be bought by the dozen from the same merchants who provided contents of the bride's trousseau; the Marquise de La Tour du Pin, who had "fifty or sixty" wedding guests, complained in her memoirs that "this custom was very expensive."

Matthäus Schwarz, a sixteenth-century Augsburg accountant, undertook the unusual project of documenting his wardrobe in a series of hand-drawn portraits, rendered in rich tempera colors accentuated with costly gilding. Between 1520 and 1560, he compiled a *Klaidungsbüchlein* or "book of clothes," cataloguing his extensive and flamboyant wardrobe in images and descriptive captions. At a time when people effectively designed their own clothes with the help of tailors, dress-makers, and shoemakers, Schwarz boasted of his savvy color and fabric choices as he planned spectacular new outfits for a bewildering variety of occasions, including several weddings and

post-wedding celebrations of close friends and family members. On June 14, 1524, for example, he noted that he had attended Andre Schregl's wedding wearing a red hat with gold buttons, a bright green damask doublet, and matching hose. He accessorized with a tasseled bracelet, a sword, and a heart-shaped red purse, worn hanging from his belt. Red and green were the colors of hope and desire; together with the purse, they referenced the happy occasion while also signaling Schwarz's own ongoing search for a wife. Schwarz frequently took the trouble to match his attire to that of other members of the bridal party, just as groomsmen do today.

ABOVE: Sixteenth-century Augsburg accountant Matthäus Schwartz documented his wardrobe, including several flamboyant outfits worn to wedding celebrations.

BY ROYAL INVITATION

◆ ◆ ◆ ◆

A coveted invitation to a royal wedding brings a special kind of panic over what to wear—and how to pay for it. When Armandine-Marie-Georgine de Sérent attended Emperor Napoleon's wedding to his second wife, Marie-Louise, in 1810, she wore a red velvet train that conformed to the imperial court dress code Napoleon had established at the time of his coronation in 1804. Though the French Revolution had done away with the royal court and its rigid dress etiquette, his coronation gave Napoleon an excuse to resurrect court dress and, in doing so, to revive France's ailing textile industry. Although Napoleonic court dress was more attuned to fashion, it was equally dependent on the strength of tradition. While it conformed to the fashionable high waistline, de Sérent's train was so heavily weighted down with fine textiles and embroidery that it had to be secured by shoulder straps and belted at the front. It was likely worn over a white gown with historicized details like a Renaissance-style ruff collar and classical embroidery motifs. But this impressive garment must have paled in comparison to the bride's ermine-lined train of crimson velvet entirely embroidered in gold with oak, laurel, olive leaves, bees, and Napoleon's cipher, which weighed eighty pounds.

Similarly, when Princess Ingeborg of Sweden traveled to St. Petersburg to witness her nephew's wedding to the Tsar's cousin in 1908, she could not wear her Swedish court dress. Instead, she commissioned a new silver gown for the occasion that conformed to Russian court etiquette. Though made by Borre Lorenzen of Copenhagen, it had the long, hanging sleeves characteristic of Russian court dress, based on traditional Russian folk styles. The gown has survived in the Rosenborg Castle collection, unaltered; it was likely never worn again.

MODISH MOTHERS

◆ ◆ ◆ ◆

Though women married and had children at a younger average age in the past, the threshold of middle age was also lower, and fashion-conscious mothers of the bride (or groom) walked a fine line between elegance and outlandishness. At the wedding of her oldest daughter, Vicky, the Princess Royal, in 1858, Queen Victoria made sure all eyes were on her by wearing a gown in the trendiest shade of the time: mauve. Discovered in 1856 by Royal College of Chemistry student William Perkin, who was trying to synthesize quinine, mauve was the first chemical dye. By August 1857, the new hue was "the rage of Paris, where it is an especial favourite of the Empress Eugenie," the *Illustrated London News* reported. "Mauve mania" would persist until 1861. The queen accessorized the already eye-catching gown with the Koh-i-noor

OPPOSITE: Armandine-Marie-Georgine de Sérent donned a formal court train as a guest at Emperor Napoleon's 1810 wedding to his second wife, Marie-Louise.

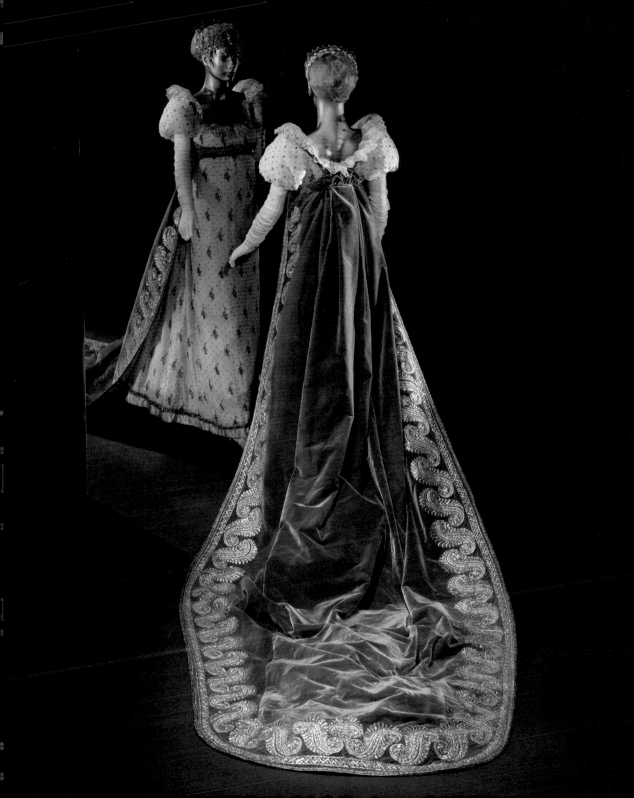

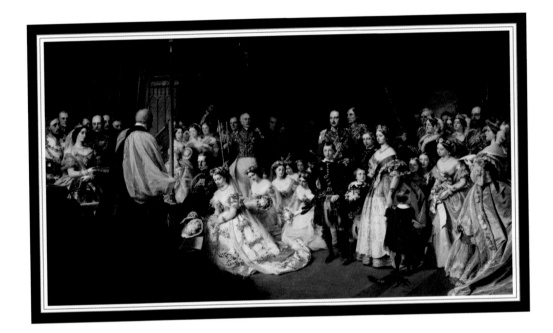

diamond, which was at the time the largest known diamond in the world.

Another scene-stealing mother of the bride, the famously well-dressed Comtesse Greffulhe, attended her daughter Elaine's 1904 wedding in an outfit so over-the-top that people in the congregation reportedly exclaimed, "Mon Dieu! Est-ce là le mère de la mariée?" ("My God! Is that the mother of the bride?") Her gown had a

Worth label, but it was probably created for the countess by Jean-Philippe Worth's protégé, Paul Poiret. The magazine *La Femme d'aujourd'hui* described it as "a sensational Byzantine empress outfit: a silver brocade gown covered with artistic embroideries with sparkling mother-of-pearl embellished with gold and dainty pearls, with a band of sable at the hem." With her gown, the countess wore a "splendid dog collar and *sautoir*

ABOVE: Queen Victoria wore a gown in the trendy and eye-catching shade of mauve to her daughter Vicky's 1858 wedding to Prince Frederick of Prussia. OPPOSITE: Comtesse Greffulhe's "sensational" Worth gown stole the show at her daughter Elaine's wedding in 1904.

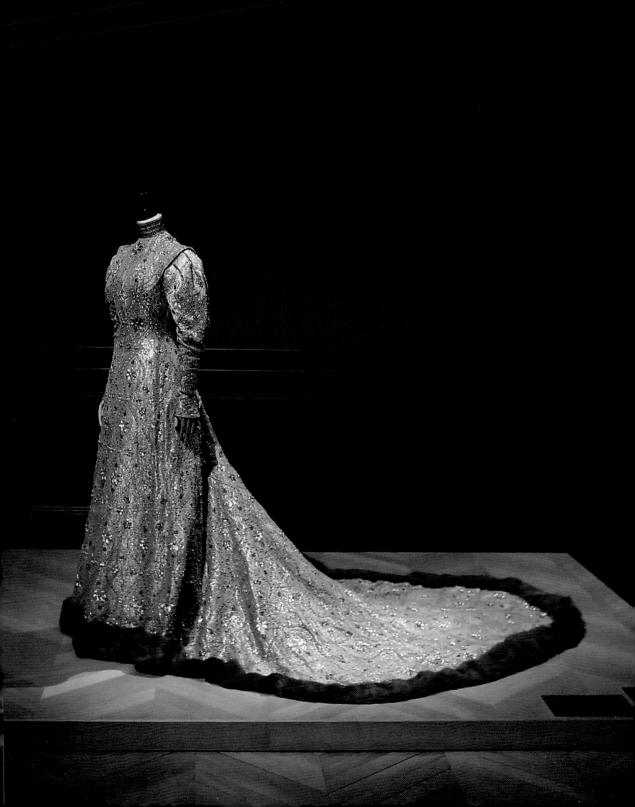

of fine pearls" and an "immense hat of silver tulle bordered with sable, with, on each side, voluminous birds of paradise, between which stood straight and proud, an enormous brilliant diamond shining like a huge tear of joy, bathed in the colors of the rainbow by the sun." Reporters covering the Parisian society wedding were so taken by Greffulhe's gown that they hardly mentioned the bride's.

As bridal fashion magazines and dedicated bridal shops emerged in the early twentieth century, fashions specifically designed for mothers of brides and grooms became available. Gray, lilac, and dusky pink (or "ashes of roses") were among the most popular colors. Helen de Koven wore a gray chiffon and satin ensemble trimmed with soutache braid by Whitney of Chicago to her son's 1910 wedding, with a matching hat. Some mothers wore the same dress to the weddings of multiple children, likely for sentimental reasons rather than out of frugality, although the opportunity to re-wear the dress may have justified a particularly extravagant purchase. Italia Blair de Soriano wore the same dramatic deep red velvet Doueillet-Doucet gown to the weddings of her daughter in Biarritz in 1932 and her granddaughter in Madrid in 1953— a testament to the timeless elegance of the medieval-style gown as well as Italia's enviable figure. Queen Victoria wore the lace from her own wedding gown to the weddings of several of her children and grandchildren (see Chapter 2).

A couture dress Maggy Rouff made for Mrs. H. Castle of Cornwall to wear to her daughter's wedding in 1947 was originally lilac, but Castle later dyed it black to get more use out of it; she also let out the darts in the back, suggesting that she kept and wore it for a long time—hardly surprising given the fact that wartime clothing rationing continued in the United Kingdom until 1949 (see Chapter 8).

At the 1924 wedding of heiress Cornelia Vanderbilt, the bride's mother gave her away, her father being deceased (see Chapter 4). According to the *Lincoln County News*, Edith

ABOVE: As mother of the groom, Helen de Koven wore sensible gray chiffon and satin trimmed with soutache braid by Whitney of Chicago in 1910. OPPOSITE: Edith Stuyvesant Vanderbilt, a widow, gave away her daughter Cornelia in 1924, wearing a "thrilling" turban and a white ostrich boa.

Stuyvesant Vanderbilt "looked perfectly thrilling in an Oriental turban of panel tissue in gold, her enormously long pear-shaped earrings, solidly set with diamonds, emphasizing the oriental effect. Of course the great fluffy white boa of ostrich was not very oriental but it made a wonderfully soft and becoming background." A famed beauty who stood nearly six feet tall, Edith could still turn heads at the age of fifty-one.

UPDATING THE DRESS CODE

◆ ◆ ◆ ◆

Prince Charles and Princess Diana's 1981 wedding will always be remembered for the bride's voluminous wedding cake of a gown, but what did the guests wear? Los Angeles socialite Betsy Bloomingdale received one of the coveted invitations to the ceremony at St. Paul's Cathedral due to her friendship with Raine, Countess Spencer, Diana's stepmother. She wore a peach-colored, silk crêpe dress with an olive cummerbund and a matching bias-cut cape and wide-brimmed straw hat by Marc Bohan for Christian Dior. Bloomingdale was a regular client of Bohan and other French couturiers, and it is a tribute to her good taste that her dress could still be worn today. The Bloomingdales traveled to London in style on Air Force One with Betsy's friend Nancy Reagan, then the First Lady. A reporter

on board the flight noted that the festive atmosphere was "not unlike college girls going to a debutante party," but failed to uncover what Betsy and Nancy would wear to the royal wedding. Like Diana, who kept her wedding gown a closely guarded secret until she stepped out

ABOVE: Betsy Bloomingdale's Christian Dior couture dress was the same color as the one her friend Nancy Reagan wore to Prince Charles and Princess Diana's wedding.

of her horse-drawn carriage, neither woman would reveal her chosen outfit—including to each other, apparently. They ended up wearing similar ensembles, though they had not planned to match; Reagan's was a peach suit and wide-brimmed hat by Los Angeles designer James Galanos.

Frequent royal wedding guest Princess Beatrice of York has garnered attention (both positive and negative) for the hats and fascinators she has worn to the weddings of her many royal cousins. For the 2008 wedding of her cousin Peter Phillips, she chose a Philip Treacy fascinator resembling a swarm of colorful butterflies taking flight. Contrast that sublime chapeau with the ridiculous pale pink Treacy fascinator she wore to the 2011 wedding of Prince William and Kate Middleton, which evoked comparisons

ABOVE: Princess Beatrice has worn a series of fascinating fascinators to royal weddings, including this Philip Treacy butterfly swarm from 2008.

ABOVE: Serena Williams (with husband, Alexis Ohanian) wore a conservative but chic Versace dress to her friend Meghan Markle's 2018 wedding to Prince Harry.

to a pretzel, an octopus, a toilet seat, and an IUD. (It was supposed to look like a giant bow.) The hat immediately spawned its own Facebook page and Twitter feed. The princess later auctioned it on eBay, raising $131,560 for UNICEF and Children in Crisis.

If modern royal weddings no longer require formal court dress, they have equally stringent dress codes. Hats are expected unless otherwise specified (as Prince Edward and Sophie Rhys-Jones did for their unusually low-key 1999 royal wedding, to which ladies were, confusingly, invited to come in evening gowns, and men in morning coats). Prince Harry and Meghan Markle's 2018 wedding invitations dictated: "Dress: Uniform, Morning Coat or Lounge Suit; Day Dress with Hat." American tennis great Serena Williams, a friend of the bride's, nailed the dress code in a conservative but contemporary long-sleeved, knee-length pink Versace dress with an asymmetrical neckline, worn with matching heels and a sculptural pink fascinator; her husband, Reddit cofounder Alexis Ohanian, wore a classic black morning coat (see Chapter 12).

One has to wonder what the dress code was at rapper 2 Chainz's wedding to Kesha Ward at the former Versace mansion in Miami a few months later. Reality television star Kim Kardashian-West arrived in a neon green latex Louis Vuitton gown, slit to the thigh, and still

managed to be upstaged by her husband, rapper Kanye West, wearing a mint green Vuitton suit accessorized with a bare chest and too-small Velcro shower shoes, from his Yeezy fashion line, worn over socks. Beach formal? ◆

ABOVE: Kim Kardashian West and Kanye West wore Louis Vuitton to a 2018 wedding at the former Versace mansion in Miami.

CHAPTER 12

GOING AWAY

FOR CENTURIES, A BRIDE DEVOTED AS much time, care, and expense to her trousseau as to her wedding gown; even before becoming engaged, she might have a "hope chest" or "bottom drawer" full of linens, silverware, and clothing (often made by the bride herself) stockpiled for use when she married. A particularly important element of the trousseau was the dress the bride wore to leave on her honeymoon in a shower of rice or confetti. "After the bridal gown, the first thing to be considered is the tailored costume . . . for the motor or the train," *Vogue* advised in 1918, adding that it "doesn't want to be an anti-climax to the wedding gown." Called the "going-away" or "setting-out" dress, this outfit represented the bride's first chance to present herself as a married woman, and her last chance to make an impression on her wedding guests. It was not just a memorable end to the wedding, but a stylish beginning to the couple's married life.

The going-away dress often complemented or contrasted with the bride's wedding attire. For a bride who wore a traditional or conservative wedding gown, the going-away dress presented an opportunity to show off her personality and fashion sense. Many brides chose to "set out" or "go away" on their honeymoons in ensembles suitable for the rigors of travel. Over the years, these styles changed along with modes of transportation. "A bride necessarily chooses her going-away dress according to the journey she is to make," Emily Post advised in the 1922 edition of *Etiquette*. "If she is starting off in an open motor, she wears a suitably small motor hat and a wrap of some sort over whatever dress (or suit) she chooses. If she is going by train or boat, she wears a 'traveling' dress." Once, this meant a tailored suit in subdued colors and sturdy fabrics. Today, it might mean an outfit referencing the honeymoon destination, or the color scheme of the reception. If a modern bride has a trousseau, it usually consists of lingerie or a few special items purchased to wear on her honeymoon, while her post-wedding ensemble is more likely to be called an "exit dress" or a "getaway dress" and donned at the end of the reception.

One of the earliest surviving going-away ensembles is in the Museum of Fine Arts, Boston. Harriet Maria Spelman wore the olive green and white striped silk dress and matching short cape after her wedding to Harvard Medical School graduate Estes Howe in Boston on August 20, 1838. The gown has the stylish puffed sleeves and bell-shaped skirt of the time, accentuated by the wide shoulders of the cape, which instantly converted the dress from indoor to outdoor wear. Like most highly fashionable clothes—especially in the volatile fashion climate of the 1830s—it may have gone out of style rather quickly, contributing to its preservation.

An alternative to the going-away dress was the "second day" dress, worn to receive guests or pay visits on the day after the wedding. It was less formal and less rich in ornamentation and symbolism than the wedding gown; thus, it could be worn again as a bride's "best" dress. The "second day" tradition was especially popular in the American South, and it was often the fashionable, colorful second-day dress rather than the formal white wedding gown that was photographed and preserved. There is no image or remnant of the gown Emeline Butler wore for her 1860 wedding to Henry Dixon Posey in Henderson County, Kentucky, but both her green and black tartan second-day dress, featuring bishop sleeves and a large crinoline, and a hand-tinted photo of her wearing the dress have survived in the Smithsonian. Queen Victoria's purchase of Balmoral Castle in 1852 helped to popularize tartan as a fashion fabric; Anna Forgey also chose a tartan dress with a crinoline for her second-day dress after marrying Robert W. Orr

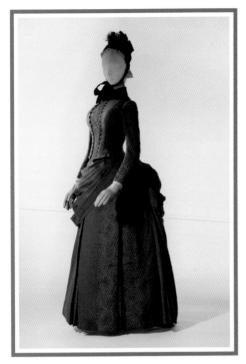

English law changed to allow afternoon ceremonies, compressing the wedding festivities into a shorter time period. The following year, a fashion journalist noted: "Afternoon weddings have caused a great reform; a bride is often married in her going-away dress." Other brides chose wedding dresses with elaborate honeymoon travel plans in mind. One such bride, Louise Whitfield, married industrialist Andrew Carnegie aboard the S.S. *Fulda* en route to their European honeymoon in 1887. She wore a versatile traveling suit made by Herman Rossberg of New York, which could be transformed into many different looks by mixing and matching an extra bodice, cuffs, collar, and red plastron. The ingenious ensemble must have been worn several times during the voyage.

in Columbus, Ohio, on January 17, 1854. Now in the Kent State University Museum, the gown has tiered bell-shaped sleeves echoing the shape of its voluminous skirt. Nearly a century later, in 1945, Mary Whittle of St. Helens, England, chose a tartan dress for her going-away outfit; she and her husband, James, were honeymooning in Scotland.

DOUBLE-DUTY DRESSES

◆ ◆ ◆ ◆

Sometimes, the wedding dress and the going-away dress were one and the same. In 1886,

A much less practical going-away ensemble survives in the Glasgow Museums collection. Elizabeth Holms-Kerr, the daughter of a Glasgow stockbroker, wore her grandmother's sixty-year-old wedding dress for her wedding to John Deans Hope in 1899. That may be why she went away in an up-to-the-minute bodice and skirt combination in luminous royal blue wool made by London court dressmakers Mesdames Hayward, appliquéd with velvet and soutache in an Art Nouveau design. Surviving going-away gowns of vivid green trimmed in blue, red velvet, and even black from the late nineteenth

ABOVE: The gray wool suit Louise Whitfield wore for her 1887 shipboard wedding could be re-styled several ways on the honeymoon. OPPOSITE: Elizabeth Holms-Kerr, the daughter of a Glasgow stockbroker, wore a gown by London's Mesdames Hayward as her going-away dress in 1899.

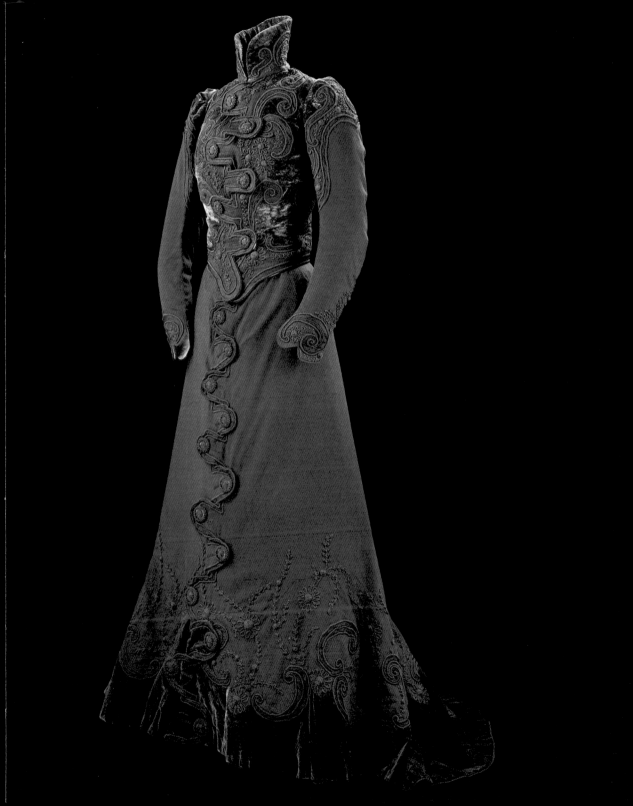

century may reflect the growing popularity of the white wedding gown.

Lina Waterfield wore her pink going-away dress in Charles Wellington Furse's painting *The Return from the Ride*, painted the year after her 1901 wedding. Her husband, Aubrey, was an artist; she was a journalist who wrote several books about Italy. The painting is not a portrait—the horse belonged to the artist, and the landscape in the background is a view near his home in Surrey—but, like many of Furse's paintings, it has the immediacy of a photograph, capturing the heroic in the everyday. Waterfield likely chose to wear her second-day dress because it was her best, newest, and most stylish dress; the soft but striking color may have appealed to the artist, a British Impressionist who often painted women in soothing pastels.

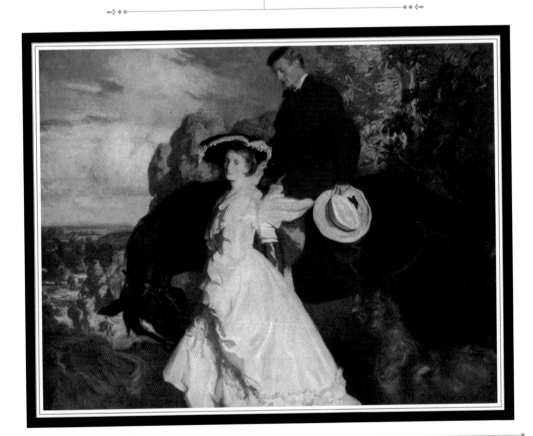

ABOVE: Newlywed Lina Waterfield (with her husband, Aubrey) wore her going-away dress in Charles Wellington Furse's 1902 painting *The Return from the Ride.*

A similar going-away suit survives in the Chicago History Museum, worn by Mrs. Frederick H. Scott in 1902. Though it is made of sturdy gray broadcloth trimmed with coarse linen lace, both outfits reflect the fashionable silhouette of the time, with a high neck, bulbous "pouter pigeon" bodice, bottom-heavy bishop sleeves, and gored skirt with a short train. Their graceful lines and easy movement are emblematic of women's newly active lifestyles.

FASHION AND FANTASY

♦ ♦ ♦ ♦

The wedding of Princess Mary, the only daughter of George V and Queen Mary, to Viscount Lascelles at Westminster Abbey on February 28, 1922, was the first royal wedding to receive extensive coverage in fashion magazines like *Vogue*. The press lavished as much attention on the bride's going-away dress as on her medieval-style silver lamé wedding dress by Reville. Long before the ceremony, news of what she would wear as she set off on her honeymoon leaked to the press, though the destination—Shropshire—was a closely guarded secret. On February 8, the *Daily Mail* described it as being "in the soft shades of pink and blue for which she has always shown a preference" and "embroidered in blue silk and beads of crystal and the palest pink coral." The *Illustrated London News* also published a preview of her trousseau on February 18, including an

illustration of the going-away dress. The caption described it as "powder blue charmeuse, embroidered with coral beads, and worn with a black satin hat adorned with a wreath of blue and pink flowers." The gown survives in the Historic Royal Palaces collection, minus the underblouse visible at the collar and cuffs, and it matches the description exactly. On March 4, a sketch of the princess and her husband boarding the train for their honeymoon appeared in the *Illustrated London News*, the going-away dress partially covered by a fur coat and muff.

ABOVE: Mrs. Frederick H. Scott's going-away suit from 1902 reflects women's increasingly active lifestyles.

Fashion magazines continued to pay close attention to going-away clothes. Though a wedding dress might represent a reader's fantasy, the going-away dress was a more relatable,

achievable fashion goal; it was a bridal fashion even nonbrides could emulate. In 1924, Cornelia Vanderbilt left her wedding at Biltmore (see Chapter 4) wearing a gown of "a smart tan cloth with V-shaped insert of brown from bodice to hem. The V-shaped collar ended in a long scarf which, when slung over the shoulder presented a novel effect," according to the *New York Times*. In September 1947, *Mademoiselle* featured a chic charcoal gray going-away suit on the cover of its wedding issue rather than a white gown.

Going-away dresses remained an essential part of a bride's wedding wardrobe until the late 1960s, and the tradition is still observed today. A surviving going-away dress in the Museum of New Zealand Te Papa Tongarew reflects the "youthquake" fashions the bride, Patricia Olliff, expected to see on her honeymoon in London in 1969. Olliff knit the short-sleeved minidress herself from a pattern, choosing a vivid pink to contrast with her cream wedding dress.

Since then, the going-away dress has continued to figure prominently in coverage of royal weddings. After her wedding on July 29, 1981, Princess Diana donned a cantaloupe-colored silk dress and matching short-sleeved bolero jacket with a ruffled white fichu collar and cuffs and white bow by Bellville Sassoon to board a train for her honeymoon on the Royal Yacht *Britannia*. She paired it with Manolo Blahnik heels and a feathered John Boyd hat. While her iconic

A B O V E : Princess Mary's going-away dress and trousseau got as much press coverage as her wedding gown in 1922.

their "going away" clothes: a navy blazer, open-collared striped shirt, and khakis for William and a blue, belted Reiss dress and black blazer for Kate.

GOING TOO FAR

◆ ◆ ◆ ◆

Modern brides often change into a more comfortable "reception dress" for dancing, which may double as a going-away dress. The lavish 1999 wedding of Manchester United's star midfielder David Beckham and Spice Girl Victoria Adams—held at Luttrellstown Castle in Ireland—was over-the-top from beginning to end, when the couple departed for their Bora Bora honeymoon wearing matching custom-made purple outfits by Antonio Berardi. His open-necked purple shirt and double-breasted jacket were less formal than the cream-colored three-piece suit and cravat he'd worn for the ceremony. Her form-fitting gown slit to the thigh and lined in red, worn with knee-high silver gladiator sandals, was a sleek, dance-floor-friendly alternative to her £77,000 corseted Vera Wang wedding gown with a twenty-foot train and an eighteen-carat gold crown by jeweler Slim Barret. The couple's infant son, Brooklyn, had a matching purple suit and cowboy hat. It was a bold his-and-her look, but one that didn't stand the test of time. "Victoria's was pretty nice," Beckham told *Vanity Fair* in 2017. "Mine, I'm like, 'What was

wedding dress could not be worn again, she wore her going-away ensemble on several occasions, including during her tour of Australia in 1982 and on a visit to Grimsby in 1983. She even ordered a second, long-sleeved jacket with future events in mind. The girlish—almost childish—style in a soft pastel hue suited the public image of the virginal twenty-year-old bride, nicknamed "Shy Di."

Although Diana's oldest son, Prince William, and Kate Middleton didn't leave on their honeymoon immediately after their 2011 wedding, the palace duly released an image of the couple in

ABOVE: Princess Diana wore a Bellville Sassoon dress and jacket with a feathered John Boyd hat and Manolo Blahnik heels to board a train for her honeymoon.

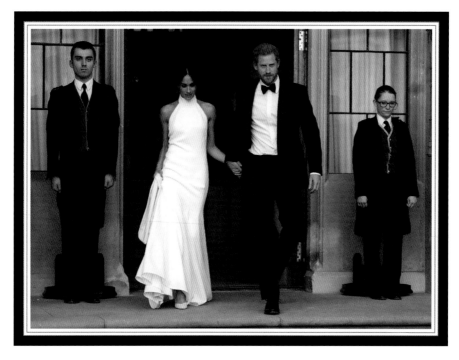

I thinking?' I look like the guys out of *Dumb &
Dumber* when they went to that party and wore
those ridiculous outfits. I even had a top hat in
purple. Unbelievable."

The Beckhams' friends Prince Harry and
Meghan Markle played it safer, setting out for
their 2018 wedding reception at Frogmore
House in evening wear that was both altar-
appropriate and ready to party. She swapped
her sleeved silk cady gown by Givenchy's Clare
Waight Keller and its dramatic but unwieldy
veil of sixteen feet of embroidered tulle for a
backless silk crepe halterneck gown by another
British designer, Stella McCartney. He traded
his Blues and Royals uniform for a classic
tuxedo. Instead of the horse-drawn carriage
that had collected them from the ceremony at
St. George's Chapel, they made their getaway in
a powder-blue electric Jaguar convertible.

As Beckham—along with countless brides
and grooms before and since—discovered, fash-
ion and weddings don't always mix. Fashion is
fleeting, flamboyant, and sometimes frivolous;
love—and wedding pictures—are forever. ◆

ABOVE: The newly married Duke and Duchess of Sussex changed clothes between
their wedding at St. George's Chapel and their reception at Frogmore House.

BIBLIOGRAPHY

Alexander, Kimberly S. *Treasures Afoot: Shoe Stories from the Georgian Era*. Baltimore: Johns Hopkins University Press, 2017.

Amnéus, Cynthia. *Wedded Perfection: Two Centuries of Wedding Gowns*. Cincinnati: Cincinnati Art Museum, 2010.

Anonymous, *Recollections of a Royal Governess*. New York: D. Appleton, 1916.

Arch, Nigel, and Joanna Marschner. *The Royal Wedding Dresses: The Splendour of Royal Marriage Across Five Centuries*. London: Sidgwick & Jackson, 1990.

Balmain, Pierre. *My Years and Seasons*. London: Cassell, 1964.

Bowles, Hamish. *Vogue Weddings: Brides, Dresses, Designers*. New York: Knopf, 2012.

Chase, Edna Woolman. *Always in Vogue*. New York: Doubleday, 1954.

Chrisman-Campbell, Kimberly. *Fashion Victims: Dress at the Court of Louis XVI and Marie-Antoinette*. London: Yale, 2015.

———. *Worn on This Day: The Clothes That Made History* Philadelphia: Running Press, 2019.

Cox, Caroline. *I Do. . . . 100 Years of Wedding Fashion*. New York: Watson-Guptill Publications, 2002.

Culpepper, Marilyn Mayer. *Trials and Triumphs: The Women of the American Civil War*. East Lansing: Michigan State University Press, 1994.

Delaney, Diane Meier. *The New American Wedding: Ritual and Style in a Changing Culture*. New York: Viking Studio, 2005.

Dunak, Karen M. *As Long As We Both Shall Love: The White Wedding in Postwar America*. New York: New York University Press, 2013.

Ehrman, Edwina. *The Wedding Dress: 300 Years of Bridal Fashions*. London: V&A Publishing, 2011.

Esfandiary-Bakhtiari, Soraya. *Soraya: The Autobiography of Her Imperial Highness, Princess Soraya*. New York: Doubleday, 1963.

Grossman, Grace Cohen. *Romance and Ritual: Celebrating the Jewish Wedding*. Los Angeles: Skirball Cultural Center, 2001.

Hartnell, Norman. *Silver and Gold: The Autobiography of Norman Hartnell*. London: V&A Publishing, 2019.

Hay, Susan, ed. *From Paris to Providence: Fashion, Art, and the Tirocchi Dressmakers' Shop, 1915–1947*. Providence: Rhode Island School of Design Museum of Art, 2001.

Howard, Vicki. *Brides, Inc.: American Weddings and the Business of Tradition*. Philadelphia: University of Pennsylvania Press, 2008.

Hyde, Charles K. *The Dodge Brothers: The Men, the Motor Cars, and the Legacy*. Detroit: Wayne State University Press, 2005.

Ingraham, Chrys. *White Weddings: Romancing Heterosexuality in Popular Culture*. London: Routledge, 2008.

Kessel, Dmitri. *On Assignment*. New York: Abrams, 1985.

Kohn, Martha. *I Do: A Cultural History of Montana Weddings*. Helena: Montana Historical Society Press, 2011.

Long, Timothy. *I Do! Chicago Ties the Knot*. Chicago: Chicago Historical Society, 2010.

Mallard, R. Q. *Plantation Life Before Emancipation*. Richmond: Whittet & Shepperson, 1892.

Miller, Russel. *Ten Days in May: The People's Story of VE Day*. London: Bloomsbury Reader, 2012.

Mills, Charles A. *The Civil War Wedding*. Apple Cheeks Press, 2016.

Rublack, Ulinka, and Maria Hayward. *The First Book of Fashion: The Books of Clothes of Matthäus & Veit Konrad Schwarz of Augsburg*. London: Bloomsbury, 2015.

Snodgrass, Mary Ellen. *World Clothing and Fashion: An Encyclopedia of History, Culture, and Social Influence*. London: Routledge, 2013.

Strasdin, Kate. *Inside the Royal Wardrobe: A Dress History of Queen Alexandra*. London: Bloomsbury Academic, 2017.

Summers, Julie. *Fashion on the Ration: Style in the Second World War*. London: Profile Books, 2016.

Thompson, Eleanor. *The Wedding Dress: The 50 Designs That Changed the Course of Bridal Fashion*. New York: Prestel, 2014.

Tobin, Shelley, Sarah Pepper, and Margaret Wiles. *Marriage à la Mode: Three Centuries of Wedding Dress*. London: The National Trust, 2003.

Walker, Catherine. *Catherine Walker: An Autobiography by the Private Couturier to Diana, Princess of Wales*. New York: Universe, 1998.

Wead, Doug. *All the Presidents' Children: Triumph and Tragedy in the Lives of America's First Families*. New York: Atria Books, 2004.

PHOTOGRAPHY CREDITS

INDEX

ACKNOWLEDGMENTS

There have been many books on wedding dress, but this is my first trip down the aisle. I am grateful to my editors Kristen Green Wiewora and Cindy Sipala at Running Press for helping me get over my cold feet. Also at Running Press, Cisca L. Schreefel, Martha Whitt, and Marissa Raybuck have been instrumental in shepherding this beautiful volume to completion. I am so thankful for the support and friendship of Laurie Fox at the Linda Chester Agency, who is a true romantic.

While *The Way We Wed* could not have been written without the miracle of digitized collections, documents, and oral histories, I have benefited from the IRL assistance of the staffs of The Huntington Library, the Los Angeles Public Library, the Pasadena Public Library, and the Glendale Public Library. And I thank the many museums, archives, historical societies, libraries, auction houses, photographers, photo agencies, and private collectors who provided the gorgeous images in these pages as well as information about their collections. So many people went above and beyond the call of duty to help me while furloughed or working from home during a global pandemic. I am particularly indebted to Nicole Amaral, Cynthia Amnéus, Bauer Media Australia, Annette Becker, Noelle Brown, Jeremy Dimick, Lesley Frowick, Meghan Hansen, Joanna Hashagen, Eunice Haugen, Kristina Haughland, Kevin Jones, Margaret Jones, Natalie Jones, Claudy Jongstra, Nicole Kelly, Jean McElvain, Alan Miyatake, Philip Mould, Kay Peterson Denis Reggie, Madelyn Rzadkowolski, Kristen and Ruby Scheuing, Nicholas Sinclair, and Jan Stokes.

This research grew out of my previous book for Running Press, *Worn on This Day: The Clothes That Made History*, which, in turn, drew on my @WornOnThisDay Twitter feed. My followers may have noticed that I've been posting a lot of wedding fashions lately, and I've appreciated their thoughtful comments and questions.

The Way We Wed is dedicated to my beloved husband, Ian, as we enter our twentieth year of marriage. Our wedding was one for the history books.